The Arts and
the American Home,
1890-1930

The Arts and
the American Home,
1890–1930

EDITED BY

Jessica H. Foy

and Karal Ann Marling

The University of Tennessee Press
Knoxville

Library of Congress Cataloging-in-Publication Data

The Arts and the American home, 1890–1930 / edited by Jessica H. Foy and
Karal Ann Marling. — 1st ed.

 p. cm.

 Based on papers presented at the Fourth Annual McFaddin-Ward House
Conference, Beaumont, Tex., Nov. 1990.

 Includes bibliographical references and index.

 ISBN 0-87049-825-8 (cl. : alk. paper)

 1. Arts and society—United States—History—19th century—Con-
gresses. 2. Arts and society—United States—History—20th century—
Congresses. 3. United States—Social life and customs—19th century—
Congresses. 4. United States—Social life and customs—20th century—
Congresses. I. Foy, Jessica H., 1960– . II. Marling, Karal Ann.
III. McFaddin-Ward House Museum.

Conference (4th : 1990 : Beaumont, Tex.)

NX180.S6A76 1994

700'.1'03097309034—dc20 93-32083
 CIP

Contents

List of Illustrations

Acknowledgments

The chapters in this book are derived from presentations given in November 1990 at the fourth annual McFaddin-Ward House Conference, sponsored by the McFaddin-Ward House in Beaumont, Texas. The conference was underwritten by a grant from the Mamie McFaddin Ward Heritage Foundation.

Introduction

Kenneth L. Ames

This book is a welcome and significant addition to the literature on American homes. It joins a still short, but growing, list of titles dedicated to analyzing and interpreting the cultural dimensions of past domestic life. The literature on homes and home furnishings is actually immense, but the majority of titles, at least those readily accessible within the arts and humanities community, belong to the literature of advocacy. These publications are tools in strategies for control, telling people what they ought to do and, sometimes, how to do it. Less common are thoughtful publications like this that invite readers to step back to reflect on the deeper meanings and broader ramifications of what people have done or been told to do with their homes.

This book advocates for no narrow cause. Its purpose is to promote a greater understanding of American society's most prominent, most important, and most culturally revealing artifacts. Understanding of that sort is always enhanced by study of the past. During our lifetime, confusion swirls all around us; it is hard to see patterns, to distinguish superficial and ephemeral changes from deep-seated and fundamental cultural realignments. When we look back at the past, however, some of that confusion recedes. Patterns begin to become visible. Furthermore, explorations of the past provide important benefits not easily obtained from study of the present alone. These benefits are what historian Harvey Kaye calls "the powers of the past"—perspective, critique, consciousness, remembrance, and imagination.

By *perspective*, Kaye means a realization that the way things are now is not the way they have always been or the way they must necessarily be in the future. *Critique* means the ability to debunk and demystify the contemporary world, to see that social agendas lurk behind structures and relations represented as natural or inevitable.

Consciousness means understanding not only that past, present, and future are inseparable but also that the future is always hostage to the past and present. It also means recognizing that every moment and every event are lived and understood from multiple perspectives and that social gain does not take place without struggle. *Remembrance* is understanding that the past "is a well of conclusions from which we draw in order to act." Remembrance recalls experience and struggles, aspirations, visions, and dreams, all of which enhance our ability to critically analyze the present and consider alternatives to it.

Finally, *imagination* means recognizing that the present is history and that we can shape that history by acting to prevent the barbaric and promote the humanistic. Taken together these powers of the past explain not only why the study of history is valuable but also why it is necessary. Without it we drift rudderless in the sea of the eternal present.[1]

But I want to go a step further to argue that a comprehensive study of the history of housing and homes is particularly necessary. It is necessary because housing and homes play roles of the greatest significance in our psychological, social, and cultural lives. This is a truth we seem only partially to recognize or accept. Our understanding of the importance of housing has often been undercut or compromised by cultural prejudices against homemaking, against home decorating, against activities associated with women in general, and against matters that do not readily lend themselves to "rational," scientific, or conventional male forms of analysis. And so it is typically the case that male architects who design houses are cultural heroes but the work of those who transform an architectural shell into a nurturing and supportive environment is dismissed as inconsequential or trivial. The literature on great male architects is extensive and accorded high status, whereas the literature on women's needlework is sparse and accorded low status. This pattern of behavior is both sexist and socially destructive.

This book takes significant steps toward countering the fragmentary and biased approach still too prevalent in studies of historic housing by bringing together informed and illuminating contributions from nine talented authors. These contributions reveal something of the extraordinary range of cultural products that can enrich our understanding of domestic life. Yet they also repeatedly demonstrate—sometimes explicitly, sometimes only implicitly—that seemingly diverse cultural products or expressions sometimes reveal or respond to similar technological, social, or other forces. This is a book to read and reread, for the ties that bind it together are both numerous and subtle.

Karal Ann Marling's introductory chapter sets the scene for the chapters that follow, outlining major cultural transformations and fixations. In some ways, the period from 1890 to 1930 was a time like all times, marked by dramatic shifts and upheavals. These are perhaps most visible in the realm of technology. Between 1890 and 1930, the automobile, phonograph, radio, cinema, and central heating all became commonplace. Marling tells us that these and other innovations both triggered and accompanied shifts in the furnishing, use, and, ultimately, the meaning of homes.

One notable change was the declining importance of homes as centers of entertainment; the outside world seemed to have so much more to offer. Arts and entertainments were increasingly less likely to be home produced and more likely to be products of the vast entertainment industry that had emerged by the early years of this century. By the 1920s, mass culture met the nation's aesthetic, spiritual, and material needs.

Responses to mass culture were as ambivalent then as they are today. On one hand, the technical superiority of many products of mass culture was indisputable. Yet mass culture turned a nation of active doers or at least tryers into a nation of passive recipients of cultural production. Marling notes that Americans were less likely to make music than to listen to it, less likely to read than be read to on the radio. Home crafts went into a decline and did not recover until the austerity of the Depression made them once again appealing.

What do these changes mean? Do they represent early manifestations of what is sometimes called dumbing down? Do they mark the beginning of the de-skilling of America? Is mass culture a negative force? Is it somehow less real or less authentic than the culture it supplanted? Do products of mass culture carry meanings that are less important or less intense than handmade objects? Is it really true that, as some people thought, "what we make is more virtuous and expressive that what we buy?" Are things bought bad or meaningless?

Marling thinks they are neither. Common sense and our own experience tell us the same thing, but prejudices apparent in literature of the early twentieth century persist today, particularly in the academic world. Marling notes that "one-of-a-kind statements are generally more interesting to the academic mind than those made by large groups of people" and that "a great painting still speaks with a louder voice than a $1.98 print." The conservative posture of many academics might be amusing if it did not have intellectual and social impact. For scholars' unexamined notions about what does or does not matter obviously shape their decisions about what to study and what to value.

This is not a small problem. We still have no objective measures of what kinds of things matter to people more than others. We have no clear understanding of either historical continuities or changes in the rankings of objects. We don't know whether cost is or is not a significant index of importance. We do know, however, that our society as a whole is profoundly ambivalent about mass culture. Marling shows us that this ambivalence is deeply rooted in the past.

Also traceable to at least the early twentieth century is American tolerance for artificiality. In a recent essay, architecture critic Ada Louise Huxtable wondered when Americans lost their interest in reality. She thought that it had happened by the time Colonial Williamsburg, that major early example of "fudged" reality, was being superimposed on a sleepy Virginia town.[2] The Colonial Revival may be a major culprit, for Marling reminds us of the widespread popularity of Wallace Nutting's hand-colored images of the colonial past, genuine photographs "of a culture that predated the advent of the camera." In images such as these, reality and unreality commingle. Their placement in domestic contexts pushes us to recognize the many layers of realities and unrealities, of dreams, hopes, and expectations that furnish most domestic interiors.

The chronological or phenomenological ambiguity of Wallace Nutting's images is emblematic of most homes. Kevin Lynch's famous question "What time is this place?" could be asked of any American home of the period 1890–1930.[3] The answer invariably was simultaneously of the present and of one or more identifiable pasts. The new, the old, and that which recalled or replicated the old were usually held in dynamic tension within most homes of the period. Some furnishings were old, but even those that were new deliberately and with varying degrees of accuracy recalled older styles, older traditions, older cultural and social orders. Yet kitchens, bathrooms, and numerous portable appliances were exempt from retrospection and increasingly paraded their modernity. The tension between the old and the new, the traditional and the modern, prevailed throughout the period and, except for a brief interlude of modernism, still prevails. In significant ways, domestic environments of today still conform to contours carved out early in this century.

Marling's essay frames the discourse of the following chapters. Each successive author takes a piece of the artifactual or cultural fabric of American homes and teases out its major strands. Bradley Brooks invites us to explore major shifts in ideas about the way American domestic interiors

ought to look that occurred between 1890 and 1930. He traces a startlingly clear, if sometimes erratic, transition from late Victorian interiors to a new twentieth-century aesthetic. That aesthetic, as I have already suggested, was novel, but it was grounded in and depended on objects in old styles to make its impact.

The transition involved more than historical styles. Brooks tells us that the most obvious shift was from visual clutter to clarity and simplicity. Late Victorian homes were characterized by complexity on many levels: "line, tone, texture, use of space, historical association, and geographic origin." Brooks speaks of "intricate and subtle montages," a phrase that captures exactly the spirit of these designs. Over the next decades, however, this complexity and intricacy dissipate, replaced by a renewed emphasis on symmetry, formal balance, restrained harmony, and subdued coloring. Interiors are marked by fewer furnishings, lower density, and less stylistic diversity. If late nineteenth-century interiors were often wildly eclectic, those of the early twentieth century become increasingly uniform and internally consistent. Now rooms are no longer domestic museums or cabinets of curiosities but, in effect, period rooms.

In tracing this package of transformations, Brooks leads us through decorating manuals and advice books of the period. The titles he cites belong to that literature of advocacy I mentioned above. We might also call it the literature of domination or hegemony. Like many strategies to achieve or maintain hegemony, that motivation is concealed. What we can see and interpret, however, are the ploys used in authors' attempts to gain an upper hand. Brooks shows us how advocates of the new manner sold it by appeals to logic, rationality, and deference to the past.

This new "rational approach" stressed the primacy of architecture and architectural features, elements that had previously been either hidden or considered less important in shaping the overall impact of interiors. It also raised the standard of accuracy in replicating historic furnishings, substituting direct quotations of historic prototypes for the inventive paraphrases and imaginative anthologies of the earlier period. With this new style came increased attention to color theory. Finally, the cult of rationalism in design justified a monolithic and absolutist vision of "good taste."

From Brooks's discussion of interiors as wholes we turn to examinations of particular components and functions. What elements are critical to the definition of home? The next chapters argue that fire and music are two of the most important. Kate Roberts provides a fascinating pictorial tour of

changing understandings and presentations of fireplaces over this forty-year period. She shows how fireplaces, technomically obsolete, remain critical components of houses and carry heavy symbolic and affective baggage.

Jessica Foy explores the role of music in domestic life. Although the belief that good music was essential to a home remained constant, Foy reinforces Marling's argument that people increasingly gave up being producers of music and became listeners instead. In the latter years of the nineteenth century, music was credited with moral suasive powers. Music was supposed to uplift and transform. It was a way to improve character and people's sense of well-being. Finding justification in the doctrine of separate spheres and the ideology of domesticity, men assigned the responsibility for domestic music to women. Knowing how to play a musical instrument became an attribute of genteel women around the country.

Foy helps us imagine America of the late nineteenth century as a nation of amateur musicians. Women learned to play parlor organs and pianos, instruments capable of producing complex combinations of sounds. Women staged musicales for family and friends, concerts that took place within domestic settings and featured amateur but also sometimes very accomplished musicians. What we today call "live" music was a measure of a household's well-being and was abundant in late Victorian America.

But the very expression *live music* reminds us that there are alternatives and that some of those alternatives became increasingly prominent in the early twentieth century, as first the phonograph and later the radio brought professional music to the ears of thousands and then millions. This new music was often by leading artists and was often much more musically demanding and more capably performed than music created by local amateurs. Furthermore, this new music also represented a wider range of musical traditions and trends. Through ragtime and then jazz, blacks began the long, slow process of integrating American culture and society. They gained access to the world of culture and entertainment long before they found social acceptance.

The new means of making music democratized music consumption in the home, making lack of training, skill, or even money increasingly irrelevant. But some wondered if there was too much music. Would music be devalued? Had it become too commonplace, too available?

Craig Roell takes us deeper into this exploration of music by concentrating on the period's premier instrument, the piano. Roell sees the piano as the instrument most responsible for popularizing a taste for music. For

him, the piano is such an important artifact, so rich in symbolic baggage yet so obviously and compellingly useful, that it is the key artifact of Victorian America. The piano flourished because it drew upon and sustained three important and highly valued tenets of the dominant Victorian culture: the moral value of music, the ideology of domesticity, and the work ethic. Thus the piano, although a musical instrument, was also central to a network of cultural values and assumptions that combined to elevate it in the home above all other musical instruments.

Morality, uplift, refinement, therapeutic rejuvenation, medicine for the soul—these were all alleged properties of music. More often than not, it was women's toil, sacrifice, and perseverance that brought music and its attributes into the home. Women may also have borne most of the burden of reading in the home, but reading required less rote practice, less routine repetition day after day, at least for adults. Anne MacLeod tells us that reading aloud—in the examples she cites it is women who do the reading—was as popular at the turn of the century as watching television together is today (or perhaps was in the 1950s). Reading was the most available form of entertainment for most Americans and, when public libraries became widespread, one of the least expensive.

One notable feature of reading at the turn of the century was the fact that children read adult books and adults read children's books. The distance between the two was not necessarily great. Both shared an aesthetic that featured strong narratives, romantic characters, high adventure, and an idealized picture of the world. Many of the period's best-known authors wrote for both adults and children. The period's idealization of childhood and its emphasis on wholesome subjects reinforced the idea that the best books for children were also good for adults. Yet beside this strand of approved, wholesome writing ran a broad current of formulaic popular writing that defenders of conventional morality continually combated.

But if shared reading characterized the turn of the century, within a few years this shared experience began to unravel. Adult literature took a turn toward realism and began to deal with subjects considered inappropriate for children. Children's literature became the focus of its own massive industry, an industry that perpetuated and even exalted the earlier aesthetic. Children's literature became an enclave apart from the world of adult literature. Adults and children went their own reading ways.

In her contextualizing chapter, Marling raised important questions about the ways scholars decide what artifacts are important and what arti-

facts carry significant meanings. She reminded us that prejudices often subvert the search for historic truth. Beverly Gordon tells us that needlework in particular has been a victim of such prejudice. Today needlework may still be the least understood, and perhaps the least valued, of home arts. Gordon's chapter in this book is one step toward remedying that situation.

Men have typically maintained that needlework is trivial and unaffected by the major currents of the outside world. Gordon shows that it is neither. Needlework is a responsive medium that reflects the broader world around it. The products of needlework of the past were understood to be suitable for home environments and beneficial to residents. The styles of needlework and the objects needlework adorned underwent a series of transformations that ran parallel to changes in other arts. With the Aesthetic Movement of the late nineteenth century, for example, came a free and light-hearted mode visibly distinguishable from the heavy and eclectic styles of previous decades. The impact of both English and Japanese design ideas were visible in needlework of the period, particularly in the ubiquitous crazy quilts and parlor throws.

Later came yet another series of styles, including outline work, silk work, and whitework. In some of these turn-of-the-century styles, Gordon sees response to the same factors that informed Impressionist painting and the great White City of Chicago's World's Columbian Exposition. With new times also came new kinds of goods. Sofa pillows, for instance, became widely popular and sometimes took on a vaguely risqué quality, paralleling both ragtime and the new realism of adult literature. And into the teens and twenties, needlework responded to exactly the same shifts Brooks saw affecting interiors: designs became sparer, more abstracted. Fussiness disappeared. Everything became simpler, understated.

Like interiors, needlework also responded to the pressure for a more insistently accurate engagement with the past. The Colonial Revival brought to needlework new visibility and status. Gordon says women were attracted to the Colonial Revival because they saw the colonial era as an age when women's work was respected. Needlework was understood as a tangible link to or extension of that earlier period. With the new awareness of the past also came the beginnings of the scholarly study of historic needlework and the beginnings of the revaluation of women's arts in general.

Arts and their meanings seem never to be static. Art museums may project an impression of a timeless standard of art, but that is illusory. We sometimes forget that art museums themselves are of recent vintage. William Ayres shows us a surprising correlation between the rise of art mu-

seums and the decline of picture use in domestic settings. His argument helps us see that homes and their functions never exist in a void. Nor, for that matter, do art museums.

Ayres shapes his chapter around the idea that pictures—paintings, for the most part—were used in homes as parts of social strategies. In the nineteenth century, they were understood to play active didactic roles in interiors. The assertive, bold way of framing and installing them underscored that function. But that understanding of the use and installation of pictures gradually receded.

Ayres traces the slow process of retreat, as pictures became more insistently decorative and subservient to the architecture of the room. Increasingly, pictures were hung flat against the wall. By the 1890s, pictures were markedly less evident in the homes of the affluent and in home-decorating manuals. Whereas several pictures might have been hung along a wall in earlier decades, now only one or, sometimes, no picture at all could be seen. By the end of the century, those few pictures that appeared in domestic interiors "tended to be captives of the overall plan."

Ayres tells us that the general devaluation of pictures between 1890 and 1930 was related to the gradual decline of traditional religious values. Pictures charged with meaning seemed inappropriate to people with modern, enlightened views. Yet although the use of pictures was declining in homes, they were being newly celebrated and enshrined in emerging art museums around the country. The history of painting after Impressionism and the emergence of the ideology of art for art's sake cannot be explained on the basis of internal evidence alone. The cant and mystification that surround modern art have covered up the bald truth that by the early years of this century paintings no longer found a broad-based market. As prominent household furnishings they had become obsolete.

But not all pictures disappeared from domestic interiors. Far from it. As paintings lost favor as household decor, photographs gained importance, at least for some people. One of their great merits, as Shirley Wajda points out, was their accessibility to a broad spectrum of society. Even working-class people could afford a portrait photograph of the family. If low cost made photographs commonplace, however, they were nonetheless significant.

Photographs served many purposes. They were not only documents but also status markers. They played prominent parts in adorning and adding meaning to the parlors of people of many social and economic levels. Whether housed in elegant cases, as were daguerreotypes, or collected in

luxurious, plush-covered albums, as cabinet photographs typically were, they were owned and displayed in profusion. And all evidence indicates that they were often profoundly meaningful to those who owned them.

Evidence within the images and, sometimes even more explicitly, on the reverse of cabinet photographs indicates that portrait photography was understood as an art form. Professional photographers called themselves "artistic" photographers and adorned their advertisements with references to the elite tradition of portrait painting. It was well understood that photography did not simply preserve nature; it was a product of artifice.

Yet like every other cultural form investigated here, photography too changed. The appearance of inexpensive, easily used cameras created a new generation of amateur photographers, whose images transformed yet again the nature and meaning of a central prop of domestic life. And here one of the central themes of this book appears yet again: technological change in turn sends ripples of other changes, often unforeseen, out into the larger society. Wajda neatly brings us back to some of Marling's opening observations, and the circle is complete.

Notes

1. Harvey J. Kaye, *The Powers of the Past* (Minneapolis: Univ. of Minnesota Press, 1991), 150–69. The "well of conclusions" passage is from John Berger, qtd. in Kaye, *The Powers of the Past*, 158.

2. Ada Louise Huxtable, "Inventing American Reality," *New York Review of Books* 39, no. 20 (3 Dec. 1992): 24–29.

3. Kevin Lynch, *What Time Is This Place?* (Cambridge: MIT Press, 1972).

From the Quilt to the Neocolonial Photograph: The Arts of the Home in an Age of Transition

Karal Ann Marling

1890 to 1930. The forty years between Louis Sullivan's designs for the ten-story, steel-frame Wainwright Building in St. Louis and Edward Hopper's *Early Sunday Morning*, a haunting study of an older, two- and three-story America overpowered by the new skyscraper. From the creation of Yosemite National Park to the development of the first analog computer, from nature to culture, from the garden to the machine, in a single generation.

In the American home, this was the period when the parlor spinet was displaced by the big, crank phonograph and then by the crystal set; when the hearth fires gradually flickered out all across the land and a fragmented family took to the road, one by one by one, to play miniature golf by night under the lights, to spoon on lovers' lane, to guzzle bathtub gin at the local speakeasy. What was there to do at home, anyway, once all the board games had been played, if you didn't like bridge? Read books aloud? Why bother—when there were exciting shows to be heard on the radio, complete with realistic sound effects? Why read books at all, when the stories in the magazines were shorter, snappier, and spicier, and you could take *True Story* with you on the trolley, the subway, or the new Greyhound bus? Why stay home at all, come to think of it, when you could see Garbo or Charlie Chaplin on the flickering screen of the local Bijou under a canopy of artificial clouds and electrified stars? Stay at home knitting? Quilting? Doing embroidery? Or dressmaking? Those things were fine for the old-fashioned, the sedentary, the needy, but not, surely, for the modern girl. And besides,

you could buy the loveliest up-to-date styles at Lerner's for next to nothing, all ready to wear!

Along with the automobile, mass culture is the hallmark of the forty years before the Great Depression—a mass culture celebrated and firmly seated in the national imagination by the great American world's fairs of the turn of the century and by the ads in the colorful new mass-circulation magazines. Gadgets. Machines. Factory-made products. Mechanical wonders. Labor-saving miracles. And for all our retrospective insistence that the avant-garde resisted the blandishments of technological and commercial Americana, it is clear that high culture, too, took its clues from the same low sources.[1] Marcel Duchamp invented the ready-made, the work of art bought from the housewares section of the nearest department store.[2] Precisionist painters and poets both looked at shiny fire trucks blaring down rain-slick streets in the new city of skyscrapers and incessant noise. T. S. Eliot put *The Wasteland* together from jazz lyrics and street-wise slang. Some painters copied the effects achieved by the cool, mechanical eye of the camera. Some chronicled the new, public culture of mass delight with brush and pen. Others decided that the old, traditional media were too slow, too cumbersome for modern times, and turned to cinematography, confident that the moving image was the mural of tomorrow. And meanwhile George Gershwin, the toast of Tin Pan Alley, began work on the greatest grand opera of his day.

No, high culture versus low is not the controlling dichotomy of the period. But there is a perceptible split (or perhaps just the opposite: a deadly rapprochement) between the private and the public realms, between the house and home and the world of the club, the theater, the restaurant, the bar, the store, the stadium. During the years just before and after World War I, just as the last economically productive functions disappeared from the average American home, so too did its generative role in cultural affairs suffer a dramatic decline. Americans no longer made much music in their own parlors, for example; in growing numbers, they simply listened to it. They no longer read and imagined (except in the case of sizzling best sellers); they were read to electronically, the mental pictures supplied ready made. And they no longer made beautiful things. Despite short-lived crazes for yo-yo quilts, crepe-paper flowers, woven cigar cellophanes, wood burning, and baskets made from old greeting cards, the real hobby boom came later and took its rise from the enforced idleness of the Depression and the suburban togetherness of the 1950s. The preceding era, by contrast, slowly but inexorably leached the creative and artistic energies out of the domestic sphere. What had once taken place in the private domain now

occurred in the public arena instead. Industry—including the entertainment industry—met most of the nation's aesthetic and spiritual needs along with its material ones, leaving the purpose of the modern-day home very much in doubt.

The problem was widely discussed in the 1920s by practitioners of the new social sciences. Sociologists, for instance, contrasted the productive, multifunctional family of the nineteenth century (farming, fiddling, quiltmaking, barn-building, pie-baking pioneers) with the modern edition, from which, after the advent of industrialism and urbanism, most economic, educational, and recreational activities had been shifted—to outside agencies. "The various functions of the home in the past served to bind members of the family together," noted a federal study of the early 1930s.[3] But when those ties weakened, the family structure itself was subject to erosion and ultimate dissolution: the divorce rate rose steadily and alarmingly after the turn of the century, and intact families, the experts concluded, were those that had learned to compensate for the loss of purpose by reorienting the institution toward meeting the emotional and affectional needs of its members. That was no easy task, especially when those innermost desires and longings were increasingly formed on such wayward models as the love lives of the Hollywood stars.

The floundering modern family, its habits and habitat, was the chosen subject of novelist Sinclair Lewis. With his keen eye for physical detail, Lewis is particularly useful as a guide to the household arts still honored in the middle-class, middle-American dwelling of the 1920s. Take George Babbitt, realtor and suburbanite, ensconced in his snazzy green-and-white Dutch Colonial number in Floral Heights. Babbitt loves things, the chromeplated detritus of modern, easy-credit-terms civilization. "His motor car," writes Lewis, "was poetry and tragedy, love and heroism. The office was his pirate ship but the car his perilous excursion ashore."[4] These are George's places—the driver's seat and the executive suite—arranged for his comfort and delight. Outside the home he is a pirate, a prairie pasha. But home is another matter. Between Myrna (the missus), two daughters, and his teenage son, all with ideas and opinions of their own, Babbitt feels not entirely comfortable in the bosom of the new affectional family. After dinner, while Mrs. Babbitt darns socks a more modern-minded woman would have thrown away, he is apt to retreat irritably into the comic strips that "composed his favorite literature and art," emerging at irregular intervals from behind newspaper or picture magazine to rail against the study of Shakespeare in the public schools, where Business English would do young fellas a lot more good.

Perhaps Babbitt's real problem was propinquity: the colonials and bungalows of America's emergent commuter tracts had relatively few public rooms in comparison to the number of bedrooms, and such communal spaces as were provided were small in size.[5] The house, or its ground floor at any rate, thus tended to reinforce the sociologists' image of the affectional family by throwing its constituents together, at close quarters, in leisure hours. Small wonder that Babbitt preferred his new sleeping porch, in which the reader finds him as the novel begins: new, a sure sign of success, but also wholly private, just big enough for one, a retreat from house, family, and master bedroom alike. Or his bathroom, with a full range of Modern Appliances (in capitals, of course) "as sleek as silver" and a set of fancy, talismanic guest towels, forbidden to family members. Babbitt, the public man, is starved for privacy in his own house, where the very bathroom towels speak to the public character of the place; where even the innermost sanctums contain aesthetic objects—artistic icons of a sort—intended mainly for the consumption of outsiders.

The fireplace-facing davenport (two out of three houses in the neighborhood had them), the cabinet Victrola (shared by eight of nine), the hand-tinted Wallace Nutting photo of a colonial maiden at a spinning wheel (nineteen out of twenty)—all link Babbitt's manse to that public world. The close quarters of his own living room are not truly his but belong instead to the realm of impersonal cash transactions:

> It was a room as superior in comfort to the "parlor" of Babbitt's boyhood as his motor was superior to his father's buggy. There was nothing in the room that was interesting, there was nothing that was offensive. It was as neat, and as negative, as a block of artificial ice. . . . [The contents] were like samples in a shop, desolate, unwanted, lifeless things of commerce.
>
> Against the wall was a piano . . . but no one used it. . . . The hard briskness of the phonograph contented them; their store of jazz records made them feel wealthy and cultured; and all they knew of music was the nice adjustment of a bamboo needle. The books on the table [were] unspotted and laid in rigid parallels; not one corner of the carpet-rug was curled; and nowhere was there a hockey stick, a torn picture-book, an old cap, or a gregarious and disorganizing dog.[6]

The arts in the home in Floral Heights are so many props, chilly appurtenances of the good life, public gestures lacking the private resonance that the successful family would surely require to fortify itself against the mani-

fest allures of store-bought culture and synthetic emotion. And Babbitt, predictably enough, runs off the rails in sheer despair.

He takes to the woods, the last natural refuge from an unnatural and stifling living room. He takes a blowsy mistress with a cozy, frumpy flat, with chairs a man can stretch out in and "the colored photograph of Mount Vernon"—the nation's ideal home—"which he had always liked so much."[7] Babbitt's lady friend, of course, knows how to play the piano. But in the end, Babbitt goes home to his Victrola and his Wallace Nutting print, more than a little relieved to be back in a predictable environment, where things—even the annoyances and frictions of the affectional family—work according to a certain logic, without much thought or effort on the part of those involved. The sofa and the unread gift books (in F. Scott Fitzgerald's *Great Gatsby* of 1925, the pages of Jay Gatsby's books are uncut!) on the table nearby will remain as they are. Babbitt lacks the energy to fight the public conventions that deaden and defeat his private yearnings.

Symbolic display is not quite that neatly disposed of, however. Although the public aspects of interior arrangements are important—Babbitt's household aesthetic announced the family's economic status and its willingness to conform to peer standards and, as Lewis realized, reflected what it was possible to buy in a given price range—it is easy to overlook the private satisfactions, the emotional or even affectional role Babbitt's prints and furnishings played in the culture of Floral Heights. To express one's status by acquiring an artifact or a class of artifacts is an act that gratifies the buyer on the deepest level. Furthermore, George Babbitt genuinely liked cars of a certain brand and color, things made of chrome, a particular comic strip, and pictures of Mount Vernon: there is no reason to doubt his testimony on issues of taste. Yet when the buyer is not a Morgan or a Getty, historians too often discount the legitimacy of purchase as an expression of real aesthetic feelings. Although in our century only the rich and the marginal live in a matrix of handicrafts they commission or create, the belief somehow persists that what we make is more virtuous and expressive than what we buy, that displaying good taste via a hand-wrought, gallery-expensive original is a more potent and meaningful statement than one made with a factory-fresh Wallace Nutting print.

Sinclair Lewis falls into that trap, even when he himself uses store-bought goods to express his pudgy hero's interior life, or, more often, the hateful, middle-class shallowness thereof. And scholars of consumer culture carry on in the same self-lacerating vein, wishing (or so it would appear) for the end of a capitalistic system that carries with it the right to choose to live

with what holders of Ph.D. degrees might not give house-room to. In other words, the value and artistic merit of the objects possessed by the subject in question determine the legitimacy of the statements and beliefs they express—and one-of-a-kind statements are generally more interesting to the academic mind than those made by large groups of people, each of whom may purchase copies of a given mass-produced folly. We say that "great man" history is dead. But, where art objects are concerned, a great painting still speaks with a louder voice than a $1.98 print. Art historians can read "great" works of art but presume that the folks who received a yard of roses for a wedding present in 1929 and hung it proudly over a sofa that came from the Sears catalog were saying nothing much at all—because their words were simple, their grammar commonplace, their sentiments widely shared, and their bills paid on time.

The arts of the home—arts with a very big and costly A—constitute the subject matter of many American paintings of the 1890s, when the anti-Babbittical gospel of uniqueness was in full cry. William Merritt Chase's pictures, for example, provide a sort of serial stroll through his New York studio and the family's summer home on Long Island. There are figures present from time to time—children, visiting connoisseurs, guests, pupils, pretty women—but they are mere reference points supplied to bring the backgrounds into sharper focus. For the domestic or quasi-domestic environment is Chase's real theme. And what a place it is, this artist's world that popular magazines of the day also illustrated and decorators aped, this tasteful, rich, expressive place that (albeit in an attenuated and updated form) became the prototype for Babbitt's 1922 abode. The Chase household is adrift in bric-a-brac assembled from the far corners of the earth: oriental parasols, stuffed geese, Italian marriage chests, ships in bottles (or out of 'em), carpets, tapestries, brass chargers, copies of famous paintings, original etchings. The stuff tells of travel, of cosmopolitan values, of a certain disdain for American mass culture in its infancy. Its knowing, fussy disposition reeks of taste, personality, the householder who propped the plate upon the scarf upon the bench just so (much as Myrna Babbitt put the books on her coffee table). Never an austere environment, even when stripped and straw-matted for the summer, Chase's crowded interiors also allude to the multiplicity, the prodigal abundance of the machine age, although factory-made products are nowhere to be seen.

But above all, this kind of scene focuses attention on the expressive act of choice, picking one thing over another, as the unseen arranger did, and as the potential buyers who browse through Chase's painted chambers will

shortly do, cash in hand. A student of department-store displays of the late nineteenth century has recently compared them with the artistic settings depicted in American paintings of the Chase epoch.[8] The material sumptuousness, the imperialistic exoticism, and the principle of controlling or ordering the chaotic confusion of mass culture with superior intellect and taste are clearly identical in kind, if not in degree. Even homebound high art, in other words, is a creature of the marketplace from which poor Babbitt would shortly emerge with his shopworn values and silk lampshades, ready to declare his allegiance to the ethos of Floral Heights by the just-right placement of his pretty Nutting spinstress and his never-to-be-read aesthetic books.

From the 1890s through the 1920s, Americans assumed that their living rooms reflected themselves, even when the contents came from chain stores and soulless factories, on easy credit terms. Emily Post's *Personality of a House*, published in 1930, defined personality as the expression "of . . . *your* old-fashioned conventions, . . . your emancipated modernism—whichever characteristics are typically yours," through the appointments of the family home.[9] And her assertion that there were two ways to go, or two viable personalities—old-fashioned versus emancipated modernism—exposes yet another key dichotomy manifest in the domestic sphere. The very modern Mr. Babbitt (he of the gadgets, the chrome-plated bathroom, and the disdain for Shakespeare) still harbored some amazingly old-fashioned ideas and artifacts, without seeing any contradiction between old and new. Like most Americans of the 1920s, the premise of a Wallace Nutting "colonial"—that this was a genuine photograph of a culture that predated the advent of the camera—bothered the Babbitts not one bit. Like most Americans, they wanted a colonial house, redolent of the homeyness attached somehow to the "good old days," but they wanted it equipped with the most modern plumbing and appliances that contemporary industry could supply. Henry Ford understood their mentality when, as he was remodeling the colonial Wayside Inn in South Sudbury, Massachusetts, in 1923, he insisted that walk-in closets and lavish tile baths be added to the picturesque old bed chambers.[10] Modern tourists bound for the New England past in their Ford cars—his hoped-for clientele—would have it no other way.

Walter Lippmann gave a name to the syndrome: Puritanism de luxe. Americans who bought Martha Washington china sets and Nutting colonials, Lippmann wrote in 1923, on the occasion of Calvin Coolidge's dramatic swearing-in in his aged father's rustic keeping room, "are delighted with the oil lamps in the farmhouse [in Vermont], and with the fine, old

Colonel Coolidge and his chores and his antique grandeur. They are de-lighted that the President comes of such stock, and they even feel, I think, that they are ascetic, and devoted to plain living because they vote for a man who is. Thus we have attained a Puritanism de luxe in which it is possible to praise the classic virtues, while continuing to enjoy all the modern conve-niences."[11]

But the old ways, the old stuff, the old methods of setting out the con-tents of a room, changed very slowly, even in modern times, as Colonel Coolidge's archaeological farmhouse testified. The chrome bathrooms and the color-coordinated gas ranges were tucked away, out of sight, in the pri-vate precincts of the home. In the living room, old pieces stood side by side with new ones, the piano cheek by jowl with the Victrola. Suburbanites, in their ersatz colonial cottages, were more apt to buy things strictly appropri-ate for the new house, but the pattern of too-muchness, inherited from the late Victorian magazine articles on artistic interiors (or colonial manors) or from one's own parents' cache of untouchable whatnots, persisted. Nev-ertheless, however modern the appointments, however expressive of today, of last week's sale at the Bon Ton, the sense of what was suitable, of what looked nice in the home, went back to childhood. Despite a radical change in content, the Babbitt home, in a formal, quantitative sense, is more like William Merritt Chase's studio apartment of the 1880s and 1890s than Lewis was willing to admit.

In extended families, especially rural ones, the persistence of nineteenth-century household arts into the go-go twentieth century was sometimes fraught with misunderstanding and tension, indicative of how much has always been at stake when somebody elects to make an aesthetic statement by setting a table or planting a flower. Iowa writer Ruth Suckow chronicles a dramatic clash between old and new in a 1928 short story "Midwestern Primitive." Bert Stratzer, her heroine, is about to open a midwestern ver-sion of the Wayside Inn in her family home, a former farmhouse at some remove from Cedar Rapids. The appointments have come by mail order: the "little fringed napkins of pink crepe, the tinted glass goblets . . . , the spray of sweet peas at every place, one pink and the next one lavender, made of tissue paper."[12] Like her sense of style, Bert's ideas for the menu—roast chicken, not that old, countrified fried kind—and the decor of the upstairs room in which the guests would leave their coats have come straight out of the latest women's magazines. But when the food critics arrive from the city, expecting an old-time country inn, they ooh and aah over her mother's dandelion wine, her quilts, her plush album of daguerreotypes, the dark

hulking family furniture hidden away in the back bedrooms, and the garden, full of real, live flowers.

The author is a romantic: like Margaret Mead in the South Seas, the city folk in search of an authenticity missing from their own lives revel in the honesty of grandma's midwestern primitivism. Bert's efforts to change her environment by importing newfangled ideas purchased from mail-order catalogs is ridiculed. Conservatism prevails. Things that are bought are bad, or meaningless, because they are rootless, depersonalized, even unwomanly. And although George Babbitt ruled the sleeping porch, the artistic elements of the household continued to be assigned to the Myrnas and the Berts. Bert asserted her modernity by espousing a business-oriented house, fitted out according to the dictates of mass culture, and thus she rejected the handmade past of antimacassars and quilts. Indeed, throughout the Midwest in the early decades of this century, managers of state fairs predicted the imminent demise of the quilt.

A prime symbol of female enterprise, it had been an absolute necessity of frontier life, before woolen mills came into operation in the western territories. Like the hooked or braided rug, the quilt also served to demonstrate the housewife's industriousness, thrift, forbearance, and aesthetic sensibility: in a frontier society sorely lacking in pleasures for the eye, the quilt was often the primary means whereby the unslaked thirst for beauty was satisfied. But as civilization crept across the plains, the quilt became a focus for a growing anxiety about the changing status of the family in general and of women in particular. The Minneapolis papers, for instance, took to predicting that the quilt would soon vanish from the Minnesota State Fair premium list, a casualty of "this . . . faster age."[13] And for a time, in the 1910s and 1920s, entries did drop off dramatically. Aged ladies who had moved into rest homes in town after a lifetime on the farm still pieced and appliquéd quilts for the fair, but the busy young clubwomen of the day, when they found time for handiwork at all, were more liable to make crepe-paper sweet peas or to paint china, following printed instructions issued by firms that sold the materials. The link between artistic embellishment and sheer physical need was ruptured at the very moment when mass culture burst into gaudy, artificial flower, at the moment when manufacturers' leaflets replaced tradition as the teacher of the first principles of loveliness.

Carol Kennicott comes to *Main Street*, Gopher Prairie, in this uneasy period of transition, before World War I. If Sinclair Lewis's *Babbitt* stands for a slightly later era, and a suburban set of problems, his Carol confronts the beginning of modern times, and the potential destruction of closely held

values, in a small town, where everything worth seeing can be inspected in thirty-two minutes flat, and ideas about women, art, and the home have the status of defensive dogma thrown up against such modernistic heresies as might import themselves to Gopher Prairie by parcel post. Carol herself, the bride of Doc Kennicott, comes to town by train, fresh from college and a library career in St. Paul, full of progressive notions and vague discontents disclosed mainly in her schemes for the artistic reform of Main Street. Gopher Prairie is proud of the Minniemashie House, "the corners covered with sanded pine slabs purporting to symbolize stone," and the Bon Ton Store, its plate glass windows bound at the edges with brass.[14] Convinced that "a small American town might be lovely as well as useful in buying wheat and selling plows," Carol, however, proposes a neocolonial facelift for the mismatched facades of Main Street, "a new Georgian town as graceful and beloved as Annapolis or that bowery Alexandria to which Washington rode."[15]

Fleshed out by the how-to-do-it columns in home-decorating magazines and by pictures in back issues of *National Geographic*, her pleas for modernization still fall on deaf ears. Most of the neighbors she badgers are skeptical of any change and blind to the defects of the place they call home. "What's the matter with the town?" asks one well-disposed businessman, bent on saving the persistent Carol from sure social ostracism. "Looks good to me. I've had people that traveled all over the world tell me time and time again that Gopher Prairie is the prettiest place in the Middlewest. Good enough for anybody."[16]

The plan goes nowhere. Civic leaders cite the expense and the lack of any real need for change as reasons for their indifference but it is also plain that Main Street is not the aesthetic province of women. Business and its architectural expressions are men's business. The artistic ambitions of women are restricted to papers on European cathedrals delivered at club meetings and the decor of their own homes. In interior design, too, Gopher Prairie tends toward a frugal preservationism that retains the contributions of mothers and grandmothers, in a stylistic mélange Lewis calls "the crammed-Victorian school." In one typical parlor Carol visits on her round of colonial proselytizing, she encounters walls plastered

> with "hand-painted" pictures, "buckeye" pictures, of birch-trees, newsboys, puppies, and church-steeples on Christmas Eve; with a plaque depicting the Exposition Building in Minneapolis [ca. 1886], burnt-wood portraits of Indian chiefs of no tribe in particular, a pansy-

decked poetic motto, a Yard of Roses. . . . One small square table contained a card-receiver of painted china with a rim of wrought and gilded lead, a Family Bible, Grant's Memoirs, the latest novel by Mrs. Gene Stratton Porter, a wooden model of a Swiss chalet which was also a bank for dimes, a polished abalone shell holding one black-headed pin and one empty spool, a velvet pin-cushion in a gilded metal slipper with "Souvenir of Troy, N.Y." stamped on the toe, and an unexplained red glass dish which had warts.[17]

This is the woman's world, the domain of art: "I must show you all my pretty things and art objects," murmurs her hostess.

Shut out of the wider world of town reform, Carol retreats to her own home, or rather, to the Doc's old house, which he had once shared with his mother. This undistinguished place, this "prosaic frame house in a small parched lawn" will become, Carol vows, "her own shrine." It is another gloomy Victorian horror, highlighted by a bay window to the right of the porch hung with cheap starched lace, through which the passerby could glimpse "a pink marble table and a conch shell and a Family Bible."[18] First, she proceeds by small and stealthy measures: the old sewing table reemerges as a tea table, bearing the embroidered lunch cloth and mauve-glazed Japanese cups brought with her from St. Paul. Then, with the first snow, she claims the parlor. Out go the golden oak table with the brass knobs, the brocade chairs, the picture entitled *The Doctor*. Workmen rip out a wall, creating a single long, open chamber. The smart stores in Minneapolis yield up their treasures: a Japanese obi in gold and ultramarine, hung against a wall of maize; a new couch—a divan—with pillows of sapphire velvet banded in gold; a set of chairs that, in Gopher Prairie, suddenly look "flippant." She "hid the sacred family phonograph in the dining-room, and replaced its stand with a square cabinet on which was a squat blue jar between yellow candles."[19]

To christen this "shrine" to advanced taste, wide intellectual horizons, and contemporary Arts-and-Crafts-ism, Carol throws a party—an improbable oriental soiree—at which she appears in jade green pajamas, serves chow mein, and urges the guests to imitate a Chinese orchestra. It's a predictable disaster, with everything, including the divan, too unfamiliar for comfort, entirely too strange, a perfect mirror of the personality of the twitchy young hostess. And after the party, Carol gives up on the house. Although she still agitates for change, and even flees Gopher Prairie briefly for a fling in the big city, her rebellion is essentially over. When she comes

back to her husband, at the end of the war, she talks about art and refuses to "admit that Main Street is as beautiful as it should be"—but Carol has settled for the aesthetic of marble table, conch shell, and family bible.[20] The old decor identifies a shrine in which the old values are still honored.

Art is a dangerous proposition, particularly when it is unleashed within the sacred precincts of the family home. The Armory Show of 1913—the year Carol wed Will Kennicott—was greeted with howls of derision because modern art challenged old assumptions about how the world looked and ought to look, the meaning of representation, who had the right to decide what art meant: whether, in fact, the fine arts were still accessories of the good life, of the ideal home, or something else altogether. Was art moral, edifying, instructive, the guiding light of the family circle? Or was it abstract, formalistic, indifferent to issues of right and wrong? Was art comforting, familiar, an outlet for emotion, a conduit for sentiment? A yard of roses or something on the order of Gertrude Stein's "a Rose is a rose is a rose"? A plush album, a family picture, a view of beautiful Minnehaha Falls—or a photograph of a tall, steel-frame office building obscured by fog? Carol and George and Bert all struggled toward an answer and failed, alas, to find one. But their trying underscores the importance of the problematic relationship between art and the home, between tradition and modernity, between the private and the public realms in the age of mass culture.

Notes

1. See, e.g., Kirk Varnedoe and Adam Gopnik, *High and Low* (New York: Museum of Modern Art/Harry N. Abrams, 1991).

2. Phil Patton, *Made in U.S.A.* (New York: Grove Weidenfeld, 1992), 30–31 discusses commercial sources for Duchamp's ready-mades.

3. M. Sue Kendall, *Rethinking Regionalism: John Steuart Curry and the Kansas Mural Controversy* (Washington, D.C.: Smithsonian Institution Press, 1986), 102–4.

4. Sinclair Lewis, *Babbitt* (1922; rpt. New York: New American Library, 1961), 23.

5. See, e.g., Clifford Edward Clark, Jr., *The American Family Home, 1800–1960* (Chapel Hill: Univ. of North Carolina Press, 1986), 172.

6. Lewis, *Babbitt*, 78.

7. Ibid., 259.

8. Sarah Burns, "The Price of Beauty: Art as Cultural Package in the Late 19th Century Studio Interior" (Paper delivered at annual meeting of the American Studies Association, Toronto, 4 Nov. 1989).

9. Karal Ann Marling, *George Washington Slept Here: Colonial Revivals and American Culture, 1876–1986* (Cambridge: Harvard Univ. Press, 1988), 272.

10. Ibid., 283.

11. Walter Lippmann, "Puritanism de Luxe," in *Meet Calvin Coolidge*, ed. Edward Connery Lathen (Brattleboro, Vt.: Stephen Greene, 1960), 51–54.

12. Ruth Suckow, *A Ruth Suckow Omnibus* (Iowa City: Univ. of Iowa Press, 1988), 250.

13. Karal Ann Marling, *Blue Ribbon: A Social and Pictorial History of the Minnesota State Fair* (St. Paul: Minnesota Historical Society Press, 1990), 64.

14. Sinclair Lewis, *Main Street* (1920; rpt. New York: New American Library, 1961), 36–38.

15. Ibid., 130.

16. Ibid., 139.

17. Ibid., 135–36.

18. Ibid., 33.

19. Ibid., 70.

20. Ibid., 432.

CHAPTER TWO

Clarity, Contrast, and Simplicity: Changes in American Interiors, 1880–1930

Bradley C. Brooks

Between 1880 and 1930 the appearance of American interiors changed dramatically. As Americans enjoyed literature, music, and other arts in their homes during this period, the clutter and visual confusion of the high Victorian interior gave way to the clarity and simplicity endorsed by reformers who sought to imbue the decoration of rooms with a beauty born of logic and deference to the past. Between the Aesthetic Movement interiors pictured in *Artistic Houses* in 1883 and 1884 and the emerging classicism seen in the World's Columbian Exposition of 1893 and codified in *The Decoration of Houses* (1897) lay a distinct shift in the compositional aspects of interiors. Although interiors were literally the stages and backdrops for the production and enjoyment of domestic arts, they were notable as art forms in themselves and will well repay an examination of their formal qualities and cultural significance.

Nineteenth-century decorative arts have been characterized as the products of a "century of revivals," and as those of "innovation, revival and reform,"[1] but for the purposes of this chapter, it is important to remember that historic revivals continued to play a significant role in decorative arts and interiors well into the twentieth century, retaining their role in reform. This essay will discuss some of the stylistic trends in interiors and furnishings of the late nineteenth and early twentieth centuries, using decorating manuals and advice books as well as images of interiors from the period as sources. This evidence will be skewed toward the upper end of the economic scale, as the greater part of the literature was directed there, and the greater

part of surviving and accessible photographs was made there. Although such an approach is far from inclusive, it does allow for a consideration of interiors that made the most of the decorative styles of their times, that spoke the contemporary visual languages most fluently and expressively.

The interiors and furnishings of the final third of the nineteenth century were nothing if not stylistically energetic, often displaying a visual ebullience that scholars have termed *eclecticism*, or *synthetic eclecticism*, designating the freedom with which styles were adapted, combined, and reinterpreted. The interiors of the early twentieth century, from the historically inspired to the self-consciously modern, evolved along a path that left many characteristics of late nineteenth-century decoration behind. To describe the visual changes in interiors from 1880 to 1930 most succinctly would be to identify them as a shift from complexity to simplicity. During that time, the multifaceted complexity of the nineteenth century was replaced by a simplicity that was sometimes visual, sometimes conceptual, sometimes both.

Interior photographs from the late nineteenth century suggest many aspects of complexity: line, tone, texture, use of space, historical association, and geographic origin. Photographs of some rooms reveal spaces that appear so dark and densely patterned, so filled with furniture and crowded with objects that the modern viewer may respond with confusion. Where is the visual emphasis? What is background, and what foreground? Were such rooms practical to live in? A more informed understanding that moves beyond these reactions must be based on a careful examination of late nineteenth-century decorative complexity on its own terms and in its own context.

The fashionably furnished homes of the late nineteenth century, exemplified by interiors illustrated in *Artistic Houses*, published in 1883 and 1884, were intricate and subtle montages of architecture, art, furniture, and furnishings (fig. 2.1). Products of the Aesthetic Movement of the 1870s and 1880s, these interiors carried their own ideological content, however confusing they may at first appear. Among its goals, the Aesthetic Movement sought to unite art with design and workmanship, to return them to the Edenic relationship that was thought to have existed between them before the fall precipitated by industrialization. Proponents sought to bring more media under the umbrella of art, to raise more objects and techniques to a level of serious artistic consideration. Furniture, wallpaper, textiles, ceramics, and metalwork all became "artistic" in their own right, competing more aggressively for the viewer's attention in the interior and contributing to the lack of visual focus that would be so much reviled by later critics.[2]

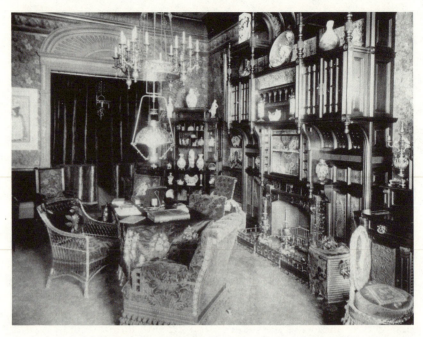

Fig. 2.1. An Aesthetic-period interior. Boudoir in the home of D. L. Einstein, New York. *Artistic Houses* (New York: D. Appleton, 1883), vol. 1, pt. 1, following p. 25. Courtesy, the University of Delaware Library, Special Collections, Newark.

Artistic Houses depicts residences of the very wealthy, where the aesthetic of complexity found some of its fullest expressions, and where, among the seemingly endless possibilities presented by the high style of the time, we may discern its dominant architectural and decorative themes. In a given house, rooms were often decorated in markedly different styles: a French drawing room, a medieval library, a Moorish smoking room. These themes might be carried through from architecture to furnishings, or they may have been creatively juxtaposed. In many rooms, walls were divided into three horizontal registers: the lower wainscoting, or dado; the area immediately above it, called the fill; and uppermost, the frieze. These walls often combined molded or carved wooden paneling with patterned hangings or wallpapers. Ceilings were frequently beamed, coffered, or otherwise dimensionally enriched in wood or plaster, and embellished with decorative painting. The most prominent architectural features of the rooms—fireplaces, doorways, and built-in furnishings such as sideboards and inglenooks—were often vigorously

sculptural. Wealthy home builders lavished workmanship and expense on these elements, giving exquisite detail to massive interior elements.[3]

One extant house in Galveston, Texas, effectively illustrates this phase: the Gresham house, begun in 1887 to the designs of Galveston architect Nicholas Clayton for railroad magnate and politician Walter Gresham (fig. 2.2). Before turning to its interiors, a brief consideration of the exterior and plan will be helpful, as they demonstrate the ways that architectural design participated in the same aesthetics as did interiors and furnishings. Seen in elevation, the Gresham house is irregular in silhouette, its elaborate roof line punctuated with a variety of chimneys and turrets. The house's plan is irregular on both axes, bulging with porches and projections. The corner turret bays, one circular, the other polygonal, feature windows with rounded Romanesque arches, Gothic arches, and plain, square heads, with varying rhythms of fenestration. Wall surfaces are enriched by an interplay of horizontal bands of textures and colors in the stonework, and the whole is liberally sprinkled with stone carvings.[4]

These characteristics of the Gresham house's exterior were echoed on the interior by a similar approach to the use of space, form, and detail. This is most immediately evident in the entrance hall, designed with a flueless, gas-burning fireplace and a spiraling octagonal staircase lighted by leaded-glass windows and an unseen dome above (fig. 2.3). This room synthesizes an important group of interior architectural concepts: dynamic interplay of mass and void, diversity of materials and decorative techniques, coloristic richness, and a very high level of workmanship and detail over broad areas.

Just as architecture often emphasized a number of design themes simultaneously, so did interiors employ a variety of stylistic idioms, rendered in a diversity of techniques and materials, in furniture, objects, and textiles. Not only were these furnishings visually complex, they drew on a range of associations that are vital to our understanding of them. The concept of complexity and its meaning in nineteenth-century furnishings has been effectively addressed by Katherine Grier in *Culture and Comfort*, which discusses visual complexity in furnishings as a material expression of the nineteenth century's aspiration to refinement and gentility. Grier compellingly describes the analogies implied by words such as *finish*, used to describe both furniture and manners, noting that in both, great value was placed on control, either of materials or of personal deportment, and that an increase in either was considered evidence of progress and the advance of civilization.[5]

An examination of some elements of nineteenth-century complexity will permit a better-informed understanding of their associations and cultural

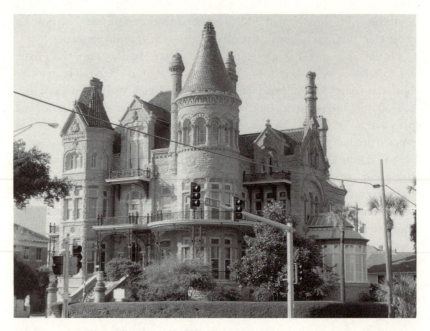

Fig. 2.2. Walter Gresham house, Galveston, Texas. Photograph by Penny Leveritt. Courtesy, the Moody Mansion & Museum.

significance. Late nineteenth-century interiors prominently exhibited a material cosmopolitanism unprecedented in scope. Many rooms dating from the 1880s and 1890s seem to have gathered furnishings from all over the world. Some objects were the products of other countries: Far Eastern and European ceramics, Middle Eastern arms and armor, and oriental rugs are only some of the most obvious examples. In general, these emblems of cosmopolitanism were gathered from cultures in which the union of art and workmanship was thought to be untouched by industrialization.[6] Western interpretations and adaptations of exotic ideas also had an impact on American interiors. The "Turkish corner" often combined objects of foreign and domestic manufacture in a place of exaggerated comfort and informality closely tied, as Karen Halttunen has pointed out, to the developing idea of the living room.[7] As the reforms of the twentieth century took hold, Turkish corners were held up to ridicule as among the very worst products of undiscriminating Victorian taste (fig. 2.4).

Exoticism and cosmopolitanism were similar components of visual complexity, examples of perceptions and products of foreign cultures placed in

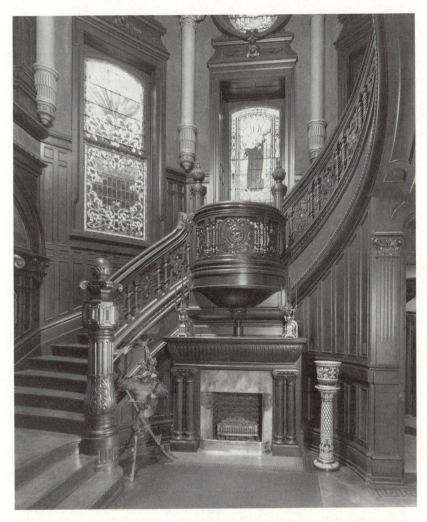

Fig. 2.3. Entrance hall, Walter Gresham house. Photograph copyright © by Herbert K. Barnett.

the service of Aesthetic Movement precepts. Materials, workmanship, and design in domestic products likewise collaborated to increase complexity. The inherent properties of materials were often exploited to the full in late nineteenth-century decorative arts, usually with design emphasis on manufacturing processes. Wicker, iron, and glass adapt with equal ease to sober or extravagant design, but the desire to increase and emphasize artistic ex-

Fig. 2.4. Turkish corner, J. H. Kirby house, Houston, Texas, ca. 1906. Dorothy Knox Howe Houghton et al., *Houston's Forgotten Heritage: Landscape, Houses, Interiors, 1824–1914* (Houston: Rice University Press, 1991). Courtesy, Rice University Press.

pressiveness led to exaggeration and experimentation. The resulting objects were tours de force of the designer's and workman's skills and creativity, of mastery of techniques with malleable and flexible materials.

Whereas some objects spoke to cosmopolitanism or to unmistakable handcraft, others demonstrated domesticity and the beautifying and personalizing touch of the homemaker's hand. China painting on mass-produced blanks was a popular pastime at the turn of the century, continuing the centuries-old tradition of women's decorative work. Following Aesthetic Movement principles, china painting combined the fine and industrial arts, bringing together easel painting, the quintessential fine art, with the products of modern industry.[8] Other crafts, such as pyrography, or woodburning, similarly enabled individuals to contribute personal touches to their homes.

Individually, decorative objects were too small to have any notable effect on the interior. They were, however, significant as a part of what one author has termed *bricabracomania*, a phenomenon that had an undeniable visual

impact on the interior.[9] Along with the increasing tendency to fill interiors with objects of display came a growing need for other classes of objects that could uphold, encase, or otherwise present these accumulations. Pedestals, easels, and parlor cabinets were among the objects that filled this role. Although not new furniture forms, these, like so many others, were made and used in unprecedented numbers near the end of the nineteenth century. Logical accompaniments to the "artistic" interior, they were honorific devices that emphasized the presence of art objects in the home and added another layer of artifactual density to a room's composition.

These interiors, filled with furniture and objects, with color and pattern on ceilings, walls, and floors, were often further enriched by a lavish use of textiles that included upholstered tabletops, draped mantels and shelves, layers of rugs and rich window and door draperies. Textiles softened, darkened, and muffled interiors of the late nineteenth century, reducing sensual immediacy for their occupants, blurring visual and tactile distinctions.[10] This lack of visual definition and all-embracing heterogeneity of furniture forms and stylistic antecedents would be among the qualities of the late nineteenth-century style to be most derided by advocates of the newer vision of interior decoration that emerged as the new century neared.

In 1893, ten years after the first segments of *Artistic Houses* were published, the Chicago World's Columbian Exposition highlighted an architecture less influenced by exoticism and eclecticism. The exposition's numerous large buildings gave a group of architects the opportunity to work in a common idiom, and the resulting White City focused attention on a strengthening movement toward classicism.[11] Just as the 1893 exposition is important as a concise expression of returning architectural classicism, *The Decoration of Houses* gives a concise expression to corresponding ideas in interior decoration, ideas whose influence would be strong in the new century. First published in 1897, this collaboration of author Edith Wharton and architect-decorator Ogden Codman, Jr., addressed with authority and precision the relationship of architecture to interiors and of interior architecture to interior decoration. Edith Wharton's crisp prose was brought to bear chiefly upon architectural concepts such as proportion, symmetry, and harmony, and their application to doorways, windows, fireplaces, ceilings, walls, and floors.[12]

Wharton and Codman were among the first to articulate a new approach to interior decoration, and to voice criticisms of late nineteenth-century aesthetics that would be repeated by numerous others well into the twentieth century. Late nineteenth-century interior decoration, according to the

authors, had degenerated into a "labyrinth of dubious eclecticism" that had disintegrated the proper relationships between the architect and the function of architecture and between architecture and decoration. Wharton and Codman condemned the earlier aesthetic of complexity, exoticism, and self-expression as "cheap originality" and strongly urged a thoroughly rational approach to architecture and decoration, often proposing the Italian Renaissance as a model. For Wharton and Codman, the aesthetic of complexity was inappropriate, not because it displayed bad taste in itself, but because it committed the sin of irrationality, obscuring architecture and inverting what they held to be proper visual agendas. For example, Wharton and Codman argued logically that doors were meant to insure privacy, to be hinged so as to swing into rooms, and to remain closed when not in use, not to be pushed into wall pockets and remain open simply to provide a space in which to hang portieres. Likewise, windows were openings to admit light and air, and to articulate the architectural rhythm of a room, not to be coyly hung with lace curtains, which the authors likened to "lingerie effects," and swathed in yards of elaborate draperies. Well-conceived architectural structure had to be the basis of all decoration, which should provide a complement, but never competition.[13]

Wharton and Codman spoke with a seemingly unassailable logic and authority about the appeal and correctness of Renaissance architecture and its later derivatives, and about the importance of architectural proportion and symmetry. Despite its biases in favor of an upper-class readership and grand European precedents, *The Decoration of Houses* opened the way for numerous other authors to address interior-decoration reforms across a range of economic levels. Many of their productions were concerned with imbuing American rooms with "good taste," a phrase that often signified their advocacy of a group of historical styles markedly different from that in favor during the closing decades of the nineteenth century. Interest in cultural exoticism waned, replaced by an emphasis on increasingly accurate interpretations of certain European and American styles of the renaissance, baroque, rococo, and neoclassical periods. Many authors during the first two decades of the twentieth century devoted a significant portion, sometimes a majority, of their works to discussing the characteristics and applications of the styles. Two representative examples of this genre are Lucy Abbot Throop's *Furnishing the Home of Good Taste* (1912) and the collaborative effort of Howard Donaldson Eberlein, Abbot McClure, and Edward Stratton Holloway, *The Practical Book of Interior Decoration*, first published in 1919 and alive in new editions at least as late as 1937.[14] Throop covered a

broader chronology of furniture styles than many, briefly treating the decorative achievements of Egypt and Greece before going on to Renaissance Italy, and then to France and England. Eberlein et al. were much more typical in their approach to the subject of styles, concentrating almost exclusively on the evolution of interior decoration in England, Italy, Spain, and France, with America mentioned as little more than a footnote to its mother country. Chapters with titles such as "Interior Decoration in Italy Prior to the Eighteenth Century" and "Nineteenth-Century Episodes" betray the authors' prejudice, framing each subject by its relationship to the eighteenth century. Although many wrote about these stylistic subjects, Eberlein and his coauthors were extraordinary in the detail and extent of their discussions, running to some 165 pages. In less-thorough treatments of the historic styles, interiors and furniture were grouped with less differentiation between historical periods and countries of origin, with emphasis usually on five styles: Spanish, Italian, French, English, and American.[15]

Although narrowing the field of stylistic choices, many interior design writers and theorists sought to raise the standard of accuracy in historic furnishings, to make furniture manufacturers hew to the line of historic precedent and to make consumers aware of the criteria constituting "good taste." Eberlein and his coauthors, quoting a furniture company executive, claimed that "not 10 per cent of [mass-produced] furniture gives . . . even a faint idea . . . what those styles really were, wherein lies their charms, and why those products of a vigorous, acute and progressive age should have so much appeal for us today." Lucy Abbot Throop felt that "thickening a line here and there, or curving a curve more or less" was sufficient to ruin the effect of reproduction furniture, leaving it with a "vulgarity of appearance."[16] In general, Throop and her contemporaries advocated furniture that incorporated simplicity of design and faithfulness to historical models. These two criteria might sometimes appear to be in conflict, as the historic styles were often interpreted with elaborate carving, inlay, or other embellishments, as was often the case with late nineteenth-century furniture, but even when richly decorated, the historic reproduction furniture of the early twentieth century possessed a simplicity and directness of reference and a lack of the design freedom that had characterized the products of late nineteenth-century eclecticism.

Along with the emphasis on more historically accurate furnishings came new ideas of how a room should function visually. The diffuse focus of the Aesthetic interior and its delight in covering surfaces with ornament came under sharp criticism. "Lack of emphasis . . . marks degeneracy," wrote

one commentator in a 1916 *House Beautiful* column entitled "Preventive Aesthetics." "One of the characteristics of a . . . vigorous intelligence is the power to distinguish between important and unimportant . . . In degenerate work there is no centre of interest."[17] In order to provide this center of interest, the prescriptive literature sought to manage color, contrasts, form, and balance so that objects, furniture, and architectural features would appear with the desired degrees of emphasis. The nature of wall treatments was central to this effort. Clarence Cook, representative of the earlier thinking, recommended that walls be "divided up horizontally into [their] natural parts, the wainscot . . . the wallpaper, the frieze and the cornice" and that wallpaper "ought to harmonize with the pictures or ornaments; it should diffuse . . . the tone of objects that hang upon it over the whole wall."[18] By these means, contrast between walls and furnishings was diminished, not heightened.

The currents of early twentieth-century interior design ran directly counter to this; the newer ideas called for unobtrusive wall treatments, preferably with classical architectural references such as paneling or pilasters, that would not provide visual competition for furnishings. B. Russell Herts, in *The Decoration of Apartments* (1915), called on his readers to "accept the wall treatment . . . as final backgrounds against which everything else must stand . . . they must step back in order that everything else may come forward." Predictably, injudicious use of strongly patterned wallpapers was almost universally condemned, often with a caution against any design that might compel a room's occupants to count its endlessly repeated elements.[19]

The use of color was another important factor in achieving the desired unassertive effect in wall treatments, and in managing degrees of contrast and emphasis throughout the interior. For Clarence Cook, a desire for the enjoyment of color led him to criticize "large stretches of wall with pale tints—grays, ashes of roses, apple-greens." After the turn of the century, colors such as these regained favor. *The Practical Book of Interior Decoration* counseled that neutrality "means some of the most beautiful tones in a beautiful world. Among these are the ivories, champagne, dull gold, creams, buffs, and certain tans; pinkish grey or ashes of rose, bluish grey, greenish grey and mauve grey."[20] Many twentieth-century authors wrote extensively on color theory and its relationship to interior decoration, setting out an array of guidelines for success. Decorating literature frequently noted that a room's orientation would predispose it toward "warm" or "cool" colors for northern or southern exposures, respectively. Against the background pro-

vided by the wall treatment, colors had to be combined to create restful and soothing interiors; harsh or jarring contrasts were to be avoided. To maintain interest, a proper balance of harmony and contrast was the desired end.[21] Harmony could be created by using several values of the same hue, or with colors sharing a common element. For contrast, "advancing" colors could be used in conjunction with "receding" colors, or elements of complementary or vivid primary color could be added. Magnitude of contrast was also to be carefully considered; a satisfying interior required not only the proper colors but also their mixture in correct proportion, with controlled use of color intensity. Some authors referred to this as controlling the "scale" of an interior's color. "If on entering a room any object 'jumps' at one we may be sure that it is out of scale."[22] In a properly considered composition, the size and intensity of a room's color elements would combine to provide gradations of contrast and intensity building outward from the neutralized background of the wall. Such a room might then feature a "half intense or even more intense hanging [with] a small lamp shade or bit . . . of pottery, of full intense color" allowing each to have "its share of importance." The same author summarized this approach, recommending that "the larger the area, . . . the less intense a color should be and conversely, the smaller the area, the more intense a color may be."[23] Eberlein and his coauthors brought the color wheel into the service of this carefully orchestrated use of color, proposing that the larger elements of a room's color scheme, such as the walls, be tinted with a hue farthest from the primaries at the color wheel's center, whereas furnishings and accessories, moving away from the walls, could take on brighter, less diffuse colors. One example described an arrangement that included 14/32ds of a quartenary color, 5/32ds each of two tertiary colors, 6/32ds of a secondary color, and 1/32d each of two primaries. This method gave a room's color scheme an objective, logical standard, controlling contrast and emphasis by rendering the conceptual relationships of the color wheel into tangible juxtapositions of distance, size, and color.[24] Vivid primary colors in small items presented themselves against larger elements of textiles and furniture that were less coloristically intense and that were, in turn, seen against a nearly neutral background in a strategy that seems perfectly calculated to counter the visual confusion of fashionable late nineteenth-century interiors.

Of all the historical interior styles that were prominent during the early twentieth century, none owed more to strong contrast in form, color, and texture than the Italian Renaissance and Spanish Colonial styles. Although houses in these styles were geographically widespread, they were thought

particularly appropriate to warm climates, especially in those states that had colonial Spanish histories: "Florida, the Gulf Coast, Louisiana, and the lower Mississippi valley, . . . Texas, New Mexico, Arizona, California, and parts of Nevada, Utah and Colorado."[25] Some authors took great pains to discuss the differences between furnishings in the Spanish and Italian styles, although they were sometimes grouped together based on their common Mediterranean origins and their shared visual characteristics.[26] Again and again, writers on interior decoration praised these styles as fine expressions of some of the early twentieth century's most desired qualities: simplicity, contrast, and honesty. "The charm of the Spanish house lies in its austere simplicity, its directness, . . . its sturdy straightforwardness in construction, and its contrast of materials, textures and colors." In the Spanish and Italian styles, simplicity and contrast were enhanced by broad expanses of rough-plastered walls, which provided a foil for "the dark wood of the furniture [and] richly colored hangings and upholstery." Coloristic enrichment and contrast also came by way of tiles used for "floors of . . . living rooms and corridors . . . in niches, stair risers, . . . and in . . . the reveals of doors and windows," and elaborate wrought-iron architectural hardware and furnishings introduced a strong linear component.[27] Beamed, coffered, or otherwise enriched ceilings brought structural members into plain view, emphasizing the honesty and integrity of construction.

In 1930 work was underway on a new house for William Lewis Moody III, the elder son of a prominent Galveston banker and insurance entrepreneur. The house, called Rio Bonito, was completed in 1931 near the town of Junction, some forty miles west of Kerrville, in Kimble County, Texas. Designed in the Spanish style, Rio Bonito was the work of Hollywood, California, architect Carl Weyl,[28] built for Moody while he was riding a wave of success in his natural-gas pipeline conglomerate, the Moody-Seagraves Company. Although not depicting the original furnishing scheme, the view of Rio Bonito's living room in figure 2.5 demonstrates the decorative importance of beamed ceilings, tile work, and plain plastered walls in creating an atmosphere of spaciousness and simplicity that heightened the visual impact of carefully chosen furnishings.

Along with color and contrast, another component of the reformers' agenda for bringing logic, clarity of focus, and emphasis into the interior was a strengthening of the relationship between architecture and furniture placement. As noted above, one of Wharton and Codman's most important principles was that architecture should be the basis of all interior decoration, that furnishing should not obscure or inhibit architectural features or

Fig. 2.5. Living room of Rio Bonito (W. L. Moody III house) near Kerrville, Texas, ca. 1931. Courtesy, the Moody Mansion & Museum.

function. Lucy Abbot Throop gave similar advice, that architecture and decoration should not be "disconnected subjects" but should play "into each other's hands, . . . to form a perfect whole." She further echoed *The Decoration of Houses* with her assertion that during "the great periods," walls were "treated architecturally and the feeling of absolute support which they gave was most satisfactory."[29] The fashionable interiors of the early twentieth century were to reveal and enhance their architectural frameworks, and the style and placement of furniture and ornaments were calculated to add further emphasis to a room's architectural character. Frank Parsons wrote in *Interior Decoration: Its Principles and Practice* (1916) that the furniture and architecture of a given historic style had a natural visual relationship to each other in line and proportion, each reinforcing the other's strengths.[30] The placement of furnishings should conform to a room's configuration, underscoring the interior's architectural underpinnings. "The only position for [rugs] and for the main pieces of furniture is in accordance with the walls, either lengthwise or across," wrote E. S. Holloway in *The Practical Book of Furnishing the Small House and Apartment* (1922). Parsons considered this precept so important that he warned that if it were ignored, "the principle of the room as a structural unit is violated," inviting "unrest, pandemonium, and an ultimate destruction of everything pleasant in the way of decorative thought."[31]

Placement of furnishings within the architectural matrix of a room was further ordered by observing the rules of symmetry, one of the criteria of "artistic common sense" that "made the old rooms so satisfying."[32] Once again, the decorative theorists of the early twentieth century were turning away from the ideas of the Aesthetic Movement. Clarence Cook felt that nature's asymmetry and irregularities, so engagingly captured in Japanese art, were more useful than arbitrary symmetry as models for the decorative arts and interior decoration, that there was no necessity for "one side of a chimney pier to reflect the other," and that "the classic laws of symmetry and unity are no longer . . . absolute rulers of . . . decorative art."[33] Such a reflection of natural variety was not a part of the early twentieth-century decorative agenda, which sought formal balance, harmony, unity, symmetry, and proportion. These qualities would help establish "a feeling of satisfaction that comes from a sense of rest and repose."[34] The balance that produced such restfulness could proceed from either strict bilateral symmetry or from what was termed *occult balance*, a condition that "is felt rather than one methodically or scientifically determined." Another author embraced both types in his definition of balance as "an equal weight of effect."[35] Al-

though occult balance might result in the desired effects of restfulness and repose, images in popular periodicals more frequently illustrated examples of straightforward, bilaterally symmetrical arrangements (fig. 2.6). These strategies for symmetry and furniture placement in sympathy with a room's architectural lines were intended as antidotes to the perceived disarray, lack of focus, and restlessness of late nineteenth-century interiors, attempts to impose control and order on the proliferation of goods that grew more and more available as the nineteenth century progressed. Perhaps, from a Veblenian perspective, the surfeit of affordable goods on the market and filling interiors during the late nineteenth century drove wealthy Americans to formulate a new way of creating material definitions of themselves. If conspicuous consumption in the usual form no longer sufficed, less had to become more, but only if regulated by the extensive and sometimes arcane dictates of a new definition of taste.

Just as the new approach to interiors called for fewer furnishings and less density in individual rooms, the rooms of a tasteful house were to exhibit less stylistic diversity in an effort to achieve unity. Clarence Cook again provides a good point of reference on the taste of the 1880s and 1890s, advising that "each room ought to be considered by itself, no matter if it be only nominally separated from another by the piers on each side of a wide archway."[36] An approach such as this encouraged houses to have rooms with markedly different decorative styles, as does the Willis-Moody house in Galveston, Texas, completed in 1895 for Narcissa Willis (fig. 2.7). Its interiors, designed by Pottier & Stymus of New York, juxtaposed a Louis XV reception room with an Empire library, both opening onto a classically inspired hall. Houses such as this prompted *The Practical Book of Interior Decoration* to sympathetically consider the visual discomfort they might cause a visitor who, upon "entering the hall and . . . glancing about" would see "disunity opened before him."[37] Eberlein and his contemporaries found the earlier diversity of room treatments to be among the vulgarities of Victorianism, and sought to put a quieter, more restrained homogeneity in its place.

Of all who took up the call to reform sounded by Wharton and Codman in *The Decoration of Houses*, none is so familiar today as Elsie de Wolfe, author of *The House in Good Taste*, first published in 1913. One of the first interior decorators in the modern sense, de Wolfe helped popularize a visual style closely related to that of *The Decoration of Houses*, a style based on her criteria of suitability, simplicity, and proportion.[38] Like Wharton and Codman, de Wolfe emphasized the importance of a room's architectural framework, but

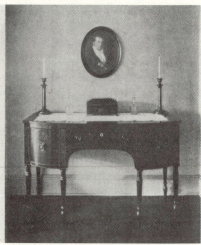

Fig. 2.6. Imposing symmetry on the sideboard. Roger Caye, "The Top of the Sideboard," *House Beautiful,* December 1916, 24. Courtesy, *House Beautiful*, copyright © December 1916, The Hearst Corporation. All rights reserved. Photograph, the Winterthur Library: Printed Book and Periodical Collection.

her emphasis was less thoroughgoing, less pedantic. In her breezy, informal advice to the reader, de Wolfe recommended that moldings and door frames be painted to contrast gently with walls and ceilings. She advocated a subdued palette; gray and cream were among her favorite colors.[39] Chintz was used so frequently for draperies and upholstery that de Wolfe remarked that she had earned the nickname, "the chintz decorator."[40]

These tenets inclined interiors to a degree of visual unity not possible in earlier rooms that had relied heavily on unpainted woodwork and patterned walls with strong horizontal divisions. Both *The Decoration of Houses* and *The House in Good Taste*, like most advice books of the time, warned sternly against using too much pattern, particularly on walls, and both urged readers not to overcrowd rooms with poorly chosen, ill-proportioned bric-a-brac. These books were effective in removing what their authors judged to be clutter and excessive pattern from interiors and replacing visual confusion with a quieter style much indebted to eighteenth-century precedents.

In 1915 de Wolfe was called on to partially redecorate The Open Gates in Galveston, completed in 1889 for George Sealy, a Pennsylvania-born merchant and railroad developer who was instrumental in creating the Gulf, Colorado and Sante Fe railroad.[41] The Open Gates was built to the designs

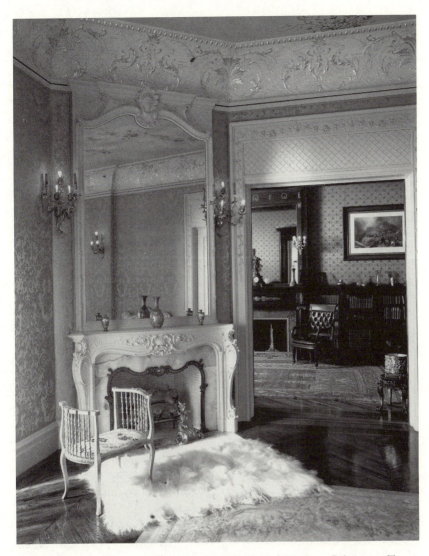

Fig. 2.7. Reception room and library, Willis-Moody house, Galveston, Texas. Photograph by Katherine Wetzel. Courtesy, the Moody Mansion & Museum.

of McKim, Mead, and White in a style that has been aptly described as a combination of picturesque massing with classical ornament (fig. 2.8).[42] Like those of the Willis-Moody house, The Open Gates' interiors were far from unified in the sense advocated by twentieth-century reformers. Its oak-paneled living hall stood in marked contrast to a French drawing room

and a colonial dining room; its library featured glazed, shoulder-height bookcases typical of the late nineteenth century.[43] De Wolfe was commissioned to redecorate the house's library and bedrooms, and although they may not have presented the freedom she might have wished, she worked to bring her style to rooms first decorated a generation before, and it is in the bedrooms that that style was most evident. Figure 2.9, a photograph of one of The Open Gates' bedrooms decorated by de Wolfe, shows that she complemented the room's Renaissance-style furniture, probably original to the house, with a group of della Robbia bas reliefs, and hung its windows and bed with chintz featuring an oriental medallion pattern. The walls and woodwork were painted in paler shades that allowed the textiles to dominate, while the house's earlier combination gas/electric light fixtures were retained.

George and Magnolia Sealy were representative of de Wolfe's wealthy clientele, and *The House in Good Taste*, with its complete disregard for the cost of decorating projects and the practical aspects of housekeeping and its reliance on high-style antique models was certainly most accessible and meaningful to an audience of financial means. Authors like Wharton, Codman, de Wolfe, and Eberlein concentrated on historic styles and European precedents, either assuming substantial means on their audience's part or allowing them to determine for themselves how their recommendations might be applied to their own homes with less expense. Another group of authors took up the task of providing decorating advice to those of more modest incomes, writing with less emphasis on the fine points of historicism and with more on direct how-to recommendations for creating simple but attractive interiors. Ekin Wallick's small advice books, including *Inexpensive Furnishings in Good Taste*, *The Small House for a Moderate Income* (both 1915), and *The Attractive Home* (1916), provide good examples of this genre, as does Lillian Green's *The Effective Small House* (1917).[44] Wallick and Green were experienced in writing for broader audiences, both having worked on the editorial staff of the *Ladies' Home Journal*. Explicitly and implicitly, their work was much indebted to that of de Wolfe and others who wrote for more affluent readers. Green noted in her preface that *The House in Good Taste* was "delightful and valuable" but obviously "not meant for the vast majority of women, who not only do their own decorating, but their housekeeping as well."[45] Wallick's books made many of the same points as those of other authors, stressing simplicity and economy, abhorring Victorian aesthetics, and recommending restraint in the use of color and pattern.[46] In choosing furnishings, Wallick selected from among those deemed to be in good taste

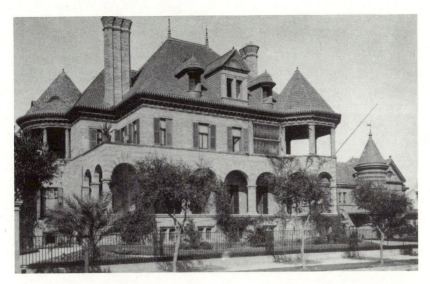

Fig. 2.8. The Open Gates (George Sealy house), Galveston, Texas. Courtesy, Rosenberg Library, Galveston, Texas.

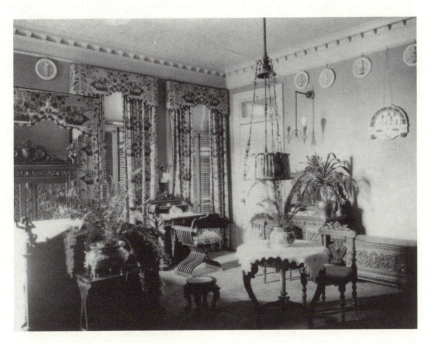

Fig. 2.9. Bedroom in The Open Gates decorated by Elsie de Wolfe. Courtesy, Rosenberg Library, Galveston, Texas.

by de Wolfe and others types that were most affordable and easily available, especially painted furniture and wicker.[47] Furniture illustrated in his books recalled historic styles without elaborate decorative detail. It was, he wrote, "merely designed in the spirit of a certain style without any attempt at serious reproduction."[48] Chintz for window treatments and furniture coverings was another de Wolfe motif that worked well in budget-conscious interiors. So intent was Wallick on economy that *Inexpensive Furnishings in Good Taste* depicted typical mass-produced furniture along with price information and an invitation to readers to write for names of suppliers, attempting to prove that good taste was indeed available to all. Interior designs from Wallick's books show rooms that are plainly furnished, without architectural embellishment or well-developed historical references, embodying simplicity, the most significant tenet of the early twentieth-century reformers (fig. 2.10).

The eighteenth-century focus of many of these decorating books was certainly consistent with, if not identical to, the Colonial Revival, unquestionably the most popular American reaction to the eclecticism of earlier decades. Colonial architecture and interiors, as interpreted by the late nineteenth and early twentieth centuries, were usually equated with Georgian forms, and thus easily accommodated Wharton and Codman's pleas for more symmetry and rationality in design. Picturesque irregularities, whether of plan or elevation, yielded to more regularized treatments. Like those of other popular historical styles, Colonial Revival interiors were visually simplified, the strong dimensionality and horizontal emphasis of the 1880s giving way to more planar compositions in lighter palettes with greater vertical orientation, often incorporating paneling or other wall treatments based on one of the classical orders (fig. 2.11). Colonial furniture also was considered closely related to English forms, allowing colonial interiors to be treated as just one of a group of historical modes of decoration similar in conception and execution.

In America, the historicism of early twentieth-century interiors strengthened against a background of rapidly changing social conditions. The late nineteenth century was a period of dramatically increasing immigration, a new kind of immigration that was widely perceived to be a greater and more insidious threat than any that had come before. Observers noted that after 1882, more and more immigrants were from southern and eastern Europe, whereas arrivals from northern and western Europe dwindled, threatening the traditional ethnic and racial balance of the country and endangering the genetic viability of America's native stock.[49] Colo-

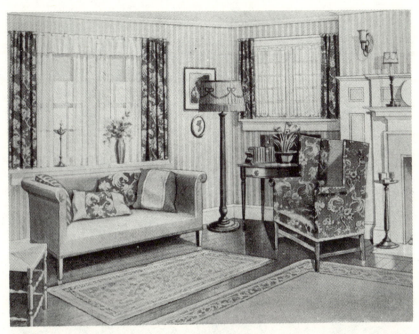

Fig. 2.10. Design for a living room. Ekin Wallick, *Inexpensive Furnishings in Good Taste* (New York: Hearst's International Library, 1915), 28. Courtesy, *House Beautiful*, copyright © 1915, The Hearst Corporation. All rights reserved. Photograph, the Winterthur Library: Printed Book and Periodical Collection.

nial America was praised as a homogeneous society, mostly British in origin, its greatness in direct proportion to its purity.[50] Instances of urban political and labor unrest, such as the Chicago Haymarket Riot of 1886, gave focus and a sense of urgency to xenophobic anxieties and fears of anarchy. In reaction to these tensions, the late nineteenth and early twentieth centuries witnessed the founding of numerous prominent genealogical and preservation organizations, including the Association for the Preservation of Virginia Antiquities (1889), Colonial Dames of America (1890), Daughters of the American Revolution (1890), Daughters of the Republic of Texas (1891), and Society for the Preservation of New England Antiquities (1910). The genealogical societies encouraged Americans to rediscover and reassert their lineages, their hereditary links to ancestors and the past, rewarding connections to certain progenitors with memberships and badges. In much the same way, accurate reproductions of antique furniture provided

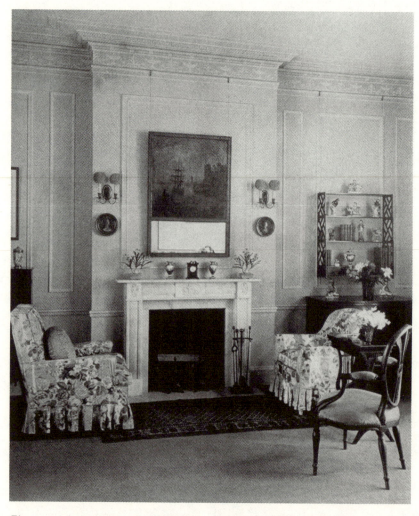

Fig. 2.11. A Colonial Revival interior. Boudoir in the home of Mr. and Mrs. George Brewster, Oyster Bay, Long Island. *House and Garden,* November 1928, 87. Courtesy, *House & Garden.* Copyright © 1928 (renewed 1956) by The Condé Nast Publications Inc.

a tangible link to a restricted group of historical periods in selected western European countries. Responding to a perceived need to acculturate and instruct recent newcomers, colonial architecture and decorative arts were sometimes used as object lessons in American history and virtue, culminating in the 1924 opening of the American Wing of the Metropolitan Mu-

seum of Art. Significantly, the same year saw the passage of the Immigration Act of 1924, severely restricting immigration and basing quotas on proportions of existing foreign-born populations.[51] *The Melting Pot Mistake*, published in 1926, noted that the law expressed Americans' "determination to keep the racial tone of the population about what it was at the time of the Declaration of Independence."[52]

Although the European historical styles, with their purity of pedigree, received the majority of authors' attention, many writers also made reference to two early twentieth-century styles that were largely ahistorical in intent: the Arts and Crafts and the Modern. The self-consciously plain, even austere, Arts and Crafts furniture that eschewed carving and other ornament sometimes figured in interiors that continued its themes of honesty of construction and truth to materials with rough masonry, exposed structural members, and hand-wrought decorative objects. Design writers sometimes acknowledged Arts and Crafts furnishings as a necessary step in the evolution away from Victorian excesses, but less often judged it aesthetically successful. *The Practical Book of Interior Decoration* remarked that the "Mission style, . . . as [an] attempt to escape from the jig-saw and gingerbread, is praiseworthy, [but] is strictly utilitarian, heavy, unbeautiful, ungraceful, . . . with lines as austere as the ark." Its rectilinearity appealed to Frank Parsons as having greater sympathy with a room's architectural lines, and Lucy Abbot Throop thought it particularly appropriate to dens and libraries, rooms with traditionally masculine associations.[53] Indeed, one author expressed the opinion that Arts and Crafts furniture and interiors resulted from "a masculine uprising, a full size man's revolution" against the preciousness and effeminacy of the Aesthetic period.[54]

The second of the ahistorical modes was the so-called Modern movement, closely related to the work of Josef Hoffman and the Viennese school of architects and designers, which received somewhat more attention in the advice manuals. Many of the Modern interiors illustrated by American authors were sparsely furnished, with a delicate planarity of wall surface enhanced by stenciled linear designs, in keeping with the call for simplicity. The movement's use of color attracted the most comment. Whereas most American authors advocated neutral backgrounds and carefully controlled color and contrast, the Modernists proposed schemes with brilliant, clear colors and strong contrasts, filling the need of "a strong and vital people to express itself in strong and vital colors." Some critics accepted the bright colors as an understandable reaction to late nineteenth-century taste or to the "quiet tones" popularized by early twentieth-century reformers, and another hoped that "the violent contrasts suggested by futurism" would never

supplant the "greys and browns and beautiful dull blues that America has at last achieved."[55]

Whether surrounded by the neutral background colors of the historic revival styles, the woodwork of the Arts and Crafts, or the bright hues of Modernism, the early twentieth century strived for simplicity—in its freedom from superfluous decoration and ornament, in its visual emphasis, and in its use of history. Although serving the visual agenda, this simplicity served a functional agenda as well: reduction of household maintenance. As many American households came to have fewer servants, housekeeping was made increasingly easier by a growing array of electrical appliances and fewer and simpler furnishings.[56] Some prescriptive household literature had been at odds with prevailing decorative practices for decades, warning of the health hazards invited by dust and dirt trapped in carving, wall-to-wall carpeting, and in the tufting, pile, and trimmings of drapery and upholstery. The influence of design and health reformers helped sweep away the drapery craze of the 1880s and 1890s. Fireplace lambrequins, fringed table covers, and elaborate window treatments yielded to a less heavily upholstered look for rooms and to leaner window curtains in lighter fabrics with less trimming. This hygienic movement clamored for healthful light and air in the interior, and for furniture and decorations that aided the cause. Simplicity of surface meshed with the enthusiasm for hygiene, and with changing patterns of household labor and maintenance.

Trends toward mechanization and simplification in early twentieth-century interiors go hand in hand with modernism, and although linked to functionalism and ahistoricism, the interiors were simultaneously tied to decades of revivalism and antimodernism. Fashionable interiors of 1920 appeared markedly different from those of 1880, but on a more fundamental level they were much the same—expressions of a desire for the psychic comfort provided by the familiar in the midst of a rapidly changing, sometimes threatening, world. Important cultural continuities underlay the striking changes that occurred in the American home's interior decoration during the decades on either side of the turn of the century, continuities that warn against inferring radical change in meaning from change in form. In *No Place of Grace*, Jackson Lears has argued cogently that much of nineteenth-century American intellectual and artistic energy was expended in attempts to depict or recapture authentic experience, to be in touch with the "real life" obscured by the complexities of modern urban existence. In this view, historical revivalism, cultural exoticism, and Arts and Crafts utopianism were all means of refuge from the more unsettling aspects of mod-

ern society.[57] In the decades between 1890 and 1930, antimodernism in interiors and decorative arts remained constant, even though its manifestations changed markedly as the vocabulary of decoration changed from one of complexity to one of simplicity.

Notes

The author wishes to acknowledge a fellowship given by the Henry Francis duPont Winterthur Museum to further the research on which this essay is based.

1. Ulysses G. Dietz, *Century of Revivals: Nineteenth-Century American Furniture from the Collection of the Newark Museum* (Newark: Newark Museum, 1983). Mary Jean Madigan et al., *Nineteenth Century Furniture: Innovation, Revival, and Reform* (New York: Art & Antiques, 1982). Dietz's book is a brief stylistic survey based on the collection of the Newark Museum; Madigan's is a collection of essays whose subjects touch on a variety of interpretive themes suggested by nineteenth-century furniture.

2. A compelling discussion of nineteenth-century design reformers' attempts to redefine the boundaries of art and standards of taste is Brent C. Brolin, *Flight of Fancy: The Banishment and Return of Ornament* (New York: St. Martin's Press, 1985). The effects of their efforts on art, architecture, and decorative arts are discussed in Doreen Bolger Burke et al., *In Pursuit of Beauty: Americans and the Aesthetic Movement* (New York: Metropolitan Museum of Art and Rizzoli, 1986).

3. Arnold Lewis, James Turner, and Steven McQuillin, *Opulent Interiors of the Gilded Age: All 203 Photographs from "Artistic Houses"* (New York: Dover Publications, 1987), 26–29. The authors' introduction to the photos from *Artistic Houses* focuses clearly on the shared characteristics of the interiors.

4. Stephen Fox, "Broadway, Galveston" (essay for a forthcoming exhibition catalog, *The Grand American Avenue: 1850–1920*, sponsored by the American Architectural Foundation), 17–18. Architectural drawings of the Gresham house (1402 Broadway, Galveston, Texas) made for the Historic American Buildings Survey have been collected and published in pamphlet form: *"The Bishop's Palace": Architectural Drawings, Walter Gresham Home* (Galveston, Tex.: Privately published, n.d.).

5. Katherine Grier, *Culture and Comfort: People, Parlors, and Upholstery, 1859–1930* (Rochester: Strong Museum, 1988), 129–62. Chapter 5, "The Quest for Refinement: Reconstructing the Aesthetics of Upholstery, 1850–1910," gives extensive consideration to the aesthetic of complexity, analyzing the linguistic implications of discourse about the interior, and relating visual preferences to social and cultural structures.

6. For example, Christopher Dresser wrote of Japanese potters and lacquer

workers that they were "invariably lost in their art. They give themselves up to the production of the excellent, the beautiful, the loveable; and whether their food is of the poorest or the best they do not seem to care." Christopher Dresser, *Japan: Its Architecture, Art, and Art Manufacturers* (London: Longmans, Green, 1882), 412–13.

7. Karen Halttunen, "From Parlor to Living Room: Domestic Space, Interior Decoration, and the Culture of Personality," in *Consuming Visions: Accumulation and Display of Goods in America, 1880–1920*, ed. Simon J. Bronner (New York: W. W. Norton, 1989), 164–65.

8. Cynthia Brandimarte, "Somebody's Aunt and Nobody's Mother: The American China Painter and Her Work, 1870–1920," *Winterthur Portfolio* 4 (1988): 203–24.

9. Remy G. Saisselin, *Bricabracomania: The Bourgeois and the Bibelot* (London: Thames and Hudson, 1984).

10. Grier, *Culture and Comfort*, 147–49.

11. Richard Guy Wilson, "Architecture, Landscape, and City Planning," in *The American Renaissance, 1876–1917* (Brooklyn: Brooklyn Museum, 1979), 74–109. Hubert Howe Bancroft, *The Book of the Fair: An Historical and Descriptive Presentation of the World's Science, Art, and Industry, as viewed through the Columbian Exposition at Chicago in 1893* (Chicago: Bancroft, 1895). Wilson's article describes the architectural milieu out of which the White City grew. Bancroft's two-volume work contains many views of the exhibition grounds and buildings throughout the text.

12. Ogden Codman, Jr. and Edith Wharton, *The Decoration of Houses* (1897; rpt. New York: W. W. Norton, 1978). The book's extremely rational approach is evident in the table of contents, which shows chapters dedicated to walls (chap. 3), doors (chap. 4), windows (chap. 5), fireplaces (chap. 6), and ceilings and floors (chap. 7), before following with chapters on specific room types.

13. Codman and Wharton, *The Decoration of Houses*, 2, 17, 22–23, 48–51, 64–73.

14. Lucy Abbot Throop, *Furnishing the Home of Good Taste* (New York: McBride, Nast, 1912); Howard Donald Eberlein, Abbot McClure, and Edward Stratton Holloway, *The Practical Book of Interior Decoration* (Philadelphia: J. B. Lippincott, 1919).

15. Eberlein discussed historic styles with these broader designations in "Essentials of Decorative 'Periods' in Furnishing," *Arts and Decoration*, Aug. 1925, 23–26, 56, 71.

16. Eberlein, McClure, and Holloway, *Practical Book of Interior Decoration*, 307–8; Throop, *Furnishing*, 129.

17. Elizabeth Stone McDonald, "Preventive Aesthetics: The Old Age of Art," *House Beautiful*, Aug. 1916, 148.

18. Clarence Cook, *The House Beautiful* (1878; rpt. Croton-on-Hudson, N.Y.:

North River Press, 1980), 334; Clarence Cook, *What Shall We Do With Our Walls?* (New York: Warren Fuller, 1880), 18.

19. B. Russell Herts, *The Decoration and Furnishing of Apartments* (New York: G. P. Putnam's Sons, 1915), 42; Elsie de Wolfe, *The House in Good Taste* (New York: Century, 1913), 68.

20. Cook, *What Shall We Do*, 5; Eberlein, McClure, and Holloway, *Practical Book of Interior Decoration*, 217.

21. Edward Stratton Holloway, *The Practical Book of Furnishing the Small House and Apartment* (Philadelphia: J. B. Lippincott, 1922), 52–58; Frank Parsons, *Interior Decoration: Its Principles and Practice* (Garden City, N.J.: Doubleday, 1916), 46; Eberlein, McClure, and Holloway, *Practical Book of Interior Decoration*, 198.

22. Eberlein, McClure, and Holloway, *Practical Book of Interior Decoration*, 218, 219, 45–48; Holloway, *Furnishing the Small House and Apartment*, 49–52, 42.

23. Parsons, *Interior Decoration*, 42.

24. Eberlein, McClure, and Holloway, *Practical Book of Interior Decoration*, 211; Holloway, taking the logical approach typical of the time, said that colors "are real and may be dealt with accurately. Just as in mathematics two and two make four, just so surely does the admixture of yellow and blue create green." *Furnishing the Small House and Apartment*, 39.

25. Helen Koues, *On Decorating the House* (New York: Tudor Publishing, 1928), 197; Rexford Newcomb, *Mediterranean Domestic Architecture in the United States* (Cleveland: J. H. Jansen, 1928), n.p.

26. Newcomb, *Mediterranean*, n.p.; Koues, *On Decorating the House*, 206; Margaret McElroy, "Backgrounds for Furniture," *House and Garden*, Feb. 1925, 124.

27. Rexford Newcomb, *The Spanish House for America: Its Design, Furnishing, and Gardens* (Philadelphia: J. B. Lippincott, 1922), 41; McElroy, "Backgrounds for Furniture," 124; R. W. Sexton, *Spanish Influence on American Architecture and Decoration* (New York: Brentano's, 1927), 185.

28. "Galveston Man Builds Palatial West Texas House," *Galveston Daily News*, 22 Sept. 1930, 6.

29. Throop, *Furnishing*, 111, 120.

30. Parsons, *Interior Decoration*, 57, 58.

31. Holloway, *Furnishing the Small House and Apartment*, 59; Parsons, *Interior Decoration*, 60–61.

32. Throop, *Furnishing*, 115.

33. Cook, *The House Beautiful*, 333; *What Shall We Do*, 17.

34. Parsons, *Interior Decoration*, 78.

35. Parsons, *Interior Decoration*, 79–82; Eberlein, McClure, and Holloway, *Practical Book of Interior Decoration*, 286.

36. Cook, *The House Beautiful*, 333.

37. Eberlein, McClure, and Holloway, *Practical Book of Interior Decoration*, 215.

38. De Wolfe, *The House in Good Taste*, 17–26. These three canons of taste received treatment in a chapter by themselves.

39. De Wolfe, *The House in Good Taste*, 17, 26, 36, 59–60, 80–83.

40. De Wolfe, *The House in Good Taste*, 95.

41. Jane Pinkard and Rebecca Pinkard, *Lest We Forget: The Open Gates* (Privately published, 1988), 56, 10–13.

42. Fox, "Broadway, Galveston," 20.

43. David L. Barquist, "The Furnishing of American Domestic Libraries, 1840–1940" (Paper delivered at Reading in America, 1840–1940, a symposium at the Strong Museum, Rochester, Nov. 1986), 17–20.

44. Ekin Wallick, *Inexpensive Furnishings in Good Taste* (New York: Hearst International Library, 1915); Ekin Wallick, *The Small Home for a Moderate Income* (New York: Hearst's International Library, 1915); Ekin Wallick, *The Attractive Home* (Boston: Carpenter-Morton, 1916); Lilian Bayliss Green, *The Effective Small House* (New York: Robert McBride, 1917).

45. Green, *The Effective Small House*, ii–iii.

46. Wallick, *Inexpensive Furnishings in Good Taste*, n.p.; Wallick, *The Attractive Home*, 12; Wallick, *Inexpensive Furnishings in Good Taste*, 23.

47. De Wolfe, *The House in Good Taste*, 99, 247, 248.

48. Wallick, *Inexpensive Furnishings in Good Taste*, 77.

49. Henry Pratt Fairchild, *The Melting Pot Mistake* (Boston: Little, Brown, 1926), 105, 107; John R. Commons, *Races and Immigrants in America* (New York: Macmillan, 1908), 69; Robert de C. Ward, "The Restriction of Immigration in North America," *North American Review* 179 (1904): 236.

50. Edward R. Lewis, *America: Nation of Confusion, A Study of Our Immigration Problems* (New York: Harper & Bros., 1928), 90; Fairchild, *The Melting Pot Mistake*, 102; Sydney G. Fisher, "Alien Degradation of American Character," *Forum* 14 (1892–93): 613.

51. Wendy J. Kaplan, "R. T. H. Halsey—An Ideology of Collecting American Decorative Arts" (Master's thesis, Univ. of Delaware, 1980). Kaplan outlines the background of the American Wing's creation, and discusses it as an example of nativism and antimodernism. Robert A. Divine, *American Immigration Policy, 1924–1952* (New Haven: Yale Univ. Press, 1957). Divine's first chapter (pp. 1–25) discusses the political and social events leading up to the Immigration Act of 1924.

52. Fairchild, *The Melting Pot Mistake*, 128.

53. Eberlein, McClure, and Holloway, *Practical Book of Interior Decoration*, 297; Parsons, *Interior Decoration*, 70; Throop, *Furnishing*, 160.

54. "The Individualist," *The Upholsterer and Decorator*, Nov. 1927, 93.

55. Hazel H. Adler, *The New Interior: Modern Decoration for the Modern Home* (New York: Century, 1916), 41, 42, 47; Eberlein, McClure, and Holloway, *Practical Book of Interior Decoration*, 212; Herts, *Decoration and Furnishing*, 14.

56. Harvey Green, *The Light of the Home: An Intimate View of the Lives of Women in Victorian America* (New York: Pantheon Books, 1983), 59–92. Chapter 3, "Cleanliness and Godliness: The Tyranny of Housework," addresses many of these issues.

57. T. J. Jackson Lears, *No Place of Grace: Antimodernism and the Transformation of American Culture, 1880–1920* (New York: Pantheon Books, 1981). Lears's book, concerned primarily with intellectual, literary, and religious antimodernism, delineates the cultural backdrop against which revival styles in architecture and furnishings flourished.

CHAPTER THREE

Fireside Tales to Fireside Chats: The Domestic Hearth

Kate Roberts

"All the perfection of the best system of heating and ventilating does not . . . banish from our minds the desire for an open fire in the living room," wrote Andrew Jackson Downing in 1850. "We must have a little of the living soul—the glow of the hearth—there." Writing at the time when stoves and furnaces were displacing fireplaces as the primary source of heat in American houses, Downing's vision of the fireplace as a symbol of home was a sentiment that would be echoed by generations of Americans.[1] The images that follow illustrate changes in the definition and use of the fireplace from the end of the nineteenth century through the early decades of the twentieth century.

In Victorian homes, fireplaces in living halls and front parlors were backdrops for domestic gatherings, as well as settings for artful arrangements of objects that signified the good taste of their owners. Fireplaces also appeared in private areas such as bedrooms and libraries, and in both masculine and feminine settings. Like the eclectic Victorian home itself, the fireplace assumed a variety of appearances in response to the owner's sensibility and personality.

In the early twentieth century, the simple bungalow emerged as an affordable antidote to the architectural excesses of previous generations. From rustic havens to tidy Colonial Revival cottages, from the designs of Frank Lloyd Wright and Gustav Stickley to those of anonymous plan-book designers, bungalows of many forms featured the glow of an open hearth as an icon of abiding power.[2]

By 1936, when Americans first tuned in their household radios to hear

Fig. 3.1. "Another Way of Dealing with Commonplace," Clarence Cook, *The House Beautiful: Essays on Beds and Tables, Stools and Candlesticks* (New York: Charles Scribner's Sons, 1878). According to Cook, intellectual and spiritual benefits resulted not only from the quiet contemplation of an open fire but from the "beautiful and chosen things" around it.

the reassuring voice of Franklin Roosevelt as he delivered the first of his "fireside chats," home and hearth were well-established counterparts. Roosevelt's voice was brought home through advanced technology, but only when the hard edges of that technology were softened by the familiar, comforting image of the fireplace was the president's message heard loud and clear.

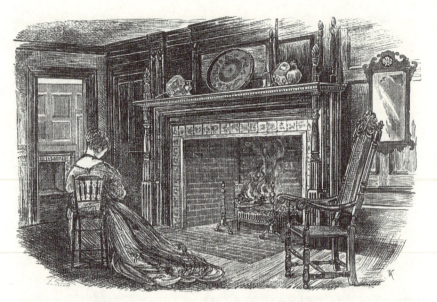

Fig. 3.2. "Things New and Old," Cook, *The House Beautiful.* Built in the early eighteenth century, the Robinson house in Newport, Rhode Island, was renovated by architect Charles Follen McKim in 1872. This sketch of the Robinsons' rear parlor reveals several themes associated with the fireplace in the late nineteenth century. The tasteful mantel arrangement is supplemented by touches of the Colonial Revival, such as the brass andirons and the tiles bordering the fireplace opening. And in this scene, typical of many such views, a woman presides over the hearth.

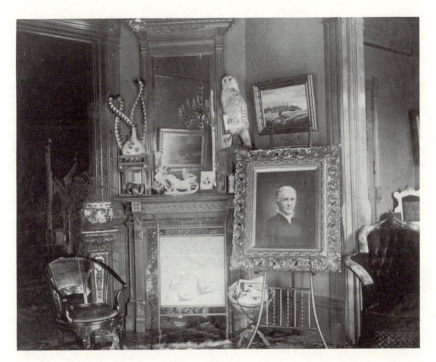

Fig. 3.3. Parlor, John T. Blaisdell residence, Minneapolis, Minnesota, about 1890. Courtesy, the Minnesota Historical Society Collection. As the ideas of Clarence Cook and other taste makers took hold in the Victorian home, furnishings were seen as reflections of their owners' interests and pretensions. Mantels were carved, stained, painted, festooned, and ornamented with a seemingly endless assortment of designs and motifs, each one a testament to its owner's good taste and sound character. In the Blaisdells' parlor an appreciation for family, fine art, and the natural world are evident.

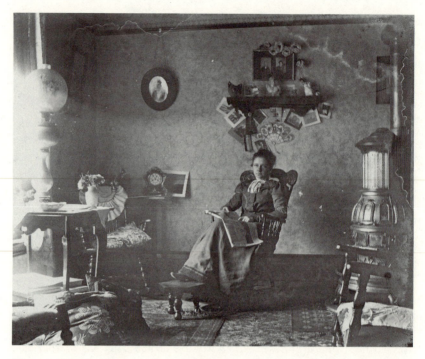

Fig. 3.4. Woman at home, St. Paul, Minnesota, about 1900. Courtesy, the Minnesota Historical Society Collection. Parlors and sitting rooms without fireplaces were often outfitted with "impromptu mantels"—narrow shelves loaded with artful bric-a-brac. "A room without any mantel," wrote Harriet Prescott Spofford in *Art Decoration Applied to Furniture* (New York, 1878, 233), "has not the dignity of a tent."

Fig. 3.5. "Mr. Frank Furness's Smoking-Room," George Sheldon, *Artistic Houses: Being a Series of Interior Views of a Number of the Most Beautiful and Celebrated Homes in the United States* 2 (New York: D. Appleton and Co., 1884); reprinted in Lewis, Arnold, James Turner and Steven McQuillin, *The Opulent Interiors of the Gilded Age: All 203 Photographs from "Artistic Houses"* (New York: Dover, 1987). While women were closely associated with the fireplace in the late nineteenth century, it was not their exclusive province: so-called men's rooms often featured rustic hearths. In architect Frank Furness's smoking room, the fireplace surround is blackened with soot and a hearth broom and shovel are prominently displayed. The rugged hearth was depicted as a living, working component of this personalized room, the accumulation of ashes and soot as much a part of the self-conscious decorative scheme as the animal hides and Indian blankets.

Fig. 3.6. Cover, *Keith's Magazine on Home Building* 35 (April 1916). Bungalows appeared with a variety of exterior styles in the early twentieth century, but they were unified by the glow of their central fireplaces. In his 1911 book *Bungalows* (Philadelphia: John C. Winston, 135), Henry Saylor wrote that "a bungalow without a fireplace is as much of an anomaly as a garden without flowers."

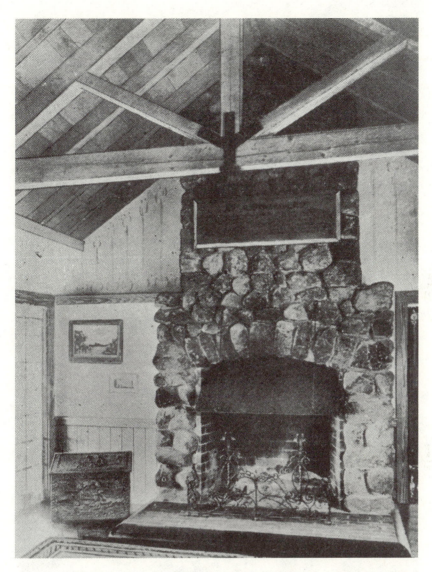

Fig. 3.7. "At Journey's End," Anthony Woodruff, "The Bungalow Fireplace,"
Keith's Magazine on Home Building 35 (April 1916). Elements of the natural world,
such as unworked boulders and rough-hewn timbers, were often used to construct
bungalow fireplaces. As the title of this photograph suggests, such rustic surround-
ings were promoted as timeless havens from the increasing demands of the modern
world.

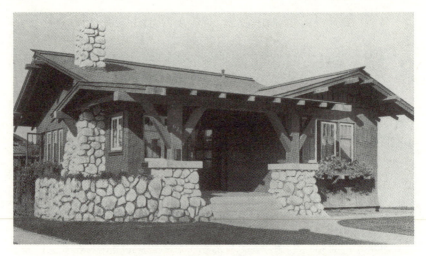

Fig. 3.8. "The retaining wall of cobble-stones—nature's own building material," W. J. Keith, "Homes of Individuality," *Keith's Magazine on Home Building* 35 (April 1916). The rustic theme often extended to the exterior of the bungalow through the use of prominent stone chimneys accented with vines or other plantings.

Fig. 3.9. Living room, George Luxton residence, Minneapolis, Minnesota, about 1915. Courtesy, the Minnesota Historical Society Collection. Newspaper photographer George Luxton documented each room of his Minneapolis bungalow. The clean, uncluttered lines of the fireplace are in keeping with the Craftsman-era simplicity of the living room.

A crackling grate fire, comfy hearthside furniture and a pipe—what more could a man want? Whatever your mood, the hospitable glow of firelight flames cast their spell, kindle your vivacity or pensiveness. For wonderful is the spell of leaping flames and changing shadows!

Fig. 3.10. Feature illustration, *Furniture of the Times,* September 1922. As the twentieth century progressed, the domestic hearth was promoted as a place for quiet reflection. Attention was focused on the open fire itself, with its promise of peace and renewal.

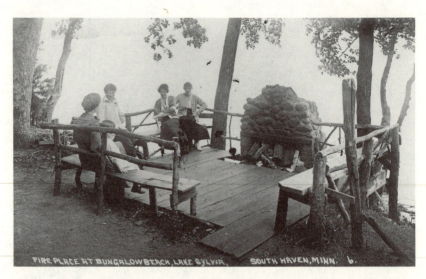

FIRE PLACE AT BUNGALOW BEACH, LAKE SYLVIA, SOUTH HAVEN, MINN. 6.

Fig. 3.11. Outdoor fireplace at Lake Sylvia, Wright County, Minnesota, about 1920. Photograph by Minnie and Martha Hoelzel, Minnesota Historical Society Collection. Just as a rustic fireplace could bring a touch of the outdoors inside, so this fireplace transplanted outdoors provided a focal point for this beach-front living room.

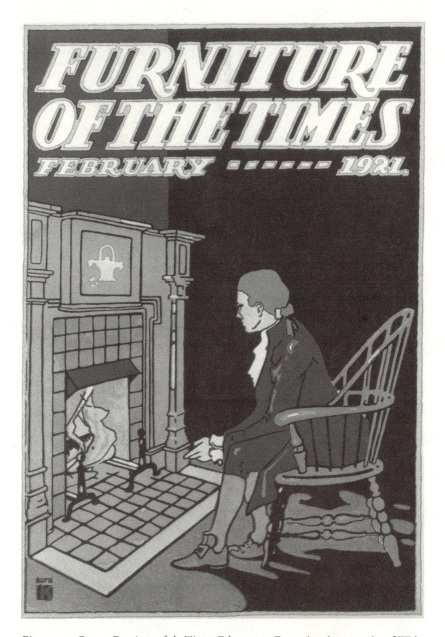

Fig. 3.12. Cover, *Furniture of the Times*, Feb. 1921. From the photographs of Wallace Nutting to the covers of home-decorating magazines, the fireplace was a key component of Colonial Revival decorating schemes of the 1920s.

Do Not Affront Your Fireplace with Unsentimental Obtrusive Radiators

Strange, isn't it, how we put such stress on the joys of having a fireplace, of its friendliness, its comfort, its sentiment side, and then consent to having radiators obtrusively setting about in all their abject utilitarian emphasis.

How it does distract—yes affront, if not cheapen the fireplace effect.

Happily for you, there is a way out. Obscure your radiators with enclosures made with our Ferrocraft grilles.

Then your radiators become an article of furniture—pleasing, yet in no way affecting the efficiency of your heating.

Drop in at any of our offices—and let us talk it over.

Or write us for any further information you may wish.

TUTTLE & BAILEY MFG CO.

Established 1846

36 Portland Street, Boston 2 W. 45th Street, New York 1123-29 W. 37th Street, Chicago

Fig. 3.13. Advertisement, Tuttle & Bailey Mfg. Co., *House and Garden,* December 1922. The desire to keep signs of modern technology out of the living areas of houses in the 1920s was so strong that radiators caused decorating nightmares for dedicated revivalists. Compared to the sight and sound of an open fire crackling on the hearth, the stark lines and sputtering sounds of the radiator were a poor second.

Plan now for Winter Comfort

Thrush System consists of equipment to be added to the hot water heating plant (old or new) to convert it into a pressure system of heating.

Putting the plant under pressure saves 20% to 40% of the coal and prolongs firing periods.

Thrush System provides positive, automatic damper regulation, keeps fires under control and makes it unnecessary to tend the fire from morning to night.

THRUSH
SYSTEM
OF HOT WATER HEATING

Modernize Your Home with Thrush System!

IF you had trouble heating your home last winter, *now is the time to correct it.* Modernize your old hot water heating plant with Thrush equipment, which will convert it into *a pressure system, automatically controlled.* That will mean greater convenience, greater economy of fuel consumption, lessened attention to firing and *more uniform and healthful temperature* conditions in your home.

H. A. THRUSH & CO.

Peru, Indiana

H. A. THRUSH & CO.,
Dept. K, Peru, Indiana
Send me your booklet "Which Heating Plant for My Home!" I am interested.

Name

Address

My Htg. Contr.

Fig. 3.14. Advertisement, H. A. Thrush & Co., *Keith's Beautiful Homes Magazine* 61 (May 1929). In their advertisements, radiator companies advanced their products as flameless hearths—substitute fireplaces where families could gather.

Fig. 3.15. Advertisement, Federal Radio Corp., *The American Home* 1 (November 1928). By the late 1920s the home radio competed with the fireplace for the attention of families. Early radios required constant adjustment of batteries, crystals, and vacuum tubes for the best reception. In this way they were similar to the fireplace, where family members often derived satisfaction from poking, prodding, and fiddling with the logs for maximum comfort and aesthetic satisfaction.

RADIO - *Styled for*
Homes of Taste

IMPERIAL TUNE-IN-TABLES

"WOMEN," says Norma B. Kastl, in her article in this issue of *House Beautiful,* "think of the radio as furniture — a piece of furniture for which a place must be found and which must be related to the other furniture and accessories in the room."

IMPERIAL Tune-In-Tables are the only complete line of radio, created exclusively as fine furniture. There is a distinctive style to harmonize with every period. See them at your local furniture store — or write for illustrations of the many smart, new designs.

IMPERIAL FURNITURE COMPANY
GRAND RAPIDS, MICHIGAN

Fig. 3.16. Advertisement, Imperial Furniture Co., *House Beautiful* 72 (October 1932). Once the radio became standard equipment in the American home, it, like the radiator, was forced to go undercover. The radio became an end table, a desk, a lamp stand—anything to disguise its telltale signs of modern technology.

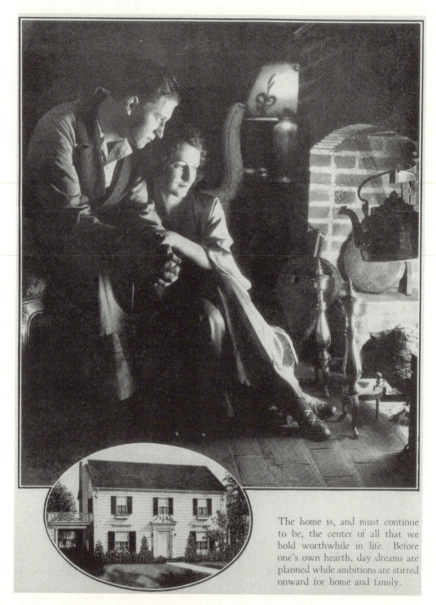

The home is, and must continue to be, the center of all that we hold worthwhile in life. Before one's own hearth, day dreams are planned while ambitions are stirred onward for home and family.

Fig. 3.17. Advertisement, *Home Ideas,* July 1931. An enduring symbol of domestic values, an old-fashioned fireplace complete with kettle and crane captured the fancy of the modern couple in this 1931 realtors' guide.

Notes

1. Andrew Jackson Downing, *The Architecture of Country Houses* (New York: D. Appleton, 1850), 481.

2. Recent scholarship suggests that bungalows are best understood in terms of the common themes they embody, rather than any common features they exhibit. This attitude was apparent during the "bungalow boom" of the 1910s and 1920s, as well. See Virginia Robie, "Bungalow Furnishings," *Keith's Magazine on Home Building* 39 (Apr. 1918): 245–48.

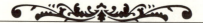

The Home Set to Music
Jessica H. Foy

In 1867, southern poet Sidney Lanier wrote that "to make a home out of a household . . . given the raw materials . . . two other things are necessary. These are a good fire, and good music. And inasmuch as we can do without the fire for half the year, I may say music is the one essential."[1] Indeed, within the context of the Industrial Revolution of the nineteenth century, music played a significant role in home life. It reinforced the notion of the home as a refuge from the new fast-paced, machine-driven, business-oriented society. It was an activity family members could enjoy together within the safe confines of home, and it was a vehicle through which they could develop moral character, learn discipline, and find comfort and security. Traditional attitudes toward music remained strong through the decades just after the turn of the century, although in the 1890s modernization had begun to challenge those notions. By 1930, technological advances had caused shifts in the primary settings for, producers of, and reasons for music in the home. Access to good music had increased; and, instead of being diminished, as traditionalists had feared, the presence of music in American homes had been enhanced and its symbolism, though somewhat altered, left intact.

Although it is not the purpose of this chapter to dwell on lyrics and melodies, a basic knowledge of the types of music prevalent during this transitional period is useful. In nineteenth-century homes, hymns and parlor songs were often heard and performed. Hymns, sung primarily in Protestant households, reinforced notions of morality and of the home as a sacred unit. Full of sentiment and romantic idealism, parlor songs often focused on themes such as family, motherhood, and home. Their messages were of purity, happiness, and stability, and their popularity in an age of

dramatic economic, industrial, and demographic change and upheaval is not surprising.

Classical music was also appropriate for the home environment. Scholars have documented how upper-class tastes, which essentially defined culture for many Victorians, usually followed European tastes.[2] In terms of music, those tastes favored the works of great European masters. Moreover, nineteenth-century advocates of the morality of music concluded that those same composers were usually men of great moral character and discipline, so their music was imbued naturally with morally uplifting qualities, a matter of great importance to Victorians.[3] Others valued classical music simply for its artistic merit—complex and artistically sophisticated, it was a symbol of culture and thus an acceptable tool for elevating one's thoughts and tastes.

To late nineteenth-century Americans, unsettled by what they thought were scary, threatening times, music was a symbol of security and uplift. Through it they could transcend the world and find the truth and beauty that eluded them in the routines of their everyday lives. The pressures to succeed and compete in the new industrial society affected almost everyone. In much the same way that physical conditioning and good health became a way to combat the stresses of the age, participating in or listening to music was seen as a way to improve, elevate, and perhaps even protect oneself against feelings of helplessness, nervousness, and failure. "It will uplift them," said one turn-of-the-century music advocate, "from the most sordid cares of life and transform the deserts of their minds, laid waste by the cares and trials of a struggle with the world, into the most luxuriant and flowery bloom."[4]

Because they linked society's ills with the failures of individuals, Victorian Americans considered efforts toward self-improvement essential to alleviating society's problems. The belief that music had the power to uplift and transform meant it could improve one's character and sense of well-being. Music was therefore something not just to enjoy but to contemplate and study. The cultivation of musical taste was considered a superior "means of self-development . . . when viewed in its relation to the totality of the individual—intellect, emotion, and character."[5] By learning about music and consciously developing musical sensibilities and preferences, people believed they could elevate themselves to higher planes of understanding and experience better lives.

The responsibility for keeping music alive in the home and for instilling an interest in music in children often fell to women. In her book *Queen of the*

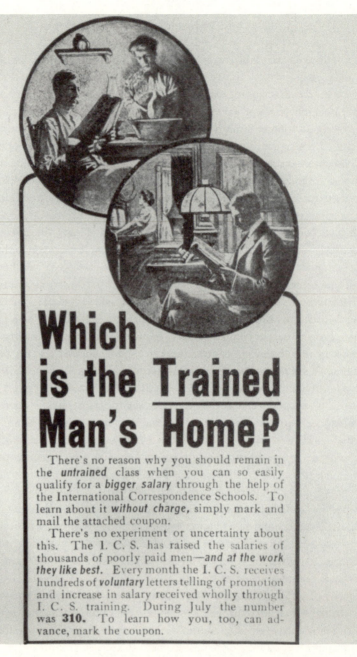

Which is the Trained Man's Home?

There's no reason why you should remain in the *untrained* class when you can so easily qualify for a *bigger salary* through the help of the International Correspondence Schools. To learn about it *without charge,* simply mark and mail the attached coupon.

There's no experiment or uncertainty about this. The I. C. S. has raised the salaries of thousands of poorly paid men—*and at the work they like best.* Every month the I. C. S. receives hundreds of *voluntary* letters telling of promotion and increase in salary received wholly through I. C. S. training. During July the number was **310.** To learn how you, too, can advance, mark the coupon.

Fig. 4.1. Advertisement for the International Correspondence Schools, *Putnam's and the Reader Magazine,* October 1908. In contrast to the hard-working, lower-class wife in the upper image, the same woman playing the piano in obviously improved circumstances in the other symbolizes the presence of music in the home of the educated, successful man.

Home, Emma Churchman Hewitt insisted it was one of women's many duties in "home-making," which, she cautioned, was not to be equated with "housekeeping," the act of keeping a house physically clean and orderly. To be successful, women were expected to possess musical skills themselves. "If only for the children's sake," Anne Guilbert Mahon pleaded in her 1912 article "Music in the Home," "the mother should cultivate any talent she possesses in this direction to the full extent of her opportunities and ability." Another suggested that mothers who were not trained vocalists take singing lessons from a "competent specialist" or at least practice vocal exercises daily. Through musical development, the average housewife could reportedly also protect herself from becoming "a common drudge, a neighborhood gossip, or a cynical recluse." Her household chores did not have to be hindrances either. To stay in top musical form while sweeping, ironing, and dish washing, for instance, one writer told women to concentrate on relaxingmuscles that would otherwise stiffen. After all, arms and fingers had to be nimble to play parlor organs, pianos, and zithers. Bread making was one of the most beneficial tasks, because it strengthened the wrists and forearms—a special advantage for piano-playing housewives.[6]

As women worked to fill their homes with music and rear their children in uplifting environments, they sought not only to refine their families' tastes but also to set a moral tone. For guidance, they could refer to any of the number of essays and books on the subject of music and morals. Seeing music as key to the journey to morality, the Reverend T. DeWitt Talmage wrote in 1889 his book *The Pathway of Life*,

> I commend among indoor recreations, music, vocal and instrumental. Among the first things created was the wind, so that the earth might have music at the start. . . . While this heavenly art has often been dragged into the uses of superstition and dissipation, we all know it may be the means of high moral culture. . . . Let all those families who have the means to afford it, have flute or harp, or piano or organ.[7]

In 1897 author and music critic Henry Finck published an essay in which he, too, equated musical taste with morality, insisting that "one of the most important moral functions of music [is] that of *weaning the people from low and demoralizing pleasures*." He believed music, as well as upbringing in any household with an "*infectious musical atmosphere*," could suppress vicious habits and promote even temperaments. He did make allowances for music teachers, "who from the very nature of their profession, rarely hear music as it ought to be, and therefore naturally become impatient and irritable." These were, he hastened to add, "not the normal, but the abnormal effects

of music."[8] This exception aside, both authors insisted that music and musical training inculcated a spirit of cooperation, reduced stress, and softened criminal leanings. Their writings reflected the generally held assumption that by aspiring to beauty through music, one was aspiring heavenward. The presence of music, then, was much more than a social diversion; it was a measure of a household's moral well-being.

Even before 1890, the parlor organ was central to this notion. A means for reiterating religious themes, hymns were almost as important to late nineteenth-century Protestant family worship as to church services, and many a hymn was played on the parlor organ, the domestic counterpart of the church organ. In this way, parlor organs were useful material tools in the quest to provide a spiritual home on earth and to prepare families for a future home in heaven.[9] They were also well-suited for performing renditions of popular parlor songs, which, though syrupy and sentimental by today's standards, often focused on themes of ideal or nostalgic living and thus helped relieve urban Americans' feelings of stress and anxiety.

Despite elaborate, sometimes churchlike and often imposing, designs, parlor organs were less expensive than pianos because they were easier to manufacture. In 1897 a household could treat itself to a fairly elaborate parlor organ for $56 by ordering from the Sears, Roebuck catalog, whereas the retailer's least expensive piano cost $125. Mail-order businesses assured the availability of these instruments even in the most rural areas. Parlor organs began to decline in popularity by 1900, when piano manufacturers began aggressive marketing campaigns and the advantages (range and clarity of tone, for example) of pianos in performing newly popular music, such as ragtime, became increasingly apparent. The disappearance of the parlor organ from the home also was concurrent with changing attitudes toward domestic space. The view of the home as a sacred space was gradually being replaced by the idea that the home was, according to historian Colleen McDannell, "an efficient, sanitary, technologically innovative space in which scientific values and rational planning produced people capable of negotiating modern society."[10] As this notion began to supersede the romanticized, Victorian view of the home, the parlor organ as a symbol of church and worship in the home lost much of its significance.

There were many other instruments in late Victorian homes. Guitars, banjos, harps, accordions, harmonicas, mandolins, and zithers, in addition to pianos and organs, were common. Kazoos, parlor bells, and toy instruments, which facilitated the effort to teach children at an early age to love music, were among the wide variety of other instruments on the market.

The belief was that any instrument could, at least in some small way, enhance the musical, and thus cultural, environment of a home. An 1880s trade pamphlet, shaped like an autoharp, contains a story titled "The Autoharp and How It Captured the Family," which reveals, albeit in exaggerated fashion, the potential impact of instruments on home life. In it we learn that by buying an autoharp for his little girl, one man elevated the excitement for music in his home to a level he never imagined possible. Every one of his children, including his teenage son and his eldest daughter, "a graduate of the conservatory," found inspiration in the autoharp and brought music into the home "from sunrise to sunset."[11]

What all these musical instruments really brought into the home were scores of music lessons and hours of practice. The lessons served as useful methods of discipline training, a key to success and self-improvement according to late nineteenth-century thought. Historian Miles Orvell writes that "the illusion of mastery and comprehension" created within a manageable form or space (in our case the home) was instrumental in bringing order to a world seemingly "beyond control."[12] Lessons provided a systematic approach to mastering musical skills, and little girls especially were subjected to them because musical skills were necessary to being good mothers. In fact, many chose to further their musical educations at finishing schools or music conservatories. Probably speaking from experience, Emma Hewitt characterized this period as a time when "daughters were expected to 'make night hideous,' and their lives a burden, by their weary hours of practice."[13] Indeed, a great percentage of domestic music must have been discordant, and one wonders how often it even approached the sublime.

This multitude of lessons and instruments produced a nation of amateur musicians. Estimates made as late as 1913 indicated that 95 percent of all music lessons were taught to students who intended to use their skills solely in the home. In 1869, *Atlantic Monthly* magazine ran an article insisting that parlor music could be improved if the performances, like those of professional musicians, were critically reviewed. While attesting to the value of music in the home, this suggestion also implies that home music should be better; home musicians were not being pushed to reach their potential. Systematic reviews never took hold, but local music clubs, which were increasing in number, provided one vehicle for amateur performances. Representatives from these clubs convened at the 1893 World's Columbian Exposition, and in 1898 the National Federation of Music Clubs was formed.[14]

Doubling as entertainment, musicales, private concerts often staged in homes, provided another format through which amateur musicians demon-

strated their skills. More than a mere recital, the musicale—"one of the greatest moral and mental educators of society," according to Mrs. Doré Lyon, guru of musicale etiquette—was intended to entertain and edify. Talented and well-trained, often amateur, musicians performed at these events, which were popular well into the twentieth century. The W. P. H. McFaddins of Beaumont, Texas, hosted a musicale less than two months after they moved into their new home in 1907, and Mrs. McFaddin, who had studied music at Mary Baldwin Seminary in Virginia, was listed on the program as a vocal soloist. The evening's program consisted of a total of nine vocal, piano, and violin solos, plus an unnamed reading. According to the newspaper report, the McFaddin home was *"en fette"* for the important social event, which merited an extensive write-up.[15]

A scaled-down imitation of a public concert or recital, the musicale represented, in a way, the imposition of a Victorian sense of order and control on a normally public event by bringing it into the safe, controllable confines of the home. Indeed, as social events, musicales were governed by a unique set of etiquette guidelines. To begin with, it was imperative that a hostess create a program of music corresponding to her guests' tastes and levels of musical appreciation. Guests could converse between numbers at informal gatherings, but if they talked during musical numbers they were out of line. As far as Mrs. Lyon was concerned, such inconsiderate guests were "offenders against public comfort." She recommended immediate reprimands. The hostess also had to make certain that her furnishings did not interfere. For example, any extra chairs (arranged in rows as at a formal concert) had to be of good quality, so that sudden creaks, prompted by the slightest movement, would not spoil a number in progress.[16] Every effort was made to create and maintain an atmosphere of dignity and culture.

If a family had a specially designated music room in its house, the musicale was held there, or at least the performers were stationed there. (Depending on room size, the audience might have sat in adjacent rooms.) In homes without music rooms, parlors (drawing rooms) were the primary settings. Architects continued to include music rooms in house designs into the second decade of the twentieth century, but they were most often found in the specialized and formally compartmentalized interiors of Victorian homes.[17]

Today we think of these interiors as cluttered and fussy in character. But for late nineteenth-century Americans, the furnishings, patterns, and accessories crammed into these spaces signaled progress, which they associated with the proliferation of material goods. It was, therefore, normal for

Fig. 4.2. Music room in W. P. H. McFaddin home on McFaddin Avenue in Beaumont, Texas, 1909. A tasseled piano cover is draped over the back of the piano, and a satin appliqué in the shape of a lyre decorates the center of each valance. The portraits are of Mr. and Mrs. McFaddin. Courtesy, McFaddin-Ward House, Beaumont, Texas.

pianos and parlor organs to be draped with textiles and to have pictures and any number of knickknacks resting on all available flat surfaces. Appropriate bric-a-brac and various decorating devices were also thought to enhance a music room's association with knowledge of and proficiency in the arts, whether or not that knowledge and proficiency had been attained. Music books, for example, were important: "Reference books on music and other books of musical character," one commentator said, "are not alone decorative, but add a note of refinement and comfort."[18] Busts of famous composers, piles of sheet music, and even small, carefully placed musical instruments also contributed to the cluttered atmosphere and to the music room's symbolic associations.

 Many of these late nineteenth-century characteristics carried over well into the twentieth century, but in the 1890s, modernization gradually began to

have its effect. Once-feared advances in technology were bringing practical new devices and opportunities. The automobile increasingly lured people away from their homes in search of entertainment. Movie theaters, which became popular destinations, thrived, drawing people out of their homes night after night. Musical entertainment was transferred, in part, to this setting, because music was a vital feature of the silent movies and integrated as background soundtracks in the talkies. Newly popular outdoor activities, such as bicycling and golf, also competed with the home as an entertainment source. *The Etude* magazine referred to such diversions as "home excavators" and accused them of causing music in the home to suffer.[19]

An undercurrent of rebellion against the formalities and restrictions of the Victorian age also developed. And, in many cases, machines served to erode economic barriers by making commodities with formerly limited accessibility, such as well-performed music, available across class lines. Traditionalists resisted such rapid change and looked increasingly to the past for reassurance. But the new sense of practicality and logic and growing acceptance of the urbanized world gradually creeping into American thought challenged their romanticized perceptions of domestic music. Even the emerging tastes in and attitudes toward music signaled society's entry into the modern era.

In the 1890s, a new type of song began to replace the conservative, chaste songs often heard in the nineteenth-century parlor. In his study of turn-of-the-century song trends, historian Hughson Mooney described these new songs as "raucous, rebellious, and ribald." Instead of focusing on sentiment and idealistic purity, they more often reflected the language and reality of life among the common folk ("Maggie Murphy's Home," 1890; "The Bowery," 1892), a new patriotic fervor ("America, the Beautiful," 1895; "Stars and Stripes Forever," 1897), and occasionally even a mild hedonism with hints of sensuality unheard of in earlier parlor songs ("Fallen By the Wayside," 1892; "Their Heads Nestle Closer Together," 1894).[20]

All in all, popular music was less formal. It tended to have a livelier, more spirited tempo, and music representing black American culture, such as ragtime (commonly referred to as "coon songs" during the period) and then jazz, began to gain a wide audience. The following imagined scenario from 1907 reveals the contrast between old and new attitudes toward music:

Mary will have to be asked to play when she goes out in society. A proud mamma will attend to that. And Mary will play, with faithful

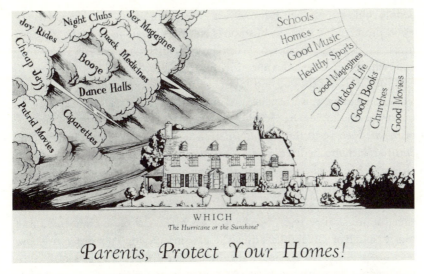

WHICH
The Hurricane or the Sunshine?

Parents, Protect Your Homes!

Fig. 4.3. "Parents, Protect Your Homes!" was the title of the article accompanying this image, which contrasts the impact on home life of modern activities, such as jazz, with those preferred by traditionalists. *The Etude,* August 1934. Courtesy, Theodore Presser Company.

accuracy, something from Chopin or Beethoven or Mendelssohn, and the young people will watch her chubby fingers thoughtfully and wonder when the selection will come to an end. They will applaud, too—when the end is reached—for that is good manners, and everybody likes Mary anyhow. And then—well, Lucy Smith, who has never taken lessons, will rollick up to the piano and begin a "coon song," hands and feet will beat time all over the room, half the listeners will hum the refrain; everybody will see the difference between the piano as a penance and as a pleasure, and only Mary's mamma will make unpleasant side remarks about the degeneracy of popular taste in music.[21]

Popular taste in music was less frequently following the dictates of upper-class tastes, and music of the lower classes was gaining new status.

In the 1920s, traditionalists were still battling new music. The problem now was the influence and pervasiveness of jazz, but by 1930 jazz was widely accepted by white, even conservative, middle-class Americans. It, like ragtime, was popular because it was fun to listen to—this was music

people could stomp their feet to.[22] An article in *Woman's Home Companion* in 1928 promoted it with enthusiasm: "Nothing has done so much good for music in its way as good jazz. It has certainly stirred up a rhythmic vitality and removed an innocuous and cloying sentimentality which threatened to enshroud music at the end of this last century."[23] More than providing comfort and security, this music offered an escape, a purely leisure activity.

New technologies were partly responsible for the vast changes in musical tastes between 1900 and 1930. Nineteenth-century Americans had become familiar with mechanized music through music boxes and mechanical novelties, such as mechanical singing birds and musical manicure sets and water pitchers. But, coming into their own between 1890 and 1930, the phonograph, mechanized instruments, and the radio had the most dramatic effect on musical activity. Mechanization led to the rapid transmission of music, much of which (black music, for example) would not otherwise have been accessible to many Americans. Indeed, from ragtime to classical, complex melodies and arrangements had often been too complicated for amateur talent or not well suited to instruments such as the parlor organ. But via machine, professional musicians brought these tunes into the home, improving the quality of music heard and supplying music appealing to a wider range of tastes.

Although homemade music was disappearing, automated devices were democratizing the consumption of music in the home. Lack of musical training and skill had become irrelevant to the enjoyment of music. Reflecting the shift (which began to occur in the 1890s) in attitudes toward musical training in the home, Emma Hewitt was "thankful . . . that the day has gone by when there must be 'an instrument' in the house."[24] She maintained that music had "a refining influence," but she also thought that forcing a child to be a musical master was a waste of time and money. Pundit C. L. Graves was not feeling thankful, however, when he warned in 1906 that the player piano and phonograph threatened "the extinction of all amateur performers."[25] One could easily turn a knob or crank to hear good music, and families took advantage of their new options for musical entertainment. Increasingly comfortable with new technologies, this nation of music performers became a nation of music listeners, and spontaneous performances gave way to recorded and programmed tunes.

With such widespread availability and appeal, both within and without the home, music was even more prevalent but, traditionalists argued, less appreciated. "If people are so unfashionable as to stay at home in the evening," Graves noted, "nothing is so unusual as to find them gathered round

the piano." And "if they invite their friends to dinner, they no longer think it necessary to treat them to 'a little music' afterwards." He was convinced that the basic problem was that "we are in danger of hearing, not too little, but too much music nowadays."[26] It was being taken for granted, he thought, now that a wide range of well-performed music was readily available. Indeed, one can argue that the democratization of the availability of well-performed music threatened the elite classes for whom, historian Orvell notes, "the chiefest evil [was] the erosion of barriers between the classes."[27] Good music was no longer an exclusive commodity.

The phonograph had an enormous impact on the democratization of music consumption. Patented in 1877 by Thomas Alva Edison, the phonograph became a major force in the 1890s. Originally intended as a business machine, these "talking machines" found a larger market as sources of mass musical entertainment.[28] The home became a natural target. An advertisement for K. B. Pierce's Music House in Beaumont in 1907 said, "Mr. Edison would like to see a phonograph on the center table of every household. We second Mr. Edison's wish." Other retailers promoted the phonograph as "an invaluable ally that never fails the hostess" and as having "melted many a conversational frost and made the callers feel right at home."[29] Advertisements for the devices often pictured family members, young and old together, clustered around their phonograph. The implication was that the phonograph could bridge the generation gap and bring families together in happiness. Edison even went so far as to name one of his phonograph models "The Home."

With extensive promotion and low prices, phonographs made their way into many homes across the country. By 1915, Americans were spending $60 million annually on phonographs and records. Magazines and manufacturers offered an abundance of information on how to care for them and even suggested that these machines could serve other purposes in the home. Extreme examples appeared in *Illustrated World* magazine, which showed how phonographs could be used as aids in polishing fingernails and silver, winding yarn, and painting china. It also suggested using worn-out phonograph needles to tack carpets, hold pictures in frames, and mend leaks in pans. In their study of living conditions in Muncie, Indiana, in the 1920s, Robert and Helen Lynd discovered that phonographs had become such an important part of living that when the father of one family was laid off in the summer of 1923, he and his family "strapped a trunk on the running board of the Ford, put the Victrola in the back seat with the little girl, and went off job-hunting." A newspaper story describes how in 1908, at a surprise

The Edison Phonograph as a Christmas Present

NO single thing furnishes so much entertainment, amusement and enjoyment to a family, especially where there are children and young folks, as an Edison Phonograph. It supplies all kinds of amusement at little expense; it gives you a means of entertaining your friends and neighbors, and it keeps you up-to-date with every kind of good music. No other gift will give so much delight for so long a time as an Edison Phonograph.

Have you seen and heard the new model with the big horn? If not go to the nearest dealer and see it, hear it and buy it. If you cannot do that, write to us for a complete descriptive catalogue.

NATIONAL PHONOGRAPH CO., 57 Lakeside Ave., Orange, N.J.

Fig. 4.4. Advertisement depicting the cross-generational appeal of the phonograph. *Cosmopolitan*, December 1907.

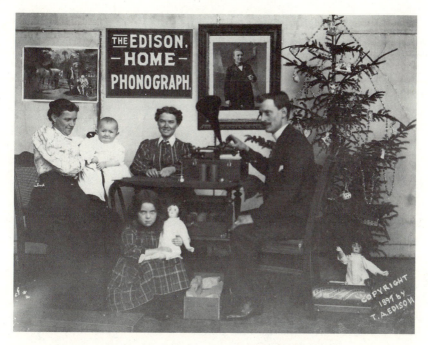

Fig. 4.5. Family posing with an Edison Home Phonograph, 1897. (Thomas Edison's portrait is hanging above the phonograph.) Courtesy, the Library of Congress.

party for Mamie McFaddin at her home, rugs were rolled up so partygoers could dance all evening to music from the Victor phonograph. Recorded music was still popular entertainment for Mamie in 1922, when she and her husband Carroll Ward took a phonograph with them to the beach on the Texas gulf coast. She revealed its heavy use during that trip in her diary: "Stayed up all night playing Victrola."[30]

Although the phonograph achieved almost universal prominence and popularity in American homes, it had vocal detractors in its early years. One of the most well known was composer and conductor John Philip Sousa, who vigorously protested "the menace of mechanical music." Music, he contended, had heretofore been an expression of the soul, but mechanization had reduced it to nothing more than a "mathematical system of megaphones, wheels, cogs, disks, cylinders, and all manner of revolving things." He woefully predicted that "the tide of amateurism" would recede until only mechanical devices and professionals were left to provide music. The deplorable results, he was convinced, meant that even "the very traditions

of babyhood" were threatened. "When a mother can turn on the phonograph," he wrote, "with the same ease that she applies to the electric light, will she croon her baby to slumber with sweet lullabys, or will the infant be put to sleep by machinery?"[31] With these remarks, Sousa was voicing the concerns of many critics reluctant to accept the phonograph, which, despite perceived threats to music and motherhood, quickly became a staple of American life.

Warning that "there are no short cuts to musical cultivation," critics harped on the intrusion of the player piano and other mechanized instruments, too. A cartoon illustrating Sousa's 1906 article in *Appleton's Magazine* portrays one of the author's imagined scenarios in which a little boy, shocked and confused, calls his mother to come to the drawing room, yelling, "There is a man in there playing the piano with his hands!" Automated pianos had replaced human pianists in many homes throughout the country. In fact, between 1900 and 1930, player pianos could be found in more than two and a half million homes. Manufacturers also touted mechanisms that, when installed, could automate regular pianos, thus bringing renewed use. "Is the piano in your home a musical instrument, and do you enjoy it as such, or does it remain unused for months at a time and become practically nothing more than an article of furniture?" asked an advertisement in 1901. The Aeolian Company maintained that to own one of its models was "to be independent of concert and opera, of musical seasons, of city opportunities, and of the whims of players and of the whole tribe of stumbling amateurs."[32] The expression of individuality through music in the home was giving way to these appealing new devices.

Bringing music as well as other programs into the home, the radio also diminished the individuality of the music heard. People were bound by the programming available at a given time. Because the radio, introduced in the early 1920s, was serious competition for the phonograph, some phonograph manufacturers responded by promoting their machines to connoisseurs, who, Hadley Cantril and Gordon Allport say in their 1935 book *The Psychology of the Radio*, did not care "to depend upon the sporadic benefactions of the radio." Radio's scheduling drawbacks were not a significant impediment, though, because the airwaves were soon crowded by stations simultaneously offering a variety of musical programming, much of which, at least early on, was classical. As a result, author Perry Scholes, and no doubt others, rated the radio the most noteworthy musical development of the twentieth century. Writing in 1926, he insisted that equivalent events in the first quarters of past centuries were the production of works by Bach

and Handel in the eighteenth century and the first performances of Beethoven's nine symphonies in the nineteenth century.[33]

Music was the backbone of this "modern substitute for the hearthside." Although radio programming included nonmusical features, musical programs were the most popular forms of radio broadcasting. Radio music was free, too; after investing in the machine itself, one did not have to buy records, sheet music, or concert tickets to enjoy it. It was truly a democratic form of musical entertainment, enjoyed by rich and poor alike. By 1935, according to a Columbia Broadcasting System report, 70 percent of the almost thirty million homes counted in the 1930 United States census had at least one radio.[34] Its widespread availability, the fact that it was inexpensive from the start, its portability, and the ease of tuning in ensured the radio's place in the American home.

A device with such rapid and widespread ownership was bound to have a profound effect on home life. One significant change in the role of domestic music, initiated by the capabilities of the phonograph and completed by those of the radio, was the transition from music as a primary event to music as background entertainment. Cantril and Allport's study revealed that two-thirds of radio listeners were engaged in another activity, such as reading, housecleaning, eating, or milking the cow, while listening.[35] Music was now widely enjoyed as a means of passive entertainment.

Whereas the automobile and moving pictures had pulled people away from home, the radio brought a renewed focus on family togetherness at home. Parents had been increasingly concerned about the time their children were spending away from home at dance halls, movies, and the like. But musical and other entertainment on the radio often enticed people to stay home. In their mid-1920s survey, the Lynds noted that "more than one mother said that her family used to scatter in the evening—'but now we all sit around and listen to the radio.'" A "shabby man of fifty" told them, "I don't use my car so much any more. The heavy traffic makes it less fun. But I spend seven nights a week on my radio. We hear fine music from Boston." A prominent movie exhibitor said, "The radio is hurting movie going, especially Sunday evening." Even people accustomed to other diversions at home were turning to the radio instead, as indicated by the telling response, "I use my time listening in that I used to spend reading."[36]

By the 1920s, when radios began to appear in American homes, music no longer was confined to one or two rooms. Victorian attempts at room specialization were gradually overridden by efforts to draw the family together and to simplify room arrangements and decor. House designs, with more

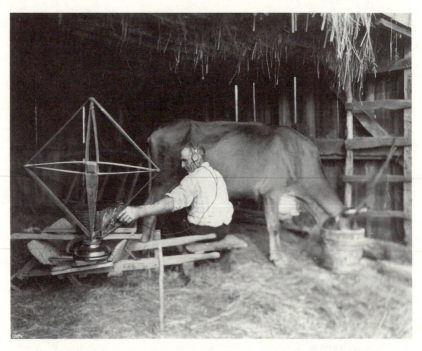

Fig. 4.6. Tuning in to a radio program at milking time, 1923. Courtesy, the Library of Congress.

open floor plans, such as those of the increasingly popular bungalow, became the norm. Simple, open rooms were deemed more attractive, and by World War I the widespread use of central heat and electricity opened the entire house to comfort and use at any time of day or night. Automobiles had moved a lot of socializing out of the home, and formal, stately settings exclusively for that purpose, such as the parlor (which often doubled as a music room), were widely eliminated from new house plans. Music rooms, too, were unnecessary, according to this philosophy, and living rooms began replacing parlors, libraries, and music rooms in new homes. Eliminating extra rooms lessened the formality of home life, making its operations more practical and efficient and making the house easier to clean—a major concern at a time when health and sanitation issues were prominent, fewer households employed domestic servants, and increasing numbers of women were working outside their homes.

The 1890s saw the beginning of a trend toward simplicity in music-room

decor. (Hereafter, the term *music room* refers to any room that was the primary setting for music in the home.) "Ugliness has had its day, and it would be impossible to furnish rooms as they were furnished a few years ago," observed a writer in her discussion of "The Home Music Room." "Beautifying [the piano] with heavy draperies or bric-a-brac; and crowning the edifice with piles of sheet music" was, according to another, no less than "musical squalor."[37] Homeowners took heed and began to straighten up their music rooms; they cleared off their pianos and organized their sheet music neatly in music cabinets, which received extensive publicity for their role in enhancing the efficiency of music spaces. Working to achieve a degree of dignity and serenity in their music rooms' atmospheres, homeowners were also admonished to avoid the potentially destructive interference of new domestic technologies. For example, part of musical good housekeeping was keeping the telephone far from the music room. "It is fatal," one writer warned, "to cut off the Kreutzer sonata just at the most frenzied climax, while the grocer explains why he forgot the lard, or the operator informs you in a bored voice that she begs your pardon."[38] The atmosphere of the music room was to be uncluttered in every way.

In 1909, *The Musician* magazine ran a series titled "The Music Room Beautiful" to assist its readers "with artistic ideas and limited means . . . in their efforts to give artistic treatment to their music rooms." In it, author Antoinette Perrett offered suggestions as to the types of rugs, floors, chairs, bric-a-brac, curtains, and wall treatments one should use to furnish the room. Her recommendations did not, for the most part, focus on music-related items; her concern was that the room's decor was tasteful. Writing about "The Music Room and the Musical House," author Charles Isaacson agreed: "You don't need to label the music room. What is in the room of a musical nature will do. Your pictures will harmonize if they are up to the standard of the music to which you listen."[39]

Antoinette Perrett did, however, advocate furnishings reminiscent of the past, or at least suitable to Colonial Revival notions of the past—antique oriental rugs, for example, and chair rails for "colonial rooms," above which "a colonial paper is used." Among her chair recommendations were eighteenth-century Queen Anne, banister-back, and Windsor models. "The comb-back Windsors," she said, "would be especially quaint for a music room."[40]

The past as a theme in the decoration of domestic spaces for music continued to develop until specific period styles became the rage for decorating musical devices themselves. Industrialization had brought about a long-

lived nostalgia for the past. Modern styles, such as that associated with the Arts and Crafts Movement, were fashionable, but for musical settings, designs representing earlier periods were the most heavily promoted. The wealthy were probably the primary buyers of these models, but what is interesting is that the piano had become vulnerable to stylistic trends in the same way furniture was. The piano's actual use in households had diminished, but its associations with culture persisted; thus, its value as a symbol increased. And as the mere sight of the instrument became more important, so did its design. If for no other reason, styles of the past were appropriate because the piano represented music produced by people, not by machines; it was another reminder of the past. At least as early as 1900, piano manufacturers were being called on to adapt piano design to colonial styles,[41] and by the 1920s, pianos were readily available in any number of period styles.

Buyers were encouraged to choose models that coordinated with the styles of the rooms for which they were intended. Complaints about the lack of decorative harmony in music rooms had begun to arise by 1890 and gained momentum during the ensuing decades. The piano, because it dominated a room and had an unwieldy nature, lay at the center of the problem. "It never seems to occur to people that this piece of furniture . . . has its own part in the good or bad *ensemble* of the drawing-room," complained Mrs. H. R. Haweis in her 1889 book *The Art of Decoration*. Four decades later, her call had been heard. "As much as possible," implored Helen Sprackling, consultant in home decoration for *The Parents' Magazine* in 1931, the piano and its accessories "should bear out the furnishing idea of the room."[42] This does not mean that everyone bought period-style pianos; indeed, many preferred simple, unornamented cases. But coordinating furnishing styles within these music settings reflected in decoration the post-Victorian trend toward efficiency; harmony of proportion, quality, and style formed the ideal in music-room decor for all classes.

Just as the piano was, phonographs and radios were increasingly designed to coordinate with other furnishings: "Decorators reckon them in the furnishing of rooms," said a writer for *House and Garden* in 1926. "They are elaborately encased and become things of beauty. They have also been accepted as part of the objects with which one must surround himself in order to make a home."[43] Many were designed and decorated in period styles, thus helping to disguise the intrusion of the machine into the home. Early in the century, the Victor Talking Machine Company had begun producing phonograph cases reminiscent of the Louis XV style, and beginning in 1925, cabinets for the new Orthophonic Victrolas had specific period

designations: William and Mary, Chippendale, Hepplewhite, and Sheraton, for example.[44] Manufacturers were also producing radios with period designs, often disguising them as sideboards, desks, and cabinets. One could, for instance, obtain radios housed in "French Provincial desks of beech, . . . in Governor Winthrop desks of mahogany and in various other pieces of Colonial mahogany and Early American maple."[45] Such models were intended for public spaces in the home, not service areas in which mechanization was displayed with pride. But music machines had become essential features in American homes, and tasteful, artistic designs justified their presence in rooms in which cultural associations were still important.

In his utopian novel *Looking Backward*, published in 1888, Edward Bellamy wrote that "if we could have devised an arrangement for providing everybody with music in their homes, perfect in quality, unlimited in quantity, suited to every mood, and beginning and ceasing at will, we should have considered the limit of human felicity already attained."[46] Bellamy did not know it, but what he wanted was a radio. At the time, the possibility of music at the turn of a knob was but a dream for those who could even imagine it. In the ensuing forty years, however, mechanical music goods exploded onto the American domestic scene, causing a significant transformation in the role of music in the American home. Traditional attitudes toward music persisted to a degree, but the effect of emerging modern sensibilities and technologies on home music was profound. Artistic self-expression was transferred from music making to creating artistic, harmonious physical surroundings for music. No longer did people have to endure tedious musical performances in their parlors and music rooms to have musical entertainment. Professionalism, instead, set the new standard for music heard. Suffice it to say, the love of music never dwindled but actually strengthened, because machines made good music accessible and music became more a form of pleasure than of edification. Likewise, instruments such as pianos remained prominent conveyors of domestic music, but their value lay increasingly in their reflection of traditional notions of culture—notions which persist, to some extent, in American homes even today.

Notes

1. "The Home Set to Music" is also the title of a short article on the importance of music in the home that appeared in *Sunset Magazine* 53 (Nov. 1924): 68, 75–76. Sidney Lanier, *Tiger-Lilies: A Novel* (1867; rpt. Chapel Hill: Univ. of North Carolina Press, 1969), 228.

2. See Harvey Green, "The Ironies of Style: Complexities and Contradictions in American Decorative Arts, 1850–1900," in *Victorian Furniture*, ed. Kenneth L. Ames (Philadelphia: Victorian Society in America, 1983), 17–34; and Miles Orvell, *The Real Thing: Imitation and Authenticity in American Culture* (Chapel Hill: Univ. of North Carolina Press, 1989), 59.

3. For example, see Henry T. Finck, "Music and Morals," *Chopin and Other Musical Essays* (New York: Charles Scribner's Sons, 1897), 143–82.

4. For information on the role of physical fitness in the nineteenth and early twentieth centuries, see Harvey Green, *Fit for America: Health, Fitness, Sport, and American Society*, (New York: Pantheon Books, 1986); Mrs. Doré Lyon, "Musicales," in *Correct Social Usage*, 11th rev. ed. (New York: Society of Self-Culture, 1909), 2: 474–75.

5. "Music and Culture," *Dial* 33 (16 Dec. 1902): 456.

6. Emma Churchman Hewitt, *Queen of the Home: Her Reign from Infancy to Age, from Attic to Cellar* (Philadelphia: W. W. Houston, 1892), 266, iv; Anne Guilbert Mahon, "Music in the Home," *The Musician* 17 (Jan. 1912): 11; Robert Haven Schauffler, "A Cradle Start in Music," *Delineator* 88 (Mar. 1916): 20; Maggie W. Ross, "Housework and Piano Practice," *The Musician* 15 (June 1910): 376.

7. T. DeWitt Talmage, *The Pathway of Life* (Richmond, Va.: B. F. Johnson, 1889), 304–5. I am grateful to John Donnelly, Jr., for bringing this source to my attention.

8. Finck, "Music and Morals," 174, 170, 163.

9. For more comprehensive analysis of the parlor organ as part of domestic material culture, see Kenneth L. Ames, "Material Culture as Non-Verbal Communication: A Historical Case Study," *Journal of American Culture* 3 (Winter 1980): 619–41; and "When the Music Stops," in *Death in the Dining Room and Other Tales of Victorian Culture* (Philadelphia: Temple Univ. Press, 1992), 150–84. For information on hymns and family worship, see Colleen McDannell, *The Christian Home in Victorian America, 1840–1900* (Bloomington: Indiana Univ. Press, 1986), 70, 82–83. McDannell notes that Catholic households contained parlor organs, too, but used them more in secular than religious contexts.

10. 1897 *Sears Roebuck Catalogue* (1897; rpt. New York: Chelsea House Publishers, 1968), 510–14; Laurence Libin, *American Musical Instruments in The Metropolitan Museum of Art* (New York: Metropolitan Museum of Art and W. W. Norton, 1985), 200; Colleen McDannell, "Parlor Piety: The Home as Sacred Space in Victorian America," in *American Home Life: A Social History of Spaces and Services, 1880–1930*, ed. Jessica Foy and Thomas J. Schlereth (Knoxville: Univ. of Tennessee Press, 1992), 184.

11. "The Autoharp and How It Captured the Family" (pamphlet published by C. F. Zimmerman Co. of Dolgeville, N.Y., ca. 1882), 1–11, in Warshaw Collection of Business Americana, National Museum of American History.

12. Orvell, *The Real Thing*, 35.

13. Hewitt, *Queen of the Home*, 218.

14. Mary M. Schmitz, "Recitals at the Homes of Pupils," *The Etude* 31 (Oct. 1913): 757; Wilson Flagg, "Parlor Singing," *Atlantic Monthly* 24 (Oct. 1869): 410; Gretchen Kreuter, "The Role of the Piano in the Lives of American Women in the Nineteenth and Early Twentieth Centuries," in *The Piano—A Mirror of American Life* (St. Paul: Schubert Club, 1981), n.p.

15. Lyon, "Musicales," 475; "In Society's Realm," *Beaumont Enterprise*, 17 Mar. 1907, 4.

16. Lyon, "Musicales," 471–74.

17. See, for example, house plans in Herbert C. Chivers, *Artistic Homes* (St. Louis, 1910).

18. F. H. Martens, "Making the Music Room Attractive," *The Musician* 19 (Apr. 1914): 229.

19. "Are We Losing Our Home Musical Life?" *The Etude* 40 (July 1922): 441.

20. Hughson F. Mooney, "Songs, Singers and Society, 1890–1954," *American Quarterly* (Fall 1954): 223–25. See also Sigmund Spaeth, *A History of Popular Music in America* (New York: Random House, 1948) for a chronological survey of popular American songs from the 1700s to the 1940s.

21. Cynthia Westover, as cited in "Society Music," *Beaumont Enterprise*, 8 Sept. 1907, 4 (originally published in *Success Magazine*, issue unknown).

22. Kathy J. Ogren, *The Jazz Revolution: Twenties America and the Meaning of Jazz* (New York: Oxford Univ. Press, 1989). Ogren discusses how audience participation, new locations, and standardization led to the increasing appeal of jazz to middle-class tastes. She also notes the developing "pluralist approach" to accepting such disparate musical forms as jazz and classical, a symbol of the new "appreciation of diversity" that began to distinguish 1920s Americans from their Victorian absolutist predecessors (pp. 164, 165).

23. Peter Hugh Reed, "Music in the Modern Home," *Woman's Home Companion* 55 (Nov. 1928): 17.

24. Hewitt, *Queen of the Home*, 218.

25. C. L. Graves, "Decline of Domestic Music," *Spectator* 96 (May 1906): 830.

26. Ibid.

27. Orvell, *The Real Thing*, 37.

28. Russel Nye, *The Unembarrassed Muse: The Popular Arts in America* (New York: Dial Press, 1970), 322. Among other useful sources on the phonograph is Roland Gelatt's *The Fabulous Phonograph, 1877–1977* (New York: Collier Macmillan, 1977).

29. Advertisement, *Beaumont Enterprise*, 19 May 1907, 8; advertisement, *Beaumont Enterprise*, 9 May 1915, 18.

30. "Expended for Music Each Year in the United States," *Journal of Education* 82 (28 Oct. 1915): 401; "Make the Phonograph Help Out at Home," *Illustrated World* 35 (May 1921): 417; "Uses for Worn-Out Phonograph Needles," *Illustrated*

World 35 (June 1921): 615; Robert S. and Helen Merrell Lynd, *Middletown: A Study in American Culture* (New York: Harcourt, Brace, 1929), 244; "Surprise Party in Honor of Miss Mamie McFaddin," *Beaumont Enterprise*, 8 Nov. 1908, 16; diary of Mamie McFaddin Ward, entry for 19 Aug. 1922, McFaddin-Ward House MS collection.

31. John Philip Sousa, "The Menace of Mechanical Music," *Appleton's Magazine* (Sept. 1906): 278–84. Sousa's article was excerpted in "Sousa's Protest Against Canned Music," *Current Literature* 41 (Oct. 1907): 426–28.

32. F. Young, "Place of Music in Modern Life," *Living Age* 269 (1 Apr. 1911): 33; Cynthia A. Hoover, *The History of Music Machines* (New York: Drake Publishers, 1975), 61; advertisement for Aeolian Co., *Delineator* 57 (June 1901): 981.

33. Hadley Cantril and Gordon W. Allport, *The Psychology of the Radio* (1935; rpt. New York: Arno Press and the *New York Times*, 1971), 29; Perry A. Scholes, "Most Important Musical Event Within the Past Quarter Century," *The Musician* 31 (Aug. 1926): 10.

34. Cantril and Allport, *The Psychology of the Radio*, 15, 217, 10, 85.

35. Ibid., 103.

36. Lynd, *Middletown*, 270.

37. Harriett Cullen Bryant, "The Home Music Room," *Good Housekeeping* 48 (June 1909): 784; Robert Haven Schauffler, "Musical Good Housekeeping," *Good Housekeeping* 62 (Jan. 1916): 21.

38. Schauffler, "Musical Good Housekeeping," 26.

39. Antoinette Perrett, "The Music Room Beautiful," *The Musician* 14 (1909); Charles D. Isaacson, "The Music Room and the Musical House," *The Etude* 40 (Jan. 1922): 20.

40. Perrett, "The Music Room Beautiful: The Walls," *The Musician* 14 (Feb. 1909): 77; Perrett, "The Music Room Beautiful: Chairs," *The Musician* 14 (Apr. 1909): 184.

41. J. B. Tiffany, "Colonial Art and its Adaptability to Modern Pianos," *Architectural Record* 9 (Jan. 1900): 268–72.

42. Mrs. H. R. Haweis, *The Art of Decoration* (London: Chatto & Windus, 1889), 318–19; Helen Sprackling, "Decorative Side of Music," *The Parents' Magazine* 6 (Nov. 1931): 70.

43. "When America Sang at Home," *House and Garden* 50 (Oct. 1926): 92.

44. Robert W. Baumbach, *Look for the Dog: An Illustrated Guide to Victor Talking Machines*, Woodland Hills, Calif.: Stationery X-Press, 1990.

45. Sprackling, "Decorative Side of Music," 71.

46. Edward Bellamy, *Looking Backward, 2000–1887* (1888; rpt. New York: Modern Library, 1982), 81–82.

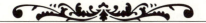

CHAPTER FIVE

The Piano in the American Home

Craig H. Roell

Few things in the culture of the American home have been more symbolically complex, and yet earnestly practical, than the piano. American families, whether urban or rural, wealthy or modest, southern, northern, or western, have spent much time together in the parlor or living room to the sounds of mother or sister playing church hymns, folk tunes, appropriate sentimental songs, and favorite classical music. While setting up their homes, nineteenth- and early twentieth-century Americans let little time pass before acquiring a new or used instrument, for as a popular Victorian adage put it, "A home is incomplete without a piano." Indeed, in the not-to-distant past, when running water and indoor plumbing were still not common in rural America, there were more homes with a piano than with a bathtub!

When Catharine Beecher and Harriet Beecher Stowe designed their modest floor plan for "a Christian House," which they published in 1869 in their best-selling domestic guidebook *The American Woman's Home*, they had carefully provided space in the drawing room for the piano. Music, they wrote, is an "elevating and delightful recreation," both physically and morally uplifting and absolutely necessary to sustain family life. In Victorian society the piano in the home became associated with the virtues attributed to music—cultural refinement, self-expression and creativity, medicine for the soul—but also with the work ethic, for to play the piano demanded toil, sacrifice, and perseverance. Because it was the woman's task in Victorian America to sustain this value system in an increasingly industrial and menacing world, music, women, and the piano became closely associated, even into the twentieth century. As the primary musical instrument, the piano became symbolic not only of the virtues attributed to music but also

of home and family life, middle-class respectability, and woman's particular place and duty. The glorification of the piano became a moral institution.[1]

"There is probably no country in the world where piano playing is so widespread as in the United States," the respected music critic and historian Louis C. Elson wrote at the turn of the century in *History of American Music*. "Almost every home, even among the humble, possesses its instrument and some amount of piano music. . . . The universal gift or habit of playing the piano, or playing at piano music, in America is undeniable." Indeed, the piano throughout most of its history has commanded a respect as "the basic musical instrument," its pleasant tones delighting the senses of both cultivated musicians and the untrained majority. It satisfies the demands of the most skillful yet allows the beginner gratifying results. Thus the piano, as the French composer Halévy put it, "is of all instruments the one which has contributed the most toward popularizing a taste for music and facilitating its study."[2]

The America portrayed by Currier & Ives and sustained by McGuffey's famous *Eclectic Readers* was a culture based on rural and small-town values, where home, church, and school were treasured moral centers of family life, and where hard, honest work brought success. These Victorian values dominated American life throughout most of the nineteenth century and remained strong until at least the World War I years. Despite the commercial culture and industrial upheavals associated with the rise of big business, together with the culture of modernism emerging by the 1920s and the trials of the Depression years, Victorian idealism provided ballast to many seeking stability in a rapidly changing society. Though a middle-class phenomenon, this outlook significantly influenced the lives and thinking of Americans in all economic and social classes. Providing balance in this Victorian culture were three intertwined value systems: the work ethic, the "Cult of True Womanhood" (also called the ideology of domesticity), and the morality of music. The ever-present piano provided a focus for—even a bonding of—these beliefs.

Thus the piano's significance in Victorian culture rested on a substructure much more intricate than historians have appreciated; too often its historical presence has been unacknowledged or noted only superficially. Although it is true that the piano was a token of affluence and respectability, its importance transcended considerations of class, wealth, social mobility, and ornament. The piano became associated with the virtues attributed to music as medicine for the soul. Music supposedly could rescue the distraught from the trials of life. Its moral restorative qualities could counter-

act the ill effects of money, anxiety, hatred, intrigue, and enterprise. Like the Victorian home, music provided an oasis of calm amid the upheavals associated with industrialization and urbanization. Because this ability to soothe was also seen as the mission of women in Victorian society, women were closely associated with music. Echoing this sentiment as late as 1929, one of the nation's most popular music magazines, *The Etude* (founded in 1883 by the Theodore Presser Company in Philadelphia), proclaimed that music and the piano were "to myriads of women a solace and a joy, the means of preserving hallowed life ideals, spiritual values, without which humankind cannot endure. . . . The responsibility for the home is the responsibility of the mother. . . . Surely of all people the mother cannot do without music."[3]

Most piano pupils were female, and both music making and music appreciation were distinctly feminized, something often acknowledged in popular music periodicals. (*The Etude*, for example, affirmed that music, "the most spiritual of the arts, is a natural possession of the finer sex.")[4] This association of music, women, and morality naturally carried over into church and schoolhouse as well, for these treasured institutions were also spheres of female influence. In Victorian America there was no shortage of girls or women able and honored to play the piano for church, Sunday school, public school, or the home. Profound and complex, the piano in so many ways was Victorian America. Whether purchased new or second hand, whether a grand, square, or upright, the piano sat steadfast, massive and magnificent in the parlors and drawing rooms of American homes, serving as a daily reminder to both country and city folks of a sublime and moral way of life.

The glorification of work and the dignification of labor as a supreme virtue—and the consequent condemnation of idleness—remain among the strongest legacies of the Victorian era. This ideology rested on the notion that nothing in this world was worth having or doing unless it meant pain, difficulty, sacrifice, and effort. Hard work was considered morally purifying because it built character, patience, fortitude, self-control, and perseverance. A person therefore had a social duty to produce. This elevation of work above leisure permeated American life and manners in the nineteenth and early twentieth centuries, leading to countless warnings against the evils of idleness. The work ethic promised solid rewards, independence, self-advancement, self-respect, contentment, and a medley of other virtues. Praise for work came from Protestant middle-class property owners: farmers, merchants, ministers, professionals, craftsmen, and industrialists.

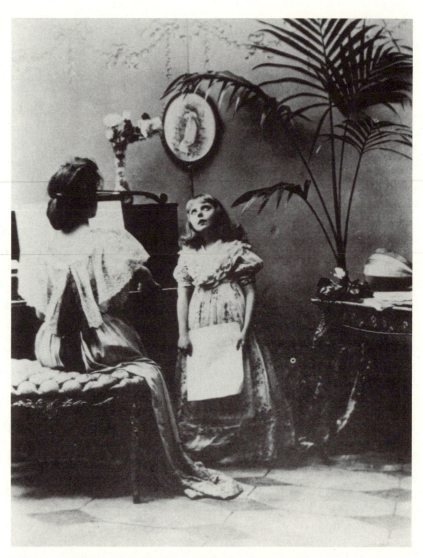

Fig. 5.1. "Home, Sweet Home," ca. 1900. Victorian ideology praised music as "the most spiritual of the arts" and "medicine for the soul," calling it a "natural possession" of mothers, sisters, and daughters. Music completed the respectable home, creating solace and joy, preserving "hallowed life ideals and spiritual values, without which humankind cannot endure." Women and music, as *The Etude* music magazine put it, were "Twin Souls of Civilization." Courtesy, the Library of Congress.

And because the middle class dominated the schools, business enterprises, and publishing houses in America, it also set the tone for society.[5]

Music teachers in Victorian America therefore placed a premium on hard work. Piano instruction in nineteenth- and early twentieth-century America followed the so-called Klavier Schule of Siegmund Lebert and Ludwig Stark, coauthors of the historic *Method* (1858). By 1884, *Method* was in its seventeenth American edition and had been expanded to four volumes. The main objective of the Klavier Schule and its imitators was to strengthen the fingers by rigidly playing studies, scales, arpeggios, and exercises "with power and energy." This athletic finger training demanded practice several hours a day, regardless of whether the pupil aspired to a concert career or merely to enhanced social graces. "Technique may be only a means to an end," wrote the Victorian music critic Gustav Kobbé, "but it is the *only* means to that end."[6]

By the late nineteenth century, by which time the "piano girl" was already an enduring element in American culture, the strenuous Klavier Schule method of teaching piano to the morally and socially inclined young lady had itself become an institution. "When I was a boy it was part of the destiny of the American female child to spend countless hours incarcerated in the parlor, pounding the piano," recounted one witness. In his 1908 report for the United States Bureau of Education, Arthur L. Manchester concurred: "Technique became the sine qua non of all effort. The aim of music teaching has been the making of players and singers or the development of composers," rather than the cultivation of amateurs who could simply enjoy music. Celebrity virtuoso Ignace Jan Paderewski, who complained that "the fault most general, not only with girl students but with professionals, is the sitting at the piano as a pastime instead of working seriously," advised that "no matter what stage of progress the student has reached, one hour daily . . . of technique is indispensable." Such methods seem unnecessarily severe for the great majority interested in playing only as a means of attaining popularity, social grace, and rudimentary musical self-expression. But in the culture of the time, idleness was a vice; work of some sort was a virtue, even in leisure. "When you play, play hard, and when you work, work hard," said Theodore Roosevelt, perhaps the most energetic symbol of the Victorian work ethic. The Cable Piano Company, echoing the best sentiments of this notion, advertised in 1915: "You can play hard on a Conover piano. It's built to last a lifetime." By no coincidence the company also quoted Roosevelt in the ad.[7]

Though rooted in the work ethic, the strenuous efforts that American

women undertook to "play nicely" were not merely work for work's sake. Playing the piano was a critical element in the Cult of True Womanhood. To Victorians, home was sacred, a shelter from the anxieties of industrial society and a shelter *for* the moral and spiritual values that the commercial spirit was threatening. Henry R. Bishop and John Howard Payne immortalized this feeling in the lyrics of their beloved "Home, Sweet Home" (1823): "Be it ever so humble, there's no place like home." Home was called an "oasis in the desert," a sanctuary where man could recover his humanity from the selfish, degrading, immoral business and industrial world. Woman's role was to create a home in which to nourish love, morality, religion, and culture. American women were not considered helpless or merely decorative. Influenced by the work ethic, motherhood and homemaking were viewed as active vocations in which the moral power of women rested in their moral influence over men and in motherhood. The cultivation of manners, education, and music was a necessary part of this role.[8]

Historians have missed an essential point by regarding the cultivation of music in the home as no more than an ornamental accomplishment denoting a well-mannered woman. The interaction of the work ethic, the ideology of domesticity, and the moral value of music formed a crucial Victorian canon. Music "carefully played" compels listening, aids conversation, and soothes the troubles of work, claimed a popular etiquette book of the day. A husband or brother "may be made almost domestic by the cheerful notes."[9] Furthermore, music added much to woman's happiness, and such happiness upheld woman's morality.

The ideology of domesticity accepted motherhood as the primary fulfillment of woman's moral destiny; and raising children correctly, nurturing them in morality, provided a rear guard against the harshness of industrial society. The musical training of a young girl and her playing the piano in the home was a significant part of this nurturing. In 1909 *The Musician*, another of America's most popular musical periodicals, considered a concerned fifteen-year-old reader's question, "Why should a young girl take up the study of music?" The editor, reinforcing traditional Victorian values, replied that the girl should "be prepared to do her part in the scheme of social pleasure [because] the social element is strong in the life of young women." Furthermore, music study and playing the piano "makes common ground" with her companions. And though he stressed the value of music in the social circle, music in the home received added emphasis: "In the home life the daughter who can contribute to lighten the hours free from the cares of business and the household is a boon to her father, to her mother, and to

her brother. 'Give us a tune, Sis,' is a common request." The "piano girl" was not just cultivating a pastime or social grace; she was playing her proper role. "Don't make them go out of the home for lack of this pleasure," warned *The Musician* sternly. "Music is wanted in the home." Finally, the editor advised that music study could be profitable: at age twenty the girl could become a self-supporting woman through teaching. But financial independence was beside the point. The essential reason a young girl should study music, especially the piano, was that "she prepared herself to minister to the joy and pleasure of others, thus fulfilling the social ideal."[10]

As late as 1934, *The Etude* still avowed that "every girl has before her a pattern of the future upon which her happiness and her usefulness to society must depend. . . . We must look to the women of tomorrow to take the responsibility for the inner workings of that most precious of all American institutions, the Home. It remains for woman to develop those spiritual and cultural things which make the difference between mere existence and joyous living." The means to this transformation remained familiar: "There is probably no other study which contributes so much to the charm of the home as music, a study which should appear in the life pattern of every girl." Despite modernization, apparently, the Victorian "piano girl" prevailed.[11]

Victorian culture demanded modesty of its women, and the piano kept its preeminence, as one authority expressed, as the musical instrument "best fitted for society." The harp, no longer fashionable in late Victorian America, was said to cause curvature of the spine. The piano "cures this posture problem." The guitar, though not forbidden, was considered more appropriate for a man. The horn, violin, and especially the cello were definitely unsuited to modest young ladies and would cause "detriment of their feminine attractions." But at the piano, she could sit posture perfect with feet demurely together, engaged in the pursuit of culture, enjoying the moral uplift of music. She also sat symbolic of her family's ability to pay for the instrument and music lessons.[12]

Not only were girls and women the great majority of amateur musicians in America, they also overwhelmingly dominated concert audiences until well into the twentieth century. Given this central role of the piano and music in the lives of American females, it is not surprising that an effeminate cast was given to music making and even its appreciation. The term piano even crept into the language as meaning gentle, mild, or weak, usually a disparaging remark reserved for men—"James Benwick is rather too piano for me," Jane Austen wrote in *Persuasion* (1818), a sentiment still

echoed more than eighty years later by Elinor Glyn, who wrote of her character in *The Visits of Elizabeth* (1900), "The Marquis . . . looked thoroughly worn out and as piano as a beaten dog." This feminization of music and piano playing directly resulted from the place of music within the American home, within woman's separate sphere. [13]

Acknowledging this, most men were either ignorant of or even prejudiced against musical study for themselves (even though many as children had "suffered" through morally inspired piano lessons at the hands of resolute mothers nesting the proper Victorian home). This notion of separateness carried into the Victorian twentieth century, though many modern writers lamented both the sissy label attached to the boy musician and the way men looked upon music as effeminate and unmanly, a softening influence in an era when men actively pursued a prescription for what Theodore Roosevelt called the "strenuous life." The separateness of the spheres could be breached by genius—the male musical virtuoso, for indeed most concert pianists were men (commanding respectable incomes)—but male musicians generally were seen as undependable, unable to support a family. "Only a trifling musician" went the phrase. And in a culture esteeming strong, rational, aggressive, competitive, businesslike men, *piano* remained an uncomplimentary observation of the decidedly unmanly man. Victorian society did not encourage a man to excel in music, but to be a good provider for his family. It was primarily girls and women who imparted music's morally uplifting qualities. Music, much like religion, would come to husbands and sons through wives and daughters.

Significantly, this notion that music has an inherent power of moral elevation and therapeutic rejuvenation is of venerable and sacred tradition and was not lost to men. When David, psalmist of God, played music for his troubled king, the Bible attests that "Saul would become refreshed and well, and the distressing spirit would depart from him." "Besides theology," wrote Martin Luther, "music is the only art capable of affording peace and joy of heart; the devil flees before the sound of music almost as much as before the word of God." Celebrating the ancient Orpheus myth, William Congreve penned his famous "Music hath charms to soothe a savage breast, to soften rocks, or bend a knotted oak." Likewise inspired was William Shakespeare's "The man that hath no music in himself . . . is fit for treasons, stratagems, and spoils; . . . Let no such man be trusted." "So is music an asylum," insisted Ralph Waldo Emerson. "It takes us out of the actual and whispers to us dim secrets that startle our wonder as to who we are, and for what, whence and whereto." The American Association for the Ad-

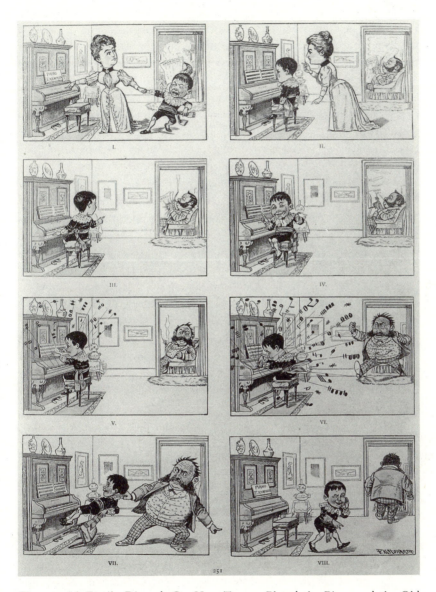

Fig. 5.2. "A Family Discord; Or, How Tommy Played the Piano and the Old Man," puns the caption for this full-page cartoon from *Puck* magazine, ca. 1895. Mother is determined to nurture her son in the morality of music through piano practice. Tommy, equally determined not to become a sissy, schemes to get Father's intervention by banging the piano. Father obliges and sends a triumphant Tommy on his way. Note Mother's sheet music, "Piano Exercises." Author's collection.

vancement of Education affirmed in 1855 that music "is one of the best means of quickening the moral sensibilities and elevating the affections of the young," a sentiment echoed in 1909 by *The Musician*, which advocated "the Formation of Character through a Proper Study of Music."[14]

The First World War, though horribly modern in so many ways, was also a consummation of American Victorian ideology in its portrayed heroic idealism, its proclaimed moral goals to "end all war" and "make the world safe for democracy," and in its avowed reliance on the moral value of music. The government of the United States held that music and pianos were vital to winning the conflict, second only to food and munitions. Thus in the fall of 1917, the War Industries Board designated the American piano industry "essential to the national welfare" and allowed the trade to continue production of pianos "practically undisturbed." After all, did not music and the piano support virtues that were the foundation of American society? "The man who disparages music as a luxury and non-essential is doing the nation an injury," President Woodrow Wilson admonished. "Music now more than ever before, is a national need. There is no better way to express patriotism than through music." Charles S. Whitman, governor of New York, congratulated the music industries for their efforts to get music and pianos "over there" to the boys and for encouraging music in the home to maintain morale. "There is no one doing more for the comfort and happiness of the land than those who are supplying the means and instruments for the expression of music of the human heart."[15]

Such notions endured even into the 1920s and 1930s, though of course for Victorians, "proper" music meant sentimental songs, folk and national tunes, church hymns, and classical music played on "proper" instruments such as the piano. It certainly did not mean jazz and honky-tonk played on such morally compromising instruments as the saxophone and (ironically) the "upright" piano so vital to "houses of ill-repute," speakeasies, and night clubs.

The historical traditions supporting the moral value of music as "medicine for the soul" assured its significance in Victorian ideology and secured the preeminence of the piano in the parlors of Victorian homes. As one authority noted, music in the home "soothes the wrinkles of a hard life of business, and lifts us from thoughts of money, intrigue, enterprises, anxieties, hatred, and what not, to a calmer, more heavenly frame of mind." "No home is complete without music," stressed another Victorian, because playing the piano and singing, being both "delightful" and "morally and physically uplifting," sustained family life. *The Etude* professed that "music is one

of the most remarkable of reconstructive tonics for the tired brain and nerves. To many it revitalizes the beautiful in life and softens the brain-breaking, nerve-snapping strain of this high pressure era." Was this not the essence of the Cult of True Womanhood? Were not Victorian women to maintain a home environment that provided essentially the same respite from the ills of commercial culture and industrialization? No wonder *The Etude* called women and music "Twin Souls of Civilization."[16]

Though historians have largely ignored this entwining of the moral value of music, the work ethic, and the ideology of domesticity, it is vital to understanding the esteemed role of the piano in the American home. It is no accident that family photographs and treasures were proudly arrayed on the parlor piano. As a piece of furniture, pianos were large enough to display a variety of mementos. By the late nineteenth century, the massive towering upright piano had replaced the square piano as the instrument of choice among American consumers, who increasingly used the piano's top board as the logical focal point for family keepsakes, pictures, and photographs. The piano, much like the hearth, literally provided for family togetherness, and much like the fireplace mantel, symbolized this association in a very real sense as a literal foundation of family heirlooms.

Nevertheless, the middle-class home also was becoming a display case of social status, elaborately decorated with upholstered furniture, carpets, and draperies. In the drawing room, kitchen, and even bathroom, Victorians sought to fill space with solid, heavy pieces. The emphasis was on comfort, but permanence was the philosophy. Thus, much of Victorian furniture was designed not to fit into a room but to dominate it. A piano salesman reported in 1880 that "three-fourths of the [piano] buyers want a top that towers high above all the bedsteads in the country, and hardly ever question the inside." The common practice among Americans to cover this massiveness with shawls and tapestries led to the fashionable "dressing" of pianos in skirts of Genovese velvet, Chinese brocade, silk, satin, or India cotton prints. This provided the basis for the long-circulated story of prudish American ladies draping the "limbs" of their pianos with "modest little trousers," which first appeared in Captain Frederick Marryat's *A Diary in America* (London, 1839). Though a good story, it is fantastic. Women in Victorian America were fashionable, modest, religious, and sincere patrons of the ideology of domesticity and the morality of music, but they were not bizarre.[17] Nevertheless, the slang term *piano legs* did become a popular, though derisive, comment on women's legs, no doubt because of their close association with the piano.

As the parlor became the center of the home, the ornate, massive upright piano became the most conspicuous and fundamental parlor piece. Pianos were expensive, and quite naturally became symbols of a family's ability to afford both the instrument and the lessons to play it. A grand piano in the home conveyed status even more powerfully, not only because it was (for most people) formidably expensive but also because its greater size demanded ample room. As an old vaudeville joke put it, "I'd like to see something better than a grand," said Madame Parvenu to the piano salesman. "Haven't you a magnificent piano?" A Kohler & Campbell piano ad stressed, "Even when a Grand piano is silent, it is impressive and inspiring. The classic shape of its cabinet and the wing-like flight of its open lid imbue a room with drama and excitement and suggest that 'something important happens here.'" (That the grand was the preferred instrument of concert artists allowed for an additional level of cultural affiliation or pretentiousness.) Even when the price of upright pianos declined with the arrival in the late nineteenth century of mass-produced instruments of varying quality and with the acceleration of the used-piano trade, clever salesmen perpetuated the association of status and piano ownership. Furthermore, piano manufacturers and retailers pioneered credit-purchase plans and inventive sales techniques, which enabled an even greater number of Americans to cultivate and enjoy a proper home.[18]

As early as 1867 the *Atlantic Monthly* reported that "almost every couple that sets up housekeeping on a respectable scale considers a piano only less indispensable than a kitchen range." But the phenomenon was not limited to urban areas or even to the middle class. The piano was truly ubiquitous. The used-piano trade tapped an enormous market swayed by tradition and manufacturers' promotions but unable or unwilling to buy new instruments. (As many as three used pianos were sold for every new one, according to estimates by the National Piano Manufacturers Association.) Furthermore, by the 1880s new pianos began reaching rural areas through the efforts of the rapidly expanding and enterprising piano retail trade and even through mail order houses such as Sears, Roebuck and Company and Montgomery Ward & Co. As piano tuner, technician, and scholar William Braid White revealed, "Cynical salesmen used to say that farmers bought their pianos as they bought their hogs—by the pound." "'Tis wonderful," remarked Ralph Waldo Emerson, "how soon a piano gets into a log-hut on the frontier."[19]

In an age of Victorian idealism, the ideal woman replenished an ideal morality in an ideal home filled with ideal sentiment and musical nurture.

Fig. 5.3. Interior of McFaddin residence at 1316 Calder Ave., Beaumont, Texas, ca. 1900. The grand piano in this well-appointed room dramatically conveyed the ideology of music and the mythology of the piano in the proper Victorian home (this one in southeast Texas). Manufacturers and dealers promoted the association of culture and status with grand-piano ownership especially. Note the family portraits on the wall placed strategically in the pianist's view. Courtesy, McFaddin-Ward House, Beaumont, Texas.

Whether urban or rural, whether in an average house or in the White House, the family assembled together at evening time and, especially, on Sunday afternoons after church. Inevitably, such gatherings included music played on the piano. The tradition continued well into the twentieth century, despite the rise of alternative entertainments outside the home, such as movies and the automobile, and despite the intrusion of the phonograph and radio into the parlor itself. Even today the piano, though often silent, still sits in homes as a symbol of Victorian idealism and traditional family and moral values. Significantly, however, the piano in the American home, though once serving as an actual foundation of those values, now merely symbolizes a past age.

In the Victorian home, music and playing the piano allowed expression

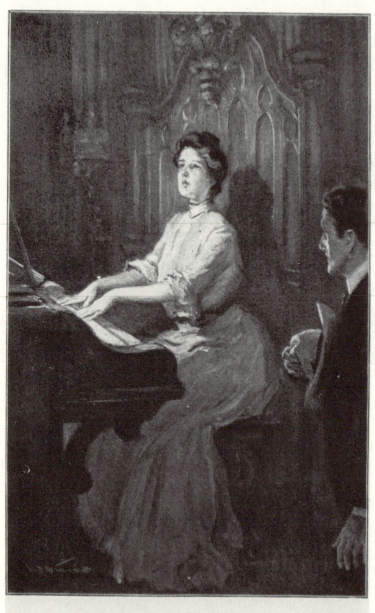

"SHE POURED FORTH SUCH MUSIC"

Fig. 5.4. "She poured forth such music." This frontispiece for Lilian Bell's 1903 novel, *A Book of Girls,* illustrates the book's story line that music allowed expression for young women that Victorian society otherwise frowned on. "Play for me! And put all your hatred and revenge into it in the most magnificent way you can," pleaded Annabel's suitor. "Then, at the end—put yourself and me into it, just as we shall always be—together!" Author's collection.

that was otherwise frowned upon. Woman's speech must remain guarded, wrote one Victorian, yet she could speak "freely in the ecstasy of the music she made [at the piano] without care or hindrance." In this way music could be a liberating experience for women. Playing the piano was also an important part of Victorian courtship. The girl who could sit at the piano and sing sentimental songs and hymns to gentlemen callers was at least popular and at best had a greater chance of a good marriage and happy home. The piano—symbol of Victorian morality and respectability—naturally lent itself to romance, serenade, and betrothal. "In many a humble home throughout our land the piano has gathered about it the most sacred and tender association," remarked President Grover Cleveland. "With its music each daughter . . . touched . . . the heart of her future husband." When Catharine Beecher (perhaps the premiere American author on the ideology of domesticity) and Alexander Fisher began singing and playing the piano together, it was recognized as the beginning of a serious courtship. Within a year the two were engaged. Piano manufacturer George P. Bent fondly acknowledged, "I courted my wife over a [Henry F.] Miller piano," and even the "father of radio," Lee De Forest, fell in love with the woman playing the piano in the apartment next to his, as "propinquity led to acquaintance."[20]

Playing the piano also had its comparatively licentious reward. Many Victorian sentimental songs were arranged as duets with relatively simple accompaniment that the lady could easily teach her gentleman with a minimum infringement on his masculinity. Such arrangements required the couple to cross hands, thus providing the opportunity for touching. A respected etiquette book reminded young ladies that piano music "vibrates on a chord of sympathy between the sexes when possibly there is no other." Wright Morris fondly recalled his girlfriend's playing "Lotus Land" by Cyril Scott, "a piece to my taste." But "even more than the music my girl liked to play," Morris continued, "I loved to see her seated at the piano, her body swaying slightly, as she was carried away by the music. At these moments I liked to fancy myself at her side, turning the pages of music, waiting for that moment when she would turn, gaze into my eyes, and I would embrace her. An embrace was a good deal more than a kiss."[21]

The piano in the American home thus played a dual role, as an aid to flirtation but also as a monument to the moral value of music and the morality inherent in the ideology of domesticity and the work ethic. Even after Victorian prudery had dissolved enough to allow couples to be alone in the parlor with the doors closed, a popular song warned the vulnerable young lady to "Keep Your Foot on the Soft Pedal." The piano might have aided

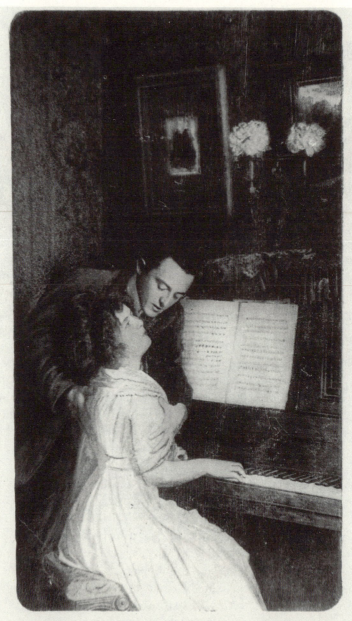

Your last note is the love note

Fig. 5.5. "Your last note is the love note." Postcard, ca. 1900. A popular theme depicted in turn-of-the-century postcards was the association of woman, the piano, and romantic courtship. This snapshot reveals an enamored crescendo. Note the fashionable fringed shawl on the piano's top board. Author's collection.

flirtation, but the moral code it symbolized was as steadfast as the piano itself. The American "piano girl" became a Victorian ideal, an intriguing blend of the work ethic, the ideology of domesticity, the moral value of music, and, of course, middle-class social life. These traditions dominated most of the nineteenth century as well as the early twentieth century. And though challenged by the automobile, phonograph, radio, movies, and countless consumer goods, the piano in the American home retained this association—largely the result of extraordinary and inventive merchandising efforts on the part of the American piano industry.

Piano manufacturers, especially leaders such as Steinway, Baldwin, Aeolian, Kimball, and Wurlitzer, pursued an artistic purpose in addition to profit. The piano was distinguished from other consumer products by its peculiar connection with the arts and notions of Victorian morality, home, and family life. Likewise, the piano industry differed from virtually any other business manufacturing products for sale. Piano makers pioneered strategies of advertising and selling that were characterized by a sense of cultural mission, strategies that imbued their products with notions of therapeutic fulfillment and Victorian morality. Specifically, such strategies impressed upon the buying public the efforts of the piano trade to extend the virtues of music to all people by making the art generally available. These efforts included building concert halls, subsidizing and promoting the recitals of artists, and manufacturing affordable pianos for the home (and encouraging sales through convenient installment plans) in order to extend those virtues into the home.

America's piano makers were proud of their industry, their art, and their product, and constantly reminded the public of these accomplishments. Their efforts both reinforced and promoted the preeminence of the piano in Victorian culture. "Mothers, increase your sons' and daughters' love of home by refining influences," stressed D. H. Baldwin & Co. "The love of music is a strong factor in welding the affections of your children to all that is good, pure and noble, and to increase their love for home attractions. As soon as the children are old enough, give them music lessons." Or as Steinway & Sons counseled, the proper piano would provide the means to rear children in the cultured tradition, to guarantee their popularity and success in the world. Only a "first rate environment" will produce a "first rate person," and the Steinway piano "assists your children through their most difficult times to a sane and beautiful life," and "subtly connect them with a glorious tradition."[22]

Most piano firms were not simply selling musical instruments. They

were promoting home, family, motherhood, culture, fine art, and the morality of music. The mythology of the piano in the American home—that is, its recurring reliance on the icons of home and family life, art, and morality that appeal to our cultural consciousness—was the result of Victorian ideals but also fashioned and shaped by the promotions and advertising of piano makers. The limitation was that music making and the piano culture were distinctly feminized and confined to those able to learn to play. To widen sales and extend the moral and cultural benefits of music, to make music making and listening universally accessible—to establish a *musical democracy*—the industry adopted and helped develop business strategies that reinforced the emerging consumer culture. It achieved mass-marketing success through the sale of the player piano, revolutionary in that this machine allowed anyone to "play" music skillfully without effort. [23]

At the turn of the century, the Aeolian Company of New York pioneered the strategy of promoting the automatic piano as easy to play. Within a decade, almost every piano manufacturer was making player instruments; by the 1920s, the industry was selling record numbers of instruments (almost 60 percent of which were player pianos) by appealing to consumers through Victorian notions of home, family life, and the benefits of music education. Thus, in selling its product, the piano trade continued to promote the traditional values that had already made the industry large and profitable, though with the crucial difference that automation made the mythology easily accessible. Often these player instruments were sold on generous installment plans or were commercial coin-operated models (the first jukebox), which were placed in countless public places, thus guaranteeing maximum exposure. The musically untrained, especially men, who traditionally had been excluded, or at least discouraged, from an active role in what was essentially part of woman's domain, now were able to participate in the musical experience and more intimately share the accompanying mythology. After all, what was "unmanly" about operating a machine?

A leader in this movement was the Gulbransen-Dickinson Company of Chicago, whose symbol was the famous "Gulbransen Baby" trademark, a toddler pictured pumping the player piano's bellows pedals beneath the caption "Easy to Play." In their ads, Gulbransen and other manufacturers of automatic instruments continued to draw upon Victorian values. The Gulbransen piano would "hold the home together" because family life "centers" around it. "Can you imagine anything that holds for you and yours such endless possibilities for downright enjoyment, entertainment and

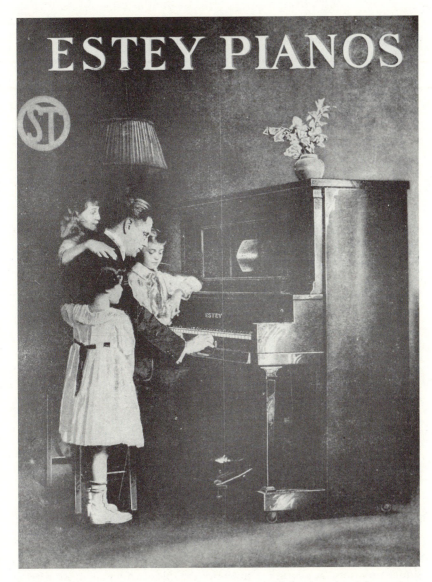

Fig. 5.6. Advertisement, Estey Pianos, ca. 1920. Ads by American player-piano manufacturers frequently focused on cherished home and family values, showing that the new device also offered universal access to the joys of music. Now *anyone* (theoretically) could "play" the piano skillfully—even men, for what could be "unmanly" about operating a machine? Author's collection.

fun?" And because the Gulbransen was "easy to play," then "all the family will quickly become expert . . . without long practice! All the joy without hard work!" Gone were the arduous days of the Klavier Schule! As the Aeolian Company touted of its famous player piano: "You bridge at one step the years that people used to spend in drilling their fingers into becoming so many delicate machines. . . . Without knowing anything about music, without being able even to strike a simple chord on the key-board, you play the piano brilliantly, beautifully, artistically, with the aid of the PIANOLA."[24]

Furthermore, according to trade literature, by having such easy access to music, society would be uplifted, the culture would be enriched, and the negative effects of industrial society assuaged. "Music has peculiar curative powers," one journal reported. "It works on the body through the mind, the soul, the delicate, responsive membranes of the mind. It effects the nerves. It will not cure all human complaints but it most assuredly will relieve a great many popular conditions, which often baffle physicians. According to the facts, every home should have a Playerpiano, just as one would have a family physician." Or as Baldwin put it, "The American home is the foundation of our nation's life—it is where character is molded, where education and refinement are influenced and where the enjoyment of life is realized in the rest hours. . . . Music is the greatest contribution to universal enjoyment. It is ever a source of wholesome pleasure. With the advent of the Manualo, *The Player Piano that is all but human,* every family can now have access to the entire world of music. If you would have your home all that it should be, tie the circle closer together with music—with a Manualo."[25]

By the 1920s such advertising had successfully stirred families to buy unprecedented numbers of new and used pianos, both player and traditional instruments. But by then the piano—as well as the American home and the traditional values—were competing with the products and value system of consumerism. Ironically, the piano industry was nearly destroyed in the 1920s by the same passive "easy play" technology that it was promoting, as radio, the phonograph, movies, and other amusements contended for consumer attention. By offering an invention capable of achieving musical proficiency without effort or investment of time, the trade undermined traditional sales methods that encouraged the amateur musician, essentially destroying the incentive to learn to play by hand. The radio and phonograph, available in "piano finished" cabinets, allowed the same accessibility at a much lower cost.

The trials of the piano industry in the 1920s reflect changes in the larger

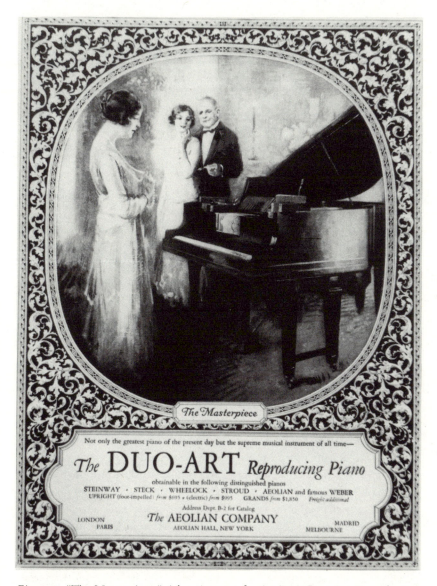

Fig. 5.7. "The Masterpiece." Advertisement for Aeolian's Duo-Art Reproducing Grand Piano, ca. 1925. The reproducing piano was the most technologically sophisticated, artistically superior, and expensive type of player piano. This ad conveys culture, status, and the modern passive musical experience. The bond between woman, the home, and the piano persists, but she now merely watches while the piano plays itself. Author's collection.

culture. The home eroded as the center of social life and cultural development in the wake of the automobile, movies, spectator sports, and an explosion of new consumer goods. Traditional values were challenged by a new system preoccupied with consumerism, a system in which powerful interests outside the home and family, such as peer groups, movies, and advertising, were defining and determining beliefs and morality. In such a changing environment, the piano inevitably lost its exalted place, though it continued to be a critical link with the traditional concept of the home. It remained a Victorian artifact, representative of an age in which the home and family, rather than business interests and consumerism, ruled society.[26]

In the 1930s the country experienced its worst economic depression, which helped contribute to the rebirth of the piano in the home. Hard times brought a revival of Victorian values and provoked a new interest in the importance of home and family life. Marriage and homemaking again were recognized as vital to social welfare, and there was greater family realization of the need for each other, an interdependence to survive severe conditions. Music, again seen as "medicine for the soul," was considered crucial to recovery. It was especially valued during the Depression, in the words of President Franklin D. Roosevelt, because music "makes us happy, better able to see values and problems in true perspective, [and gives a] saner view of life."[27] By no accident did Roosevelt's New Deal endorse and promote musical performance and appreciation. Thus, the piano—long a foundation of the Victorian home and family life—quite naturally returned to complete the modern American home.

Surviving piano manufacturers, having abandoned the nearly ruinous player piano and its passive musical experience, aided this recovery by restyling the traditional instrument to accommodate more fashionable decorating tastes (the smaller and universally popular console model piano was introduced in 1935). Having also rejected the discouraging Klavier Schule, the trade again promoted meaningful self-expression and creativity through amateur performance—but this time, significantly, for both boys and girls through modern, more enjoyable piano lessons and music programs in the public schools that stressed "music for the fun of it." The industry also launched intensive sales campaigns underscoring the piano's value for restoring traditional home life. "Let the [piano] salesman go forth secure in the knowledge that every time he makes a sale, he also makes a valuable contribution to the mental and physical well-being of an untold number of people," affirmed the National Association of Music Merchants. "Such is the power and glory of music."[28]

Primarily because of the ceaseless efforts of its industry, the piano rests secure as the basic musical instrument but also remains the emblem of the Victorian age and traditional values. This imagery is the instrument's greatest strength. If its mythology is believed, the piano magically and mysteriously exalts life and transforms a mere house into a "home." "Where else can you fight depression, invite dreams and imagination, or console broken or saddened hearts, or uplift your whole well being," the Muse might ponder rhetorically, "but in the home sitting at the piano."[29]

Notes

I want to convey special thanks to Jessica Foy, to my mother, Ruth M. Roell, and to my wife, Kay H. Roell, for their splendid assistance and spirited encouragement in bringing this chapter to conclusion.

1. I treat this theme fully in *The Piano in America*, 1890–1940 (Chapel Hill: Univ. of North Carolina Press, 1989; paperback ed., 1991). See also my "Development of Tin Pan Alley," in *America's Musical Pulse: Popular Music in Twentieth-Century Society*, ed. Kenneth J. Bindas (Westport, Conn.: Greenwood Press, 1992), 113–21 and "The Piano Industry in the USA," in *The Piano*, vol. 1 of the *Encyclopedia of Keyboard Instruments*, ed. Robert Palmieri and Margaret W. Palmieri (New York: Garland Publishing, 1993). Catharine E. Beecher and Harriet Beecher Stowe, *The American Woman's Home* (New York: J. B. Ford, 1869; rpt. Watkins Glen, N.Y.: American Life Foundation Library of Victorian Culture, 1979), 26, 296.

2. Louis C. Elson, *History of American Music* (New York: Macmillan, 1904), 279. Halévy qtd. in "Days of Glory Revived for the Piano: New Teaching Modes Repopularizing the Instrument, Once a Social Asset," *New York Times Magazine*, 31 May 1931, 16.

3. "Woman and Music: Twin Souls of Civilization," *The Etude* 47 (Nov. 1929): 793.

4. Ibid.

5. See Daniel T. Rodgers, *The Work Ethic in Industrial America*, 1850–1920 (Chicago: Univ. of Chicago Press, 1978); and Walter E. Houghton, *The Victorian Frame of Mind*, 1830–1870 (New Haven: Yale Univ. Press, 1957).

6. Ernest R. Kroeger, "Changes in Piano Teaching in Fifty Years," *The Etude* 47 (Dec. 1929): 885; Gustav Kobbé, "Musical Education in the Home: Teacher and Pupil," qtd. in *The Pianist's Guide*, vol. 3 of *The International Library of Music: Music Literature* (New York: The University Society, 1963), 346.

7. Gerald W. Johnson, "Excerpts from *A Little Night Music*," *American Home* 21 (Dec. 1938): 22, 77; Arthur L. Manchester, "The Status of Music Education in the

United States," *U.S. Bureau of Education Bulletins* 4 (1908): 78–79; Ignace J. Paderewski, "Practical Hints on Piano Study," qtd. in *The Pianist's Guide*, vol. 3 of *The International Library of Music: Music Literature*, 153; Frederick E. Drinker and Jay Henry Mowbray, *Theodore Roosevelt: His Life and Works* (Washington, D.C.: National Publishing, 1919), 455; Cable Piano Co. advertisement in *101 Best Songs* (Chicago: Cable Piano, 1915), 54.

8. "Home! Sweet Home!" Music by Henry R. Bishop, lyrics by John Howard Payne (London, 1823). See James J. Fuld, *The Book of World Famous Music: Classical, Popular and Folk*, 3d ed. (New York: Dover, 1985), 274–75. For the ideology of domesticity, see Houghton, *Victorian Frame of Mind*; Rodgers, *Work Ethic in Industrial America*; Nancy F. Cott, *The Bonds of Womanhood* (New Haven: Yale Univ. Press, 1977); Kathryn Kish Sklar, *Catharine Beecher: A Study in American Domesticity* (New Haven: Yale Univ. Press, 1973); Carl N. Degler, *At Odds: Women and the Family in America from the Revolution to the Present* (New York: Oxford Univ. Press, 1980); and Nancy Woloch, *Women and the American Experience* (New York: Knopf, 1984).

9. *The Habits of Good Society: A Handbook of Etiquette for Ladies and Gentlemen* (London: J. Hogg and Son, [1890]), 237. Published also in the United States under titles *The Ladies' and Gentlemen's Etiquette Book* (New York, 1879) and *Sensible Etiquette and Good Manners of the Best Society* (New York, 1882), both "edited by Mrs. Jane Aster [pseud.]."

10. "Why Should a Young Girl Take Up the Study of Music?" *The Musician* 14 (Feb. 1909): 72. See also Anne Bryan McCall, "Girl's Education in Music," *Woman's Home Companion*, 12 Mar. 1912, 27.

11. "Music and Her Life Pattern," *The Etude* 52 (Nov. 1934): 690.

12. *Habits of Good Society*, 232–33; Arthur Loesser, *Men, Women and Pianos: A Social History* (New York: Simon and Schuster, 1954), 65.

13. On the feminization of music, see Satis N. Coleman, *Your Child's Music* (New York: John Day, 1939), 80–81; "Is Music an Effeminate Art?" *Current Opinion* 75 (Nov. 1923): 586–87; Harold Randolph, "The Feminization of Music," *Music Teachers National Association Conference Proceedings* (1922): 194–200; Thomas Whitney Surette, *Music and Life* (Boston: Houghton Mifflin, 1979), xii, 27; Walter Damrosch, *My Musical Life*, Golden Jubilee Edition (New York: Charles Scribner's Sons, 1935), 323–32; and Herbert Witherspoon, "Music as a Vital Factor in Education," *Music Teachers National Association Conference Proceedings*, (1926): 54–65.

14. I Samuel 16: 23, qtd. from *The New Open Bible: Study Edition, New King James Version* (Nashville: Thomas Nelson, 1990), 340; Luther qtd. in Trinity Lutheran Church, Victoria, Texas, *Bulletin*, Mar. 1985, insert; Congreve and Shakespeare qtd. in *The Oxford Dictionary of Quotations*, 3d ed. (New York: Oxford Univ. Press, 1980), 160, 468; Emerson qtd. in *Open Your Life to Music*, Kohler & Campbell Piano Co. catalog (Granite Falls, N.C.: Kohler & Campbell, ca. 1970s), 35; American Association for the Advancement of Education qtd. in Lloyd Frederick Sunderman, *Historical Foundations of Music Education in the United States* (Metuchen,

N.J.: Scarecrow Press, 1971), 206–7; A. Pupin, "Formation of Character through a Proper Study of Music," *The Musician* 14 (Feb. 1909): 67.

15. On music and the piano and the U.S. government's policy toward piano manufacture in World War I, see Roell, *The Piano in America*, 19, 187–90, 327 n. 12, 328 n. 13. President Wilson qtd. in Charles Milton Tremaine, *History of National Music Week* (New York: National Bureau for the Advancement of Music, 1925), 9; Governor Whitman qtd. in *The Music Trades* 55 (8 June 1918): 38.

16. *Habits of Good Society*, 215; E. Chester, *Girls and Women*, Riverside Library for Young People, no. 8 (New York: Houghton Mifflin, 1890), 123–24, 149–50; "Woman and Music," 793.

17. Siegfried Giedion, *Mechanization Takes Command* (New York: Norton, 1948), 378, 623, 689; Gwendolyn Wright, *Moralism and the Model Home: Domestic Architecture and Cultural Conflict in Chicago, 1873–1913* (Chicago: Univ. of Chicago Press, 1980), 34; Ralph Dutton, *The Victorian Home: Architecture and Society, 1815–1915* (Boston: Little, Brown, 1979), 18–19; Woloch, *Women and the American Experience*, 116; W. Wilson, "Victorian Days that Beckon Us," *New York Times Magazine*, 30 Apr. 1933, 10–11; piano salesman qtd. in *Open Your Life To Music*, 21; Roell, *The Piano in America*, 300–301 n. 75.

18. Roell, *The Piano in America*, 22–23; Kohler & Campbell advertisement, (ca. 1920s), author's collection. See also Gerald Carson, "The Piano in the Parlor, When There Was a Parlor," *Timeline, A Publication of the Ohio Historical Society* 7 (Dec. 1990–Jan. 1991): 43–56.

19. James Parton, "The Piano in the United States," *Atlantic Monthly* 20 (July 1867): 82; Roell, *The Piano in America*, 210, 229; William Braid White, "The Decline of the American Piano Industry," *American Mercury* 28 (Feb. 1933): 211; Emerson qtd. in Annalyn Swan, "Enlightenment's Gift to the Age of Romance: How the Piano Came to Be," in *The Lives of the Piano*, ed. James R. Gaines (New York: Holt, Rinehart and Winston, 1981), 41.

20. Justus M. Forman, "The Honor of St. Cere," *Everybody's Magazine* 18 (Feb. 1908): 256; President Cleveland qtd. in Gerald Carson, "The Piano in the Parlor," *American Heritage* 17 (Dec. 1965): 55; Sklar, *Catharine Beecher*, 29; George Payne Bent, *Tales of Travel, Life and Love: An Autobiography* (Los Angeles: Times-Mirror Press, 1924), 165; De Forest qtd. in Erik Barnouw, *A History of Broadcasting in the U.S.* (New York: Oxford Univ. Press, 1966), 1: 26.

21. Ernest Lubin, *The Piano Duet* (New York: Da Capo Press, 1970), 4; *Habits of Good Society*, 215–16; Wright Morris, *A Cloak of Light: Writing My Life* (New York: Harper and Row, 1985), 12–13.

22. *Baldwin's Musical Review* 20 (1890): 2. Steinway & Sons advertisements in *Literary Digest*, 15 Nov. 1930, 41; 18 Oct. 1930, 47; and 13 Dec. 1930, 41.

23. For a more complete investigation of what I term *musical democracy* (the goal of American piano manufacturers to make music universally accessible) and the cul-

tural changes inherent in the new age of consumerism, see my *Piano in America*, 31–65, 141–60 passim; and my "Development of Tin Pan Alley," 113–20.

24. Axel G. Gulbransen developed the Gulbransen Baby from an actual incident: "A tiny baby did play the Gulbransen," said one ad. "Thousands of babies have since." Quotes are from Gulbransen-Dickinson Co. advertisements in *Saturday Evening Post*, 12 Sept. 1925, 223; 17 Nov. 1923, 95; 13 Jan. 1923, 115; and 18 Dec. 1920, 98; and from Aeolian Co. advertisements, ca. 1910, author's collection.

25. "Music Means Health," *Standard Player Monthly*, undated photographic reproduction in Harvey Roehl, *Player Piano Treasury*, 2d ed. (Vestal, N.Y.: Vestal Press, 1973), 46; "Make the Home Ties Stronger with Music," 1921 Baldwin Manualo advertising poster in possession of the author, courtesy Cincinnati Historical Society.

26. For the decline of the American piano industry in the 1920s, see Roell, *The Piano in America*, 183–232 passim; and Roell, "Is A Decline in Piano Sales Inevitable? A Historic Analysis," *The Music Trades* 138 (Feb. 1990): 104–17.

27. *New York Times*, 1 May 1932, sec. 8, p. 6; *New York Times*, 21 Apr. 1938, 17. On the return to traditional Victorian values during the Great Depression, see, for example, R. W. Wilson, "Victorian Days that Beckon Us," *New York Times Magazine*, 30 Apr. 1933, 10–11; "Slump Has Restored Family Life," *New York Times*, 24 Jan. 1932, sec. 2, p. 1; W. S. Bond, "A Message to Parents about the Piano," *The Etude* 58 (Mar. 1932): 220; "Keystone of Our Nation—Homemade Music," *The Etude* 58 (Feb. 1940): 77, 139; Warren I. Susman, "The Culture of the Thirties," in his *Culture as History* (New York: Pantheon, 1984), 150–83; and Robert McElvaine, *The Great Depression: America, 1929–1941* (New York: Times Books, 1984), 217–18, 220–21, 339.

28. "Reasons Why People Buy Pianos," in *Merchandising Music: Sales Training Manual for Music Salesmen*, ed. William A. Mills (New York: National Association of Music Merchants, in cooperation with Business Education Service of the U.S. Office of Education, 1946), 96–99.

29. My appreciation to Mrs. Ruth M. Roell for this quotation. The security of the American piano trade has been greatly challenged in the 1980s and 1990s by imported pianos and the immense popularity of electronic keyboards and digital pianos, which threaten to replace the acoustic piano as the basic musical instrument. Time will tell.

CHAPTER SIX

Reading Together:
Children, Adults, and Literature
at the Turn of the Century

Anne Scott MacLeod

Turn-of-the-century society is associated in the American mind with high decorum, large families, and lots of reading. The decorum may be exaggerated—it is always easy to believe that people behaved better in the past than they do now—and the large family is something of a myth; in fact, family size declined in the course of the nineteenth century. But there is plenty of evidence to support the belief about reading. Americans of the late nineteenth and early twentieth centuries did read prodigiously, as children, as adults, and as families; quite often, they read the same books. Families read together much as families today might watch television together, and for the same reason: reading was then, as television is today, by far the most available form of entertainment for most Americans. "Long evenings my mother read aloud," wrote Harvey Fergusson in his memoirs. "Before I could read myself I went down the great river with Huck Finn and fought Indians with Leatherstocking. . . . I walked in lace with Little Lord Fauntleroy."[1] Mary Ellen Chase recalled that her mother "somehow found time for reading to us, although how she did it remains a mystery. She liked to choose books which all of us from sixteen to six could enjoy . . . Lambs' *Tales from Shakespeare* . . . *The Swiss Family Robinson* . . . the poems of Whittier. When she read for an hour in the evening, my father always listened with us, the book mattering little to him."[2]

Mary Ellen Chase grew up in Maine in the 1890s. Hers was not an affluent family nor a leisurely household, but it was fervently literate. Her fa-

ther, Chase said, was "never without a book. My father's love for books and study [was] the consuming passion of his life." Her mother was just as intellectually inclined, managing to combine the care of a large family with supervision of their school work, with special affection for Latin studies. To the evening homework session, she brought "her enormous mending basket, heaped with underwear and stockings . . . and her own Caesar, Cicero and Virgil." When the Latin learners struggled to translate *The Gallic Wars*, "she was unsparing in her criticism of our clumsy construings, our laborious English renderings. . . . 'Orgetorix,' said my mother, holding a pair of worn red flannel drawers to the light, 'would turn over in his grave could he hear your translation!' " Chase's study of Greek was supervised by her father. "In the matter of accents and breathings, he gave no quarter, being as ruthless as one of the Homeric gods. . . . Once I had reached the . . . more thrilling labours of translation, we held together for two years high and delighted converse with the mighty dead."[3]

Chase saw nothing unusual about such home evenings in an American rural community: "Hundreds of other Maine families in the nineties . . . believed and behaved in precisely the same manner." As example she cited the case of one Sarah Alden Ripley, found by a caller at home "rocking the baby's cradle . . . shelling peas . . . teaching Calculus to one Harvard student [and] correcting a translation of Sophocles made by another Harvard student." America, Chase observed, "once saw no dissimilarity between a milking-stool and a love of Shakespeare, between a plough and the thoughts above Tintern Abbey, between the Gallic Wars and a pair of red flannel drawers."[4]

Whether that was so or not outside of the state of Maine, it was certainly true that American children of every region and of all sorts of backgrounds read with passion. "My reading," reminisced one child of the nineties, "was not just a pastime or a pleasure. It was the world in which I lived, and everything else around me turned into shadow." H. L. Mencken at about the age of eleven "began to inhabit a world that was two-thirds letterpress and only one-third trees, fields, streets and people." "We did not merely read . . . books, we lived them," wrote Una Drage in her autobiography.[5]

What they read was a great grab bag of material, good, bad and mediocre, adult and juvenile, books and magazines. Children of the time read, as reading children always do, whatever they could put their hands on, mixing levels and qualities entirely without prejudice. Edna Ferber, for example: "Our reading was undirected, haphazard. . . . By the time I was nine I had read all of Dickens, but I also adored the Five Little Pepper books, the St.

Nicholas magazine, all of Louisa May Alcott, and the bound copies of *Harper's Bazaar*, *Hans Brinker and the Silver Skates*, the novels of The Duchess [a popular romance writer of the day]. . . . Good and bad, adult or infantile, I read all the books in the house, all the books in the store stock, all the books in the very inadequate public library." Another avid reader found her way into the public library stacks. "I went through the juveniles in a few weeks and started on the adult books. I began neatly with A. . . . I read all of Thomas Bailey Aldrich, and through a lot of A's to the B's and started with Cousin Bette . . . the head librarian called on Mama to see what should be done."[6]

The list of authors grows familiar: Shakespeare, Thackeray, George Eliot, Alcott, Dickens, the Brontës, Hawthorne, Cooper, and Robert Louis Stevenson. So does the eclectic approach: "I do not remember," wrote Mary Ellen Chase, "that I was conscious of any difference in treatment between *Bleak House* and *Little Women*, between George Eliot and Sophie May, that I regarded one as duller than the other [or] more difficult to 'get into'. They were all stories. If they took me into a different world . . . I gloried in the . . . transference; if they related experiences I had had, I felt a . . . sense of companionship and sympathy."[7]

Open minded as they were, they had preferences. Fergusson may have walked with Little Lord Fauntleroy, but he considered the little Lord's life "boring." On her own, Una Hunt read Andersen (whose tales made her cry), *Pilgrim's Progress*, *Water Babies*, Hawthorne's *Wonder Book*, and *The Last of the Mohicans*. When she was about seven, her mother read *Robinson Crusoe* and *Swiss Family Robinson* to her, but Una was "a good deal bored by them." Ferber accepted much uncritically, but not Elsie Dinsmore: "I loathed the Elsie Dinsmore books and found the lachrymose Elsie a bloody bore." Heavy sentiment and transparent moralizing didn't sit well. Sunday school books, the irritatingly didactic Thomas Day, and awful Elsie were all scorned; one boy dismissed Andersen's stories as sentimental, preferring the stronger flavor of the Grimm tales. On the other hand, even books well loved in childhood were not necessarily approved in retrospect. Woodward loved Dickens, Thackeray, Scott, and Louisa May Alcott (she, too, had "no patience with Elsie Dinsmore"), but as an adult, she deplored Alcott's considerable influence on her. "The sweet and gentle benignity of her books did me a good deal of harm. They gave me preposterous ideas about kindness, and worse ones about the value of gentility."[8]

It isn't difficult to know why children read adult books. They read them because they were there to be read, because they told stories, because they

opened windows on a world of fact and fantasy that transcended daily life—all the reasons people read in any time. That so many adults read children's books, not just to children, but for their own pleasure, is more surprising. To understand the widespread adult interest in children's literature one must look at the cultural mood of the late nineteenth century, when that interest was one part of a more general view of child and adult life.

The era was the high point in the American romanticization of childhood. Conventional opinion idealized childhood as a free, golden period, when children were close to God and nature, when "the real business of life [was] play."[9] At the popular level, the romantic outlook was sentimental, dwelling on children's beauty and innocence. At the aesthetic level, romanticism went farther, surrounding childhood with an aura of myth, seeing in children the elemental qualities of nature, unspoiled.

The view of adult life was darker. The twilight of Victorianism found many Americans weary of unbridled materialism and political corruption. The affluent classes feared that their cushioned lives insulated them from "real" experience, and that the strictures of Victorian mores flattened emotional life. They hated industrial ugliness even more; in spite of exuberant economic success, late nineteenth-century America was beset by social strains: poverty, slums, exploited labor, destitute children, urban crime, and growing class conflict. By the nineties, consciousness of all these ills was high. Reaction and reform efforts marked American society to the eve of World War I.

Reaction included a cultural outlook widely shared in the middle and upper classes that has been characterized by one historian as "antimodernism," by others as anti-Victorianism.[10] Either term suggests the rising criticism of American society, a criticism that had much to do with shaping cultural tastes in the late nineteenth century. Edith Wharton's autobiography speaks of the "impoverished emotional atmosphere" of old New York. "The average well-to-do New Yorker of my childhood," she wrote, "was . . . starved for a sight of the high gods. Beauty, passion and danger were automatically excluded from . . . life."[11] In search of "beauty, passion and danger," American literary taste turned from the present to the distant past, from complexity to simplicity. Adult readers deserted domestic realism for myth, folktale, and historical romance, where they hoped to find "the childhood of the race." They admired heroic action, moral grandeur, and emotional openness. Blackmore's *Lorna Doone* was an example, recommended for what one critic called its "manly hero . . . of brawn and heart equally well tempered."[12] Medievalism had a great vogue as late Vic-

torians, looking for the virtues they believed lost in their own time, constructed a highly idealized (and highly inaccurate) idea of medieval society as simple and direct, childlike in its robust emotions and love of action. Medieval myth and legend, reshaped to nineteenth-century sensibilities, came in floods: *The Song of Roland, Robin Hood, King Arthur, Tristan and Isolde*; epic poetry in *Idylls of the King*, as opera in Wagner's *Ring Cycle*, as children's fare in Howard Pyle's buoyant versions of Malory and the Robin Hood legends, and Sidney Lanier's *Boys' King Arthur*, dense with Victorian renderings of medieval English. "Damsel, as for to tell thee my name, I take no great force: truly, my name is Sir Lancelot du Lake."[13] A good many critics suggested that such literature had a therapeutic effect. G. Stanley Hall, the psychologist often credited with "inventing" adolescence, believed that medieval legends and folk literature would elevate the adolescent imagination. To those who thought modern life tepid, Sir Walter Scott's romanticized versions of clan warfare seemed the ideal literary model. *Century Magazine* published in 1899 a verse calling for a return to Scott's vigor:

> Rhymers and writers of our day,
> Too much of melancholy! Give us the old heroic lay;
> A whiff of wholesome folly;
> The escapade, the dance;
> A touch of wild romance.
> Wake from this self-conscious fit;
> Give us again Sir Walter's wit;
> His love of earth, of sky, of life;
> His ringing page with humor rife;
> His never-weary pen;
> His love of men![14]

Families could read together because different generations enjoyed the same literature; they shared an aesthetic. For a decade or so either side of the turn of the century, there was a community of literary tastes among adults and children greater than ever before or since. Adults and children alike took pleasure in strong narratives, romantic characters, high adventure, and an idealized picture of the world, both contemporary and historical. Many of the best-known authors of the time wrote for both adults and children. The *St. Nicholas Magazine*, a spectacularly successful periodical for children, asked for and got contributions from the most respected writers of the period: Kipling, Twain, Burnett, and Cable, to name but a few.

The physical format of mainstream children's literature reflected the importance given to both children and books in middle- and upper-middle-class American life during the late nineteenth century. *St. Nicholas* was a handsome magazine, and a showcase for some of the best-known illustrators of the time, including Winslow Homer and Howard Pyle. Pyle was a major force in the illustrative art from the 1870s to his death in 1910. He established a renowned school of art in his home in Chadds Ford, Pennsylvania. A number of his most famous pupils, a group that included N. C. Wyeth, Jessie Wilcox Smith, and Maxfield Parrish, devoted much of their careers to book illustrations. Books published by the preeminent publishers of the time were lavishly illustrated by these American artists as well as by European illustrators whose names—Rackham, DuLac, and Bilibin, for example—are still honored. The legends, myths and historical romances so popular in the period offered wide scope for the kind of dramatic, highly representational art these artists produced. Pyle's famous illustrations for Robin Hood and the King Arthur tales, and Wyeth's powerful paintings for stories such as *Kidnapped*, *The Scottish Chiefs*, *Treasure Island*, and *The Black Arrow*, have never been surpassed.

A romantic view of childhood made adults susceptible to books about children as well. Adults willingly read novels with children as main characters if the children were lovable and the story sentimentally moving. *Rebecca of Sunnybrook Farm*, *Little Lord Fauntleroy*, and *Captain January* were as familiar to adults as to children. It was surely adult taste that raised *Little Lord Fauntleroy* to the status of a classic; the Burnett book passed from child to child, now as then, is not Fauntleroy, but *The Secret Garden*. No doubt children—some children, anyway—enjoyed *Peter Pan*, but it was adults who flocked to the theaters to see the play (with children, of course, but also without them), and it was adults who thought it said something true about childhood. When the play was first produced in London, in 1904, the *Daily Telegraph* proclaimed it "so true, so natural, so touching that it brought the audience to the writer's feet." The response, like much of the literature, was entirely transatlantic. When the play reached America, there was an equal outburst of enthusiasm. The American magazine *Outlook* called *Peter Pan* "a breath of fresh air . . . by the writer who . . . has most truly kept the heart and mind of a child."[15]

The *Outlook*'s words go to the core of late nineteenth-century feeling about childhood. In a better world, the crystalline qualities of childhood would not disappear with maturity; adults would be as spontaneous and as innocently joyful as children. It's not easy to imagine Robin Hood in

nineteenth-century dress, but he represented the ideal: a boyish heart and mind in manly form. The romantic view held, not only that the best adults retained much of the child in them, but that the truest literary taste was interchangeable with a child's; the best books for children were also good for adults. "Older people," wrote Kate Douglas Wiggin,

> can always read with pleasure the best children's books. . . . It would not bore you . . . to be shut up for a day or two with nothing but *Robinson Crusoe*, *Aesop's Fables*, *Arabian Nights*, Kingley's *Water Babies*, *Alice in Wonderland*, Hawthorne's *Wonder Book* and *Tanglewood Tales*, Andersen's and Grimm's Fairy Tales, *Two Years Before the Mast* . . . the simpler poems of Scott, Lowell, Whittier, or Longfellow, and sheaf of songs from the Elizabethan poets. If, indeed, you would be dreadfully bored, it is conceivable that you are a bit pedantic, stiff, and academic in your tastes, or a bit given to literary game of very high and "gamy" flavor, so that French "made dishes" have spoiled you for Anglo-Saxon roast beef. [16]

Like her list of titles, Wiggin's sentiments in this passage are characteristic of her time and class, including the preference for hearty, Anglo-Saxon influences and the slight scorn for those too effete to share the tastes of childhood.

Wiggin was speaking, of course, of mainstream, genteel, on-the-recommended-lists and in-the-library literature. The version of the *Arabian Nights* she had in mind was certainly not Sir Richard Burton's, but Andrew Lang's or her own; in any case, collections from which were removed those parts suitable only, as Lang said, "for "Arabs and very old gentlemen.""

Outside the mainstream, there was another kind of reading, not as "gamy" as the unexpurgated *Arabian Nights*, though surely not acceptable in family circles either; but a form of literature widely indulged by the young all the same. The latter half of the nineteenth century produced an immense amount of popular "trash" literature in the form of series books, rags-to-riches tales, sensational "boys' papers," westerns, dime and crime novels. Some of this was ignored in its early days, some was even accepted. (Horatio Alger's books were still being used as Sunday-school prizes in 1876.) The early trash, from about 1860 to 1880, preposterous and badly written as it was, had a kind of innocence. It was wildly melodramatic, and its style affronted the sensitive reader, but it was staunchly moral. All fights were over matters of high principle, and it was fisticuffs, not guns, that upheld the right. Nearer the end of the century, however, the morality

evaporated, leaving only an ever-increasing sensationalism. Daniel Boone and Kit Carson were replaced as heroes by hard-drinking desperadoes called Deadshot Dave or the Black Avenger, characters likelier to shoot the Sheriff and rob a train than defend the law.[17]

Tolerance soon gave way to a reformist commitment to protect children from the pernicious influence of such stuff. Within the highly successful public library movement, the also successful drive to establish specialized services for children was equally a crusade to direct children's reading to "the best." The "best" excluded low-brow trash, of course; it also ruled out undistinguished "juveniles" of all kinds. Children's literature experts insisted that early reading habits influenced a child's entire future as a reader. "If you find a twelve-year-old boy addicted to juveniles," said Kate Douglas Wiggin in 1901, "you may as well give the poor little creature up. . . . His ears will be deaf to the music of St. Paul's Epistles and the Book of Job; he will never know the Faerie Queene or the Red Cross Knight, Don Quixote, Hector or Ajax; Dante and Goethe will be sealed oracles to him until the end of time. . . . He drank too long and too deeply of nursery pap, and his literary appetite and digestion are both weakened beyond cure." Two years later, an *Atlantic Monthly* reviewer deplored the abundance of mediocre children's books: "One of the dangerous things about giving children unguided indulgence in child-books is that they are prepared to relish . . . such inferior stuff. . . . All stories are grist to the mill of infancy but it is true, nevertheless, that very few of them are worth grinding." "A child's reading," said yet another commentator, "should be chosen with the sole view of developing breadth and strength and health of character . . . it should be like a magical broom . . . sweeping away the cobwebs of moodiness and broodiness and listlessness from heart and soul. . . . Dreamy-eyed children MUST be given literature . . . that will teach the blessedness of action. . . . Dreamy children, left to themselves . . . are almost certain to become morbid men and women."[18]

These writers (and many others) urged that children's reading be guided by knowledgeable adults, and in the twentieth century, that guidance was increasingly available. A whole industry grew up around children's books, professionalized by trained children's librarians, children's book editors, and children's book reviewing services. Children's book experts were idealistic, in keeping with the spirit of the public library movement. They hoped to educate the masses, uplift the lowly, and guide the immigrant child into the mainstream, while also seeing to it that middle-class children never fell prey to the low sensationalism of trash literature or the mediocrity

of most series books. The tide of dime novels had ebbed by 1890, but series books flourished, to the growing distress of librarians, who deplored "juvenile series of the . . . ranting, canting, hypocritical sort."[19] They fought to cast out Horatio Alger; Martha Finley, guilty of *Elsie Dinsmore* and its terrible sequels; Frank Baum, producer of endless Oz books; and the octopus empire of Edward Stratemeyer, pouring forth the Rover Boys, Bobbsey Twins, Tom Swifts, and who could name what else. In many public library systems they succeeded, for many decades.

Children's book people were a strong-minded lot who were certain that they knew what was good in books and good for children. What they looked for in children's books can be gleaned from the language of book reviews, critical commentary, and recommended book lists. The most basic tenet of their philosophy was the single standard to be applied to all literature, whether child's or adult. "There is . . . no separate standard of taste by which to determine the value of books written for children. To be of permanent use, they must possess literary quality, that is, they must be whole-souled, broad, mature in temper, however simple they may need to be in theme or manner."[20]

The whole profession subscribed to statements like that; everyone agreed that literary quality admitted books to libraries while lack of it kept them out. The precisions of literary quality were less obvious: "whole-souled" and "mature in temper" were abstract, to say the least.[21] Reviews were slightly more clarifying, though not about the nature of literary quality. What reviewers revealed best were their tastes in moral tone, social values and child character. Even as they criticized low literary quality, their remarks often suggest that they really meant something else. In 1907 the superintendent of school libraries in New York spoke of popular boys' books unwelcome in libraries, in spite of their "lively style": "The books are not immoral, but they are poorly written, their heroes are too often of the 'cheap and smart' variety, and their ideals are not always the best." There was, he went on to say, plenty of other material "just as interesting and of a much higher tone [to] replace this cheap literature."[22]

Reviewers liked "healthy, true and sensible stories"—Alcott's, for example, or Jean Webster's, whose *Patty* stories were "the kind of book[s] to give our girls—clean, wholesome, and refreshing." They looked for something similar in child character. Henry James admired Stevenson's Jim Hawkins, who had "a delightful, rosy good-boyishness, and a conscious, modest liability to error." Henry James was hardly the standard critic of children's writers, but in this case, his attitude was not unusual. Reviewers warmed to

cheerful, unsophisticated fictional children without secrets or resentment; children like Fauntleroy and Wiggin's Rebecca and Laura Richards's well-bred Hildegard, whose ideals were certainly "the best." They accepted stories about "lovable, mischievous, wholesome" fun as long as it was understood that whatever "harmless mischief" there was would "always end in the proper manner."[23]

Specialists shaped children's literary experiences (as, of course they meant to) because they chose books for libraries and schools, but children's preferences also influenced the ever-expanding body of literature written for them. Grammar school children consulted in 1907 were definite about what they liked in books: action, illustration and conversation, they said, but not long description or digression. "I like it very much because there is so much asking and telling in it," explained one child. "I do not like it very much because it has no conversation in it," said another. A little girl blessed *The Rose and the Ring* because "the book is thick, but the writing is large, and you can finish it in a short while."[24] Publishers of children's books heard and responded to the views of both the experts and the child readers. The specialists got the wholesomeness they wanted; the children got large print, illustration, and "lots of conversation."

By 1910 children's and adult literature had begun to diverge again; the era of shared reading was coming to an end. One reason was the professionalization of children's literature, which had a gradual but profound effect on children's reading. As specialists trained their attention on books for children, they redefined the literature in accord with the requirements of its readers as they saw them. Reading, like teaching, became more and more specifically geared to age and grade. Adult books were not dropped because they were deemed morally unsuitable for children—at least not those by Dickens, Scott, Cooper or Defoe—but because they were too long or too complex for this or that child reader. Starting about the turn of the century, lists of recommended books, whether compiled by librarians or by publishers, showed a rising proportion of titles written for children, and a slow but steady decline of adult titles. *Robinson Crusoe* and *Pilgrim's Progress*, if included at all, were often in abridged editions. Dickens and Scott persisted, though ever more selectively, but Thackeray, George Eliot and the Brontës little by little disappeared. A 1910 purchase list of 550 children's books for public libraries included few adult titles, and those few were retellings of such classics as *Don Quixote* and Irving's *Rip Van Winkle*.[25] Professionals, after all, were enthusiastically engaged not only in selecting books for children but also in encouraging their publication, and in choosing, edi-

ting, and reviewing literature written especially for the young. With so many good children's books available, books that were wholesome, easy to read and fun, specialists steered children to children's books, sure that they would be enjoyed and certain that that enjoyment would encourage a lifetime of worthwhile reading.

At the same time, another wedge was being driven between children's and adults' reading in the twentieth century. Adult tastes had begun to shift from romanticism toward realism. The change was complex and gradual, of course, as cultural change is. Realistic fiction was not a twentieth-century invention; it had been written and read since at least the 1870s. Mark Twain, Stephen Crane, Henry James, and William Dean Howells all rank as realistic writers. But genteel and popular audiences alike before 1910 resisted strongly realistic literature, and especially the sexual frankness and "sordidness" of naturalistic fiction. Dreiser's *Sister Carrie* and Kate Chopin's *The Awakening*, both published in 1900 and both shockingly frank by nineteenth-century standards, were rejected by most of the reading public. As the literary argument between romanticism and realism continued into the twentieth century, however, it became increasingly apparent that mainstream adult literature was moving in the direction of realism. After 1910, the decision was clear.

Children's literature did not follow. The books flowing into the children's market were still romantic historical novels, wholesome (and idealized) girls' stories and equally wholesome adventure stories for boys; new, beautifully illustrated editions of myths and legends, folk and fairy tales. This is not to say that the field was in the doldrums; far from it, in fact. Supported by a prosperous economy, the expansion of the children's book business continued at a brisk pace. Publishing houses created special departments for children's books, run by editors trained in children's literature. Specialists reviewed new books as they came out; *The Horn Book*, devoted entirely to children's books, began publication in 1924. The 1920s also saw a burst of creativity applied to book-making for children. New illustrators worked out fresh concepts for picture books; visually, children's books reflected the best of the age.

Nevertheless, children's literature became an enclave. All the creative activity, all the knowledgeable producing and reviewing and purveying of children's books took place a little apart from the larger world of literature. By about 1920, children's literature was a garden, lovingly tended by those who cared about it, but isolated as well as protected by the cultural walls that surrounded it. The common aesthetic of the late nineteenth century

was gone; adults and children read different authors, different books. Adults read Sinclair Lewis, Ernest Hemingway, and F. Scott Fitzgerald; children read Alcott, Kipling, Burnett, and Andersen. Less and less frequently were children's books read or reviewed by adults not professionally involved in some way with children's literature.

The separation was never absolute, of course. Adults still read to their children, guided sometimes by the experts, sometimes by their memories of their own childhood reading. And children still borrowed from adult fare if it suited them; indeed, they eventually made of Jack London, that avatar of social realism, a writer now firmly associated with the young. Autobiography still records the eclectic tastes of childhood, mixing Emily Dickinson and Campfire Girls, Tom Swift and Ben-Hur. But the days of reading in the family circle were, for all practical purposes, over. The old mutual enjoyment of *Oliver Twist* and *King Arthur* belonged to the past; reading had divided along generational lines. It was to be a long time before adults found reason again to look over the wall into the secret garden of children's literature.

Notes

1. Harvey Fergusson, *Home in the West* (New York: Duell, Sloan & Pearce, 1944), 93.

2. Mary Ellen Chase, *A Goodly Heritage* (New York: Henry Holt, 1932), 72.

3. Chase, *A Goodly Heritage*, 225, 226.

4. Chase, *A Goodly Heritage*, 228, 229, 230.

5. Helen Rosen Woodward, *Three Flights Up* (New York: Dodd, Mead, 1935), 253. H. L. Mencken, *Happy Days* (New York: Knopf, 1940), 175. Una Hunt Drage, *Young in the Nineties* (New York: Charles Scribner's Sons, 1927), 123.

6. Edna Ferber, *A Peculiar Treasure* (New York: Doubleday, Doran, 1939), 52. Woodward, *Three Flights Up*, 255.

7. Chase, *A Goodly Heritage*, 46, 37.

8. Una Hunt, *Una May* (New York: Charles Scribner's Sons, 1914), 119, 76. Ferber, *A Peculiar Treasure*, 52. Woodward, *Three Flights Up*, 25.

9. Edward Martin, *The Luxury of Children and Some Other Luxuries* (New York: Harper & Bros., 1904), 2.

10. See T. J. Jackson Lears, *No Place of Grace: Antimodernism and the Transformation of American Culture, 1880–1920* (New York: Pantheon, 1981). Stanley Coben, "The Assault on Victorianism in the 20th Century" in *Victorian America*, ed. D. W. Howe (Philadelphia: Univ. of Pennsylvania Press, 1976), 160–81.

11. Edith Wharton, "A Little Girl's New York," *Harper's Magazine*, Mar. 1938;

rpt. in *American Childhoods*, ed. D. McCullough (Boston: Little, Brown, 1987), 169.

12. M. L. Sandrock, "Another Word on Children's Reading" in *Catholic World* 51, no. 305 (Aug. 1890): 678.

13. Sidney Lanier, *The Boys' King Arthur* (New York: Charles Scribner's Sons, 1917), 35.

14. Sir Walter Scott, qtd. in T. J. Jackson Lears, *No Place of Grace* (New York: Pantheon Books, 1981), 105.

15. Qtd. in Janet Dunbar, *J. M. Barrie: The Man Behind the Image* (Boston: Houghton Mifflin, 1970), 177.

16. Kate Douglas Wiggin et al., "The Best Books for Children" in *Outlook* 69 (7 Dec. 1901): 873.

17. Russel Nye, *New Voices in American Studies* (West Lafayette, Ind.: Purdue Univ. Press, 1966), 68, 60.

18. Wiggin et al., "The Best Books for Children," 872. H. W. Boynton, "Books New and Old," in *Atlantic Monthly* 91 (1903): 699. Sandrock, "Another Word on Children's Reading," 676.

19. Sandrock, "Another Word on Children's Reading," 676.

20. Boynton, "Books New and Old," 699.

21. And so they remain: witness today's battles over literary canons.

22. Claude G. Leland et al., *The Library and the School* (New York: Harper & Bros., 1909), 14.

23. M. L. Sandrock, "Another Word on Children's Reading," *Catholic World* 51, no. 305 (Aug. 1890): 680; *Book Review Digest*, 7th Annual Cumulation, 1911, reviews of Jean Webster, *Just Patty*, 493; Henry James, "Robert Louis Stevenson," *Century Magazine* 35, no. 6 (Apr. 1888): 877; "Reviews of New Books: Fifty of the Season's Best Books for Children," *Literary Digest* 43, no. 23 (2 Dec. 1911): 1046.

24. Leland, *The Library and the School*, 7, 8.

25. Harriet H. Stanley, comp., 550 *Children's Books* (Chicago: ALA Publishing Board, 1910).

CHAPTER SEVEN

Cozy, Charming, and Artistic: Stitching Together the American Home

Beverly Gordon

Of all the home arts, needlework may be one of the least well understood. It is often considered an expressive form that exists in its own separate world, removed from the developments of other arts and other spheres of influence. It is frequently thought of as trivial, so much so that when I explain that much of my professional work has focused on domestic needlework or "fancywork," I am usually met with an attitude of disbelief. Many of my listeners dismiss the subject as unimportant, even distasteful. They hold in their minds the image of a woman—usually an old lady—who keeps herself busy by turning out a stream of "fussy," useless objects that will later collect dust and add clutter to an already overfilled environment. The woman's activity is seen as a waste of time and human energy, and is associated with nonproductivity.

The prevalence of this stereotype and the emotional charge it engenders bear examination. Where do these images come from and what truth is embedded in them? Why are there such strong negative feelings about this subject? What was the reality of the needleworker, and what was she expressing in her work?

I address some of these questions in this chapter, and hope to indicate how, assumptions and stereotypes notwithstanding, needlework is a responsive medium that reflects and manifests the concerns of the broader world. Because some of the stereotypes seem to have developed in the period under consideration in this volume, I welcome the opportunity to examine both the evolution and the ideology of American needlework between 1890 and 1930. I consider these developments in light of social and cultural atti-

tudes and art and design movements. I also use needlework as a barometer of women's lives, and turn to the needlework literature and the artifacts themselves as primary sources of information about the changing position of women in the home.

In the mid-nineteenth century, when the production of small handwork objects became a widespread, sometimes almost manic phenomenon, it was imbued with strong ideological, and even moral, significance. As many scholars have shown, the Victorians posited and truly believed in two separate spheres: a public sphere of business, commerce, and the marketplace, an "outside" world dominated by men; and a private or domestic sphere, an "inside" retreat, represented by home and the family and dominated by women. To an extent we may find difficult to understand today, the woman's sphere was valued or respected, and women did have an important role. They served as the guardians of positive moral values, and as counter-forces to the dubious forces of the outside.[1] Everything that a woman did could affect the well-being of her family.

Needlework was seen as a proper womanly activity, one that was suitable for the home environment and beneficial to its residents. It was considered a laudable outlet, a "light" and "decorative" pastime that did not impinge upon the supposedly more "serious" art associated with the outside world. Nevertheless, it had significance. The environment, including its physical furnishings and the activities within it, *mattered*; if it was tasteful, positive, and educational, it would help create educated, moral, and tasteful individuals who would in turn positively affect the character of the overall society. As Harvey Green explained in his 1983 book, *The Light of the Home: An Intimate View of the Lives of Women in Victorian America,*

> The home was a miniature universe of culture and education . . . Here the arts and sciences of the museum, concert hall and schoolroom were translated into the . . . curios adorning the parlor, the [objects] on the walls, the piano or organ in the parlor, and the books in the library. Women were the organizing force and marshalls of this domain . . . They were charged with transforming the rude brick, stone and wood . . . into places which would both communicate a family's status and provide it with repose and moral uplift.[2]

In the Victorian context, therefore, making objects for the home was an ennobling activity, and the objects had meaning. Goods, or material things, were not clutter, but manifestations of abundance and evolution to a higher social state. Women who made things by hand, moreover, were in-

vesting themselves in the goods, making them doubly meaningful and valuable. The women were not just "filling" or wasting their time, but were "enshrining" the environment with their handwork.[3]

There were significant changes in Victorian society over the course of the nineteenth century, and the separation of the spheres was much less distinct by the 1890s, but much of the ideology relating to women in the home remained intact. Women who sewed objects for their homes were, in a very real sense, still stitching together those environments, making their houses into homes and infusing them with their own energy, good taste, and positive influence.

Handwork of the late nineteenth century was in many ways freer and more lighthearted than that of the earlier Victorian period. The new style was known as *art needlework* or *artistic embroidery*. It was usually worked in silk in free, rather than counted-thread, stitches, and if done well, looked rather painterly. The fabrics were soft, rich, exotic, and fanciful, and the style was self-consciously identified and aligned with the Aesthetic Movement and so-called Aesthetic sensibilities. The shift to this new style is associated with the 1876 Centennial Exhibition in Philadelphia, where huge numbers of Americans were exposed to new ideas and images. Two displays had a particularly strong impact. One, seen in the Women's Building, was an exhibition of work from London's Royal School of Art Needlework. This institution was led by designers who identified with John Ruskin's theories of the value of art in everyday life and espoused artistic training and hand production. The Royal School subsequently inspired the creation of similar societies in the United States, the most notable of which was the Society of Decorative Art, based in New York City.[4]

The other influence from the Centennial, which was even more dramatic in its popular impact, emanated from the Japanese Pavilion. Americans became caught up in a fascination with everything Japanese and energetically embraced elements of the Japanese aesthetic.[5] These included a new use of asymmetry and irregularity, a layering of pattern, and a generally lighter handling of images. New motifs, including branching foliage, whooping cranes, reeds and cattails, wisteria, and fan shapes, were incorporated into decorative arts of all kinds. Irregular linear patterning, perhaps inspired by the Japanese "cracked-ice" design, was so prevalent that it functioned as a kind of symbolic shorthand, standing for the "artistic." Irregular patterning was most notably seen on the new and highly popular crazy quilt, where odd geometric shapes were joined together and augmented by contrasting

freeform stitches. The spider-web image that was often worked on the quilts echoed the cracking patterns and fan shapes even further.[6]

Crazy quilts were not always fashioned as bedcovers, but also as "throws" that could be casually draped on a sofa or chair in an artistic parlor. They were typically made with the richest of materials, especially silks and velvets, which were intensely colored and luxurious. Silk was associated with Japan and the Orient, but it was by this time easily available in the United States. The American silk industry was at its peak, and even those on moderate middle-class budgets were able to purchase and use silk fabrics.[7] The same rich maroons and blacks that were popular for the dresses of the day were common on quilts and other textiles made for the home.

The interest in the Orient was not limited to Japan, and, in fact, Chinese and Japanese design elements were mixed indiscriminately.[8] Images were taken completely out of context, and the imagined Orient was appropriated as a kind of fantasy land, where everything was pretty, artistic, and charming. This period was also the time when the parlor "cozy corner" was popular. Draped with rich fabrics and filled with texture and fringe, the corner was often thought of as "Turkish," alluding to a different kind of mysterious east.[9]

This kind of exoticism, and in general a romanticized view of the far away and long ago, pervaded much of the aesthetic at the turn of the century. Women delighted in not only dressing up their homes but also dressing up themselves. They frequently staged *tableaux vivants* and other entertainments in which they appeared in romantic costumes that evoked other times and places,[10] and costuming was even worked into the ubiquitous bazaar, or fundraising fair, in which needlework objects were sold to raise money for causes of all kinds. The desired effect for a turn-of-the-century fair was the creation of a dreamy fairyland, with sweet and fanciful settings, characters, and images. Women often appeared in costumes that "matched" their booths and echoed themes of the objects sold within them.[11] Needlework with Japanese-inspired motifs might be arranged on a booth covered with fans or a huge Japanese-style paper umbrella, for example, presided over by saleswomen dressed in Aesthetic-looking kimonos and similar attire.[12]

The items made for the fairs and for display in the tasteful artistic home evoked fairyland in other ways as well. For example, fanciful images of sunny-countenanced children playing in romantic, old-fashioned clothing graced crazy quilts and other domestic linens (fig. 7.1). The images were

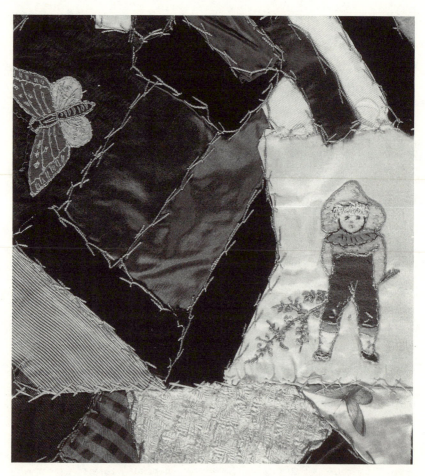

Fig. 7.1. This detail of a crazy quilt made with pieces of silk and velvet fabric indicates the use of free-form rather than controlled stitches and the use of asymmetry and irregularity, all characteristic of Japanese-influenced art needlework. The two embroidered motifs also reflected aesthetic taste: the butterfly was a "free" and "light" creature, and the child in old-fashioned dress followed the romantic prototype popularized by Kate Greenaway. Courtesy, the Helen Louise Allen Textile Collection (Accession No. QSUS-5), University of Wisconsin—Madison.

based on illustrations by the English artist Kate Greenaway, who depicted a "child-land" inhabited by quaint, sweet, and gentle children who were "always happy, . . . nearly always playing, set in the most attractive environment."[13] American manufacturers began selling patterns with images of these sweet children in the early 1880s, shortly after the appearance of Greenaway's first highly successful book, and such patterns stayed in circulation for about twenty-five years. These characters lived in a fairy-tale world, and although the original Greenaway books were intended for children, they were worked on textiles that were fully a part of the adult environment.[14]

The romanticized children were usually rendered in an outline stitch. They were worked in silk on the crazy quilts (fig. 7.1), but even more typically, they were stitched with cotton thread on white linen ground. Cloths with designs made in such "outline work" were sometimes seen on table linens but were more typically used for items for the bedroom—they were applied to pillow and bedcovers, for example, and to splash cloths that could be hung behind the washstand. They were "clean," "airy," and fresh in design and fabric, and were considered appropriate for that kind of a personal space. Other motifs in outline work were inspired by Japanese design or by the "rustic" country look that was thought to go with it (fig. 7.2), and sentimental or humorous captions were frequently paired with them. Such designs could be purchased in a pre-stamped form, and almost anyone, regardless of training, could successfully complete the embroidery.[15]

Outline work had two qualities that indicated its somewhat transitional position in the history of needlework design. On one hand, it retained the Victorian propensity toward literality or "appropriateness," as the imagery was related to the intended use of the piece. The words "splash" or "morning dip" might be fashioned on a splash cloth, and words about repose might be worked on a bed pillow, but on a cloth meant for use in the dining room, pictures of food would be more likely. At the same time, this literality was approached in a slightly wry or tongue-in-cheek manner, which was indicative of a more modern sensibility. Sometimes this kind of humor was expressed as a pun: a shoe bag might, for example, be marked "standing room only."[16] At other times the humor poked fun at the user. One popular design for a pillow cover featured the image of a sleeping figure on one side, with the caption, "I slept and dreamed that life was beauty." On the other side of the cover, the figure was more harried looking, and the caption read, "I woke to find that life was duty."[17] Fairyland included amusement, a willingness to laugh and to smile at life.

Fig. 7.2. Detail, splash cloth (ca. 1885), worked in red outline stitch on white cotton. The open handling of space and the "rustic" iconography—cattails, lily pads, and birds that look like they might fly off—also followed aesthetic ideas. Courtesy, the Helen Louise Allen Textile Collection (Accession No. EAUS 821), University of Wisconsin—Madison.

The same white linen used for outline work also provided the foundation cloth for "silk work," a type of embroidery that was slightly more difficult to execute. It featured representational images worked in satin (Kensington) stitch. The style was inspired by British art needlework, although the American examples more often featured realistic-looking fruits and flowers than did their English counterparts. American silk work was conceivably also influenced by Chinese embroidered shawls, which also featured realistic-looking flowers. These were very fashionable and were imported in great numbers at the turn of the century. American silk work was most often applied to doilies, mats, and tea cloths, and because detailed patterns were distributed by silk-manufacturing companies who gave de-

tailed instructions using their own products, it was also an accessible type of needlework. [18]

It is important to note that these categories were not necessarily mutually exclusive; there was a permeability between different types of needlework. Floral images worked in silk satin stitch were also applied to crazy quilts and silk fabrics, and the type of sentimental or humorous aphorisms that have been discussed in relation to outline work were also seen on silk embroidery.

Another look that came into prominence in the 1890s was whitework. This could take the form of white-on-white embroidery with a foundation of white linen (sometimes the same floral images were worked in white, rather than colored, silk), or it could take the form of openwork or lace, fashioned in a variety of techniques ranging from filet crochet to tatting and macramé. The new laces were generally based on relatively simple techniques, and one of these, usually referred to at the time as *Battenberg work*, featured ready-made, purchased lace tapes that were sewn together or otherwise combined. [19] Tape lace was particularly popular, because it resulted in an elegant, sophisticated-looking product that was relatively easy to master (fig. 7.3). Like outline work, it reflected the democratization, or deskilling, of needlework.

Light, airy fabrics were also adorning women's bodies by the turn of the century; this was the era of the delicate, sometimes almost frothy, high-necked white blouse. As previous discussion has implied, there was a strong relationship, almost an interpenetration, between the adornment and presentation of women and the adornment and presentation of the women's environments. This was dramatically symbolized a few years later in 1920 by a book that focused on personal appearance in the home setting, *Woman as Decoration*. [20]

The airier fabrics and garments, the lighter types of needlework, and the almost ethereal, elusive quality of the fairyland ideal can all be understood as parts of a single aesthetic response at the turn of the century. I believe they represent the same kind of preoccupation with lightness and luminosity that we associate with the Impressionist painters. This impulse or predilection was evident throughout the visual landscape, from the most public grand space—think of the World's Columbian Exposition held in Chicago in 1893, which was designed as a set-apart, almost magical environment, a White City[21]—to the most modest domestic environment with its own delicate white needlework.

Tape lace, crochet, and other whitework continued to fill women's time

Fig. 7.3. Detail, "centerpiece" (a large doily-type covering for the center of a table), worked in white linen using cut work and tape (Battenberg) lace techniques, ca. 1900–1920. The same "whitework" was applied to blouses, dresses, and other items that adorned women's bodies in the turn-of-the-century period. Courtesy, the Helen Louise Allen Textile Collection (Accession No. LBE 1087), University of Wisconsin—Madison.

and houses right up until World War I, just as women's dresses continued to get lighter in color and feel during the first years of the new century. Heavy black and red velvets and silks fabrics began to disappear from embroidery after 1900, and the rage for crazy quilts fell off dramatically. Whitework was supplemented, however, by Mission-style work, which looked even more spare and "modern."[22]

The Mission look, which was based on designs and ideas emanating from designers associated with the Arts and Crafts Movement, was particularly American, although it did evolve from philosophical and aesthetic movements that had originated overseas. Gustav Stickley and other Arts and Crafts proponents advocated design with clean, unencumbered functional lines, natural materials, and construction techniques that were true to those materials.[23] Their furniture was solid and rectilinear, typically made of oak. Additional decoration was generally eschewed, except for functional

hardware and some modest inlay. The original prototypes were made by hand, but because the lines and construction details of the style were so simple and straightforward, furniture manufacturers found it relatively easy to mass produce similar-looking pieces. With many examples on the market, the Craftsman, or Mission, look became quite affordable and quickly popular. It indicated up-to-date, educated taste.

Designs for Mission-style embroidery first appeared in the needlework press about 1903, shortly after Stickley's *Craftsman* magazine began publication. Because the woodwork was so plain and unadorned, cloths with "uncluttered," visually related designs were felt to be the perfect accessory. Embroidered motifs were typically simple and abstract forms, similar or identical to those seen in the furniture inlay and stained glass, or restrained and rectilinear versions of the floral forms of the artistic, Japanese-inspired designs of the Aesthetic and Art Nouveau styles seen a few years earlier. True to the Arts and Crafts preference for "earthiness" and philosophy of remaining true to one's materials, the ground cloth of "Mission work" was typically unbleached linen, and the embroidery floss of choice was cotton rather than silk (fig. 7.4).

Mission-style embroidery was extremely popular by 1907, just a few years after it was first introduced. By 1909 it had become so integrated into the mass culture that it was referred to as "conventional."[24] The style was popular for a number of reasons. The uncomplicated shapes were seen as "refreshing" and modern, and they were easy to execute. They translated well into stenciled designs that could be purchased in a pre-stamped form.[25] Once again, they could be worked by untrained embroiderers and were part of the shift toward democratized needlework.

Between about 1900 and 1915, the rustic theme also appeared with a new twist. Rusticity, which was often characterized by "twiggy"-looking furniture made from unfinished logs and branches, had been popular since the mid-nineteenth century and had been quite compatible with the Japanese craze.[26] Although rustic imagery was not advocated by Arts and Crafts designers, twiggy-looking needlework motifs were still popular in the early twentieth century, and the general public seemed to feel that rustic imagery "fit" with the rugged look of Craftsman furniture.[27] The natural wood of the furniture was apparently also associated with forests[28] and summertime vacation memories, and a rash of sofa pillow designs alluding to woodsy vacations began to appear. These too were worked in the Mission style.[29]

Such designs were often further identified with romance, and sometimes even had a vaguely risqué quality. Iconographic images included trees and

Fig. 7.4. Detail of a Mission-style pillow cover, worked in mercerized cotton thread on an unbleached linen ground, ca. 1910. The stylized flower was also used in whitework, but the way it is repeated in a linear sequence and outlined by a boxlike form makes it an "appropriate" accessory for Arts and Crafts-style furniture. Courtesy, the Helen Louise Allen Textile Collection (Accession No. EAUS 179), University of Wisconsin—Madison.

canoes, and accompanying mottoes were statements like "nobody's looking but the owl and the moon." Although these pillow covers might have been worked by women of any age, the romance they alluded to was clearly associated with a newly liberated youth. Like the Greenaway child-world, they represented a longing for a carefree, idealized reality, far from the demands of homemaking, but this fantasy was populated by adults. The designs also seem related to ragtime and other popular music of the day, and indicate the extent to which nineteenth-century moralism had broken down. The home was no longer the retreat from the dubious outside; the world, albeit a rather romantic and fanciful one, had clearly come into the home environment.[30]

Other designs of the prewar period featured images of upper-class leisure activities such as yachting. Although the patterns were probably purchased and worked by women who themselves would be unlikely to set foot on such

vessels, they too represent a kind of longing and are related to the same associations and interest in pleasure and leisure time.

Also related to the Arts and Crafts aesthetic and the lingering prewar interest in the rustic was a renewed interest in things Indian. For the most part this was manifested in the purchase of Indian-made rugs, baskets, and other artifacts,[31] but Indian motifs and Indian-like geometric patterning did have a limited influence on mainstream designs for sofa pillows and other crafted objects.

Harder-edged, even more geometricized stylizations became more and more common by the war years. The use of cross-stitch patterning in embroidery had been introduced (or reintroduced) as early as 1903, when the *Craftsman* magazine proclaimed it to be very democratic.[32] Cross-stitch designs were presented as stylized, abstract, rectilinear block patterns, which could also be used for filet crochet and even beadwork. Motifs of all kinds, including flowers and animals, appeared in this new form, reduced to their basic shapes or outlines, an approach which was seen as new, modern, and immediate. Once again there were parallels with developments in the "fine" arts: it was contemporaneous with a similar experimentation with geometric abstraction conducted by the most avant-garde painters and sculptors, the Cubists.[33]

World War I brought a predictable spate of patriotic designs, and much of women's needlework energy was temporarily redirected to knitting for the soldiers.[34] When it was over, however, the interest in the newer designs intensified. The country had been propelled into a self-conscious modernism, and even the remnants of older nineteenth-century attitudes began to fade. With such new realities as women's suffrage, finally achieved in 1919, and a self-perception that America was now a world power, it is not surprising that the fairyland aesthetic melted away completely. The term *fairyland* was no longer used as a laudable adjective, and even the terms *aesthetic* and *artistic* fell into disuse. *Ladies' Home Journal* declared in 1918 that there was no more "fussiness" in handwork; everything was to be simpler, more streamlined, and more up-to-date.[35]

What followed in the 1920s was somewhat paradoxical. This modern, new simplicity was a constant theme in needlework, but it was melded with an old-fashioned look. In handwork made for the home,[36] modernism was usually interpreted through motifs and ideas drawn from or colored by the Colonial Revival. The design features of abstraction, stylization, and reduction to essential shape were most often applied to "retro" images such as silhouetted hoop-skirted women or pigtailed men in breeches (fig. 7.5), or

Fig. 7.5. This 1926 illustration by Helen Grant (cover of *Needlecraft* magazine, September 1926) expresses much of the Colonial Revival ideal. It features a demure-looking maiden in "old-fashioned" dress (her bloomers, hoopskirt, and braids are almost the quintessential opposite of the short-skirted, bobbed-hair flapper), working on a cross-stitch embroidery of a silhouetted colonial figure. She is sitting on colonial-style furniture, and when she looks out the window, she can see a colonial-looking house. By doing this work, she embodies the perceived virtues of the bygone era.

motifs such as swags and flower baskets, which were associated with eighteenth-century design.

Simplicity and reduction of form was so dominant that it affected technique as well as imagery. Straight lines might even be worked in a broken fashion (running stitch), for example, creating the suggestion of a line as much as a line itself. Solid blocks of color were often worked in the ever-more-popular cross-stitch, meaning that the borders of the block were alluded to rather than actually filled in. Sometimes designs were reduced to mere points—they were built up through implied lines, created through a series of French knots. The preference for simplified design was acknowledged by needleworkers of the day. "The old fashioned sampler of our great grandmother's day, with its fine, careful stitches, seems incongruous now," wrote Ethelyn Guppy in *Needlecraft* magazine in 1928.[37] The sampler itself was evocative of an earlier age, but it had to be worked in a streamlined manner. It is this very simplicity that in later eras has been looked upon as evidence of lack of skill or design sophistication, but in the 1920s it was seen as up-to-the-minute stylishness.

As the 1920s wore on, color was once again an important element of popular needlework designs, but the preferred colors were usually tints and shades rather than bright, saturated hues, and the preferred backgrounds were still usually light. The light palette was associated with the colonial era and worked well with the spare modern aesthetic.

The appeal of the colonial or "good old days" in the midst of the so-called Jazz Age has been well explored by other scholars, who have demonstrated that there was a longing for an imagined stability and safety that seemed very far from the realities of the postwar world.[38] Turning to the colonial past was both a statement of national pride and identity and a form of escape. It reaffirmed the original American vision, which seemed to make sense amidst the rhetoric of a new world, safe for democracy. At the same time, it represented a backlash against the waves of immigrants and the increasingly specialized and technologically based realities of the machine age, which were changing the very nature of American society. The Colonial Revival reflected a longing within the mainstream culture for the days when there was simply less to contend with.[39]

The early American period was embraced particularly wholeheartedly in relation to the needle arts, furthermore, because such arts represented a direct link to the past. Women responded strongly to the Colonial Revival because they saw the colonial era as a time when women's work had been valued and respected.[40] Because things had been made by hand at that

time, moreover, present-day needlework, which was also done by hand, was seen as a living embodiment or extension of the earlier period. If modern women still stitched or knitted when it was no longer necessary to do so, they could by extension take on some of the nobility and meaningfulness that was attributed to that time.

Reflecting this same interest in the past was a new exploration of historic needlework; the first serious or scholarly studies of American textiles, including samplers, quilts, coverlets, and hooked rugs, appeared in the 1920s.[41] There was a pervasive new interest at this time in American antiques, and new outlets for learning about them. The influential magazine *Antiques* came into existence in 1922, and museums began to highlight many of these same objects. Period rooms emphasizing the colonial past and exhibiting the textiles, furniture and other items associated with it began to proliferate. The best-known and perhaps most influential of these were found at the American Wing of the Metropolitan Museum of Art, which opened in 1924.[42] In that same year, one of the important events at the Brooklyn Museum was a special "Early American Handicraft" exhibit.[43] *Early American* was defined loosely; anything that had been made before the Civil War might be included. Any older object that was "hand made" seemed to qualify, for it was its preindustrial quality that was salient.

The embroidered images of flower baskets and figures in colonial dress functioned, then, as symbols of the preindustrial past. They were echoed by similar images in other media and other types of popular culture. One of the best-loved characters of the Colonial Revival, for example, was Priscilla Mullins, the heroine of Longfellow's poem "The Courtship of Miles Standish." She was usually portrayed as an ideal, domestic creature, who sat in a simple colonial interior, sweetly stitching or spinning, and she seemed to reflect all the virtues of times gone by. Prints of other silhouetted figures, including George Washington, were also immensely popular, and whole industries were built around their production.[44] Figure 7.5, which appeared as the cover illustration of *Needlecraft* magazine in September 1926, features a hoop-skirted young woman demurely stitching an image of a silhouetted figure and captures the character of Colonial Revival imagery perfectly. It also brings us back to the paradox of 1920s needlework, for the image the woman is executing would have been perceived as up-to-date and modern, an example of the new essentialism in design. It served this function at the same time it seemed to evoke a quintessential American heritage.[45]

There was also a related vogue in the late 1920s and 1930s for "peasant

Fig. 7.6. This cross-stitch wall hanging was made from a preprinted pattern de-
signed in 1926 by Anne Orr and distributed by *Good Housekeeping* magazine. It uses
the eighteenth-century sampler format to express a contemporary sentiment about
the ideal mother. (The caption reads: Mother dreams as / She sits and spins. / And
With each thread / Love's Confidence Wins.) Author's collection.

work," or embroidery inspired by European folk textiles. Peasant embroid-
ery was also typically worked in cross-stitch, but its popularity was more
than a confluence of technique. A budding openness to "folk" art, or art of
the people, grew out of the interest in antiques, because many of the col-
lected items had not emanated from the upper strata of society. Collectors
began to appreciate American folk art in a new way, and to be more open to
folk expressions from Europe.[46] Exhibits such as "America's Making Expo-
sition," held in New York in 1921, featured the arts and crafts of the

"homelands" of Europe.[47] Similar in spirit to the Brooklyn Museum exhibition mentioned earlier, such events reinforced the positive attention given to handcraft and art of a "simpler" day.[48]

Windmills and Dutch figures in native costume were particularly popular needlework motifs in the 1920s. These cheerful images fit with the awakening interest in European folk or peasant art, but they could also be associated with the American past. The early Dutch presence in New Amsterdam (New York City) meant that Dutch culture was an integral part of the early American experience, and it was embraced as part of the Colonial Revival.[49]

Whether the imagery was Dutch, neocolonial, or otherwise reminiscent of early America, 1920s needlework was generally worked in cotton or wool thread on a cotton ground. Cotton was crisp and simple and seemed an appropriate material for work perceived as simultaneously modern and old fashioned. Late in the decade, even burlap and canvas, the most lowly or democratic of materials, were sometimes featured, and the emphasis on the look "of the people" intensified in the Depression era.

Other trends first seen in the 1920s also continued in the 1930s. Designs became even more abstracted and simplified, often with a cartoonlike quality. Silk disappeared completely, and even cotton was supplanted to a great extent by wool. Peasant embroidery was touted more and more, and the color palette continued to expand and brighten. Although there were a few truly new or modern designs that did not harken back to simpler times and places by the late 1920s—some items were specifically identified as "futuristic," and there were motifs such as gazelles that were expressly identified with the current Art Deco design style[50]—almost everything was presented with adjectives such as "charming" and "dainty"; the futurism was "tamed" or softened by the domestic and homey context of the needlework.

This statement leads back to the questions about the relationship between women and needlework and the sources of the stereotypes mentioned at the beginning of the chapter. A brief examination of the changing profile of the types of home-related articles needlework was applied to over this forty-year period will help frame this discussion.[51]

In the late Victorian era, when the ideology of the separate spheres and woman as moral guardian was still strong and a woman was still generally expected to be able to sew, needlework was applied to many objects made for parlors, drawing rooms, and other public spaces in the home. We have mentioned the popularity of crazy quilts and sofa pillows, but there were also such other decorative items as floor and chair mats, shelf valances, and

wall pockets. Useful accessories that might sit in these rooms—photograph frames, desk blotters, and ink wipers, for example—were prevalent as well.

Needlework was also applied to objects used in the bedroom and other private spaces: a woman might embroider bedspreads and pillow covers, splashers, bureau cushions, and holders for personal items such as jewelry, gloves, and neckties. As the last few items indicate, some of the more personal objects were made for men, but they were always pointedly gender specific. A man's "holder" would be made especially for collars or shaving paper, for example; a man's pillow cover would be designated for a male-identified space like a den. It would typically be worked with gender-specific imagery that emphasized leisure, such as a picture of a lounging, pipe-smoking man. Just to make sure there was no doubt about the masculinity of the object, it might include a written motto or phrase like "Bachelor Heart" or "Chappie's Delight."[52]

Designs for women's objects included toilet (bureau) cushions and holders for personal accessories, and "workbags," made to store sewing accessories and sometimes sewing projects. Handwork was still, as we have seen, woman's expected job. There were a few designs to apply on aprons, cases for cutlery, and other kitchen textiles, but these were as yet unusual and in the minority.

The profile of dominant decorative items began to change as Americans entered the modern era. The change was gradual and by no means universal, but between 1910 and 1920 a decided shift took place in the patterns and types of suggested objects that appeared in the needlework press and in supplier catalogues. Workbags and related sewing accessories became scarce; the very word *workbag*, in fact, effectively disappeared. The decorated bags that were shown had different uses: to hold clothespins and laundry; cutlery; or lettuce, celery, and other "icebox" items. By the 1920s, toaster and teapot covers were also touted, and there was a significant increase in patterns for aprons and pot holders. Additionally, designs for tea cloths, table covers, luncheon sets, tray covers and similar items were very common, and a new category of card table covers, often featuring embroidered hearts, spades, and the other suits as corner motifs, appeared. Male-identified iconography disappeared, as did designs for male-identified objects, such as shaving paper holders. Objects made for private bedrooms and for public spaces like parlors were greatly reduced.

There was a new profile, in other words, of the concerns and roles of the American woman in the modern home. She was far more involved with the backstage labor of cooking, cleaning, and washing than her Victorian fore-

mother, and she was busy with a new kind of rather frivolous afternoon activity—serving as a personal hostess. She was still identified with the family (there were many, many patterns for children's items, and rag dolls were a late 1920s rage), but her important moral and educational role had shifted. She was less concerned with creating an artistic and uplifting environment, and more concerned with making her home pleasant, charming, and entertaining. Although she was still expected to stay in the domestic sphere,[53] the woman had lost her deeper significance there; her role was more marginal. Because the home no longer stood as a retreat or shelter from the rest of the world and the woman was no longer its moral guardian, she functioned in more of a service capacity—she was a caretaker rather than a fundamental, central presence.

A similar analysis has been advanced by Jean Gordon and Jan MacArthur in their 1985 article on changing patterns of women's domestic consumption. They argue that it has only been in the modern era—from about 1920 on—that women have been trained to find satisfaction in the housewife or homemaker role. In the ideal nineteenth-century scenario, the lady of the house was concerned with the education and moral upbringing of her family, but not so much with cooking and cleaning. She would supervise these activities but was not invested in them, as they fell in the domain of servants' work. Even when there were no servants, this ideal prevailed, and cooking and cleaning were not thought of as "ladylike" activities. In the twentieth century, servants could only be afforded by the rich, and middle-class women found themselves involved much more directly with tasks such as doing the laundry and preparing the dinner. The ideal shifted, and these tasks became more generally acceptable.[54] It is no accident that in the 1920s and 1930s there were occasional patterns in women's magazines for "lady's helpers"—amusing dolls made out of washcloths, sponges, soaps and brushes that were made to look like Chinese washermen, Irish "Bridgets," and black "mammies."[55] These dolls indicated not only the mainstream woman's racist assumptions about who servants should be but also their longing for household help.[56]

In sum, needleworking women of the modern era were spending time doing what they had been doing for generations—using the "womanly" skills they had been taught to positively affect the home environment, the domain over which they had the most direct control. As the relationship between the home and the outside world changed, however, those skills were valued less and less, and the objects the women embellished were no longer thought of as noble or important. Needlework itself was seen by

many as dated and trivial, and the women who continued to find satisfaction in it were seen as old fashioned and fussy. Because the objects themselves also reflected the new, less-valued activities the women were engaged in, they were even more quickly trivialized by subsequent generations, and this was compounded by the fact that their spare and simplified aesthetic was dismissed rather than understood or appreciated.

Women's handwork has rarely been examined on its own terms or seen as part of a greater or more complex whole. I have attempted in this chapter to provide another model: to indicate how even needlework, which is often thought of as a remote, isolated, conservative, and even trivial phenomenon, can be "read" as an indicator about broader trends in the culture that it emanates from. In particular, needlework shows us the changing concerns and tastes of women, and the ways that women respond to the ethos and aesthetic of their day. It is my hope that we will continue to look to this ubiquitous and abundant type of expression, both to appreciate it as an artistic outlet and to understand the many values, ideas, beliefs, wishes, and dreams that are deeply embedded within it.

Notes

1. Nancy F. Cott, *The Bonds of Womanhood: Woman's Sphere in New England 1780–1835* (New Haven: Yale Univ. Press, 1977), 64–68; Carroll Smith-Rosenberg, "The Female World of Love and Ritual: Relations Between Women in Nineteenth Century America," in *A Heritage of Her Own: Toward a New Social History of Women*, ed. Nancy F. Cott and Elizabeth Pleck (New York: Simon and Schuster, 1979), 311–42. A nineteenth-century source that articulated the idea succinctly was "The Sphere of Woman," *Godey's Lady's Book* 39 (Mar. 1850).

2. Harvey Green, *The Light of the Home: An Intimate View of the Lives of Women in Victorian America* (New York: Pantheon, 1983), 93.

3. Laura C. Holloway, *The Hearthstone; or, Life at Home: A Household Manual* (Chicago: L. P. Miller, 1888), 33. See also Beverly Gordon, "Victorian Fancywork in the American Home: Fantasy and Accommodation," in *Making the American Home: Middle-Class Women and Domestic Material Culture 1840–1940*, ed. Marilyn Ferris Motz and Pat Browne (Bowling Green, Ohio: Bowling Green State Univ. Popular Press, 1988), 50–51.

4. Margaret Vincent, *The Ladies' Work Table: Domestic Needlework in Nineteenth-Century America* (Allentown, Pa.: Allentown Art Museum, 1988; distributed by Univ. Press of New England), 63–64; Virginia Gunn, "The Art Needlework Movement: An Experiment in Self-Help for Middle-Class Women, 1870–1900," *Clothing and Textiles Research Journal* 10 (Spring 1992): 54–63; William Hosley, *The*

Japan Idea: Art and Life in Victorian America (Hartford: Wadsworth Atheneum, 1990), 161–64. See also Francine Kirsch, "Silk Embroidery: 1800 vs. 1900," *Victorian Homes* (Winter 1991): 20–21, 95.

5. Jane Converse Brown, " 'Fine Arts and Fine People': The Japanese Taste in the American Home, 1876–1916," in Motz and Browne, *Making the American Home*, 121–39; Hosley, *Japan Idea*, chap. 2; Cynthia A. Brandimarte, "Japanese Novelty Stores," *Winterthur Portfolio* 26, no. 1 (Spring 1991): 6.

6. Penny McMorris, *Crazy Quilts* (New York: E. P. Dutton, 1984), esp. 11–13; Brown, "Fine Arts," 122, Hosley, *Japan Idea*, 172–73.

7. Merrill Taber Horswill, *The Silk Weighting Phenomenon* (Master's thesis, Univ. of Wisconsin–Madison, 1986), 17–18.

8. Brandimarte, "Japanese Novelty Stores," 1–2.

9. See Frances Lichten, *Decorative Art of Victoria's Era* (New York: Charles Scribner's Sons, 1950), 244, 262; Nicholas Cooper, *The Opulent Eye: Late Victorian and Edwardian Taste in Interior Design* (New York: Watson-Guptill, 1977), 11.

10. See Karen Halttunen, *Confidence Men and Painted Women: A Study of Middle-Class Culture in America, 1830–1870* (New Haven: Yale Univ. Press, 1982), chap. 6.

11. The subject is fully developed in Beverly Gordon, *Bazaars and Fair Ladies: A History of the American Fundraising Fair* (forthcoming). See also Beverly Gordon, "Dress and Dress-up at the Fundraising Fair," *Dress* 12 (1986): 61–73 and Beverly Gordon, "Aesthetic Meanings in Turn-of-the-Century Fundraising Fairs," *Turn-of-the-Century Women* 3, no. 1 (Spring 1986): 15–28.

12. See, for example, "For Fairs and Bazaars," *Ladies' Home Journal* 17 (Nov. 1900): 21; "Has Your Church Had Fairs Like These?" *Ladies' Home Journal* 23 (Nov. 1906): 21.

13. Note that Greenaway was a close protégé of Ruskin. The quotation is from Austin Dobson, "Kate Greenaway," *Art Journal* 33 (1902), cited in Vincent, *Ladies' Work Table*, 75. For a discussion of the impact of Greenaway designs on American embroidery, see Vincent, *Ladies' Work Table*, 73–76; Lichten, *Decorative Art of Victoria's Era*, 252, and McMorris, *Crazy Quilts*, 75–76. For a good overview of Greenaway's work, see Rodney Engen, *Kate Greenaway: A Biography* (New York: Schocken Books, 1981).

14. By the early years of the twentieth century, however, the figures were more often seen on children's items. See, for example, *Embroidery Lessons in Colored Studies* (New London, Conn.: Brainerd and Armstrong, 1907), 134; *Modern Embroidery* (Lynn, Mass.: Walter B. Webber, 1909), section on bibs. The Greenaway figures probably served as models for the sunbonnet children of a few decades later.

15. Vincent, *Ladies' Work Table*, 73.

16. A design for this kind of bag appears in *Modern Embroidery*, whose publisher, Walter B. Webber, also published the *Modern Priscilla* magazine.

17. See Vincent, *Ladies' Work Table*, 76–77. A pillow cover with the beauty/duty design is in the Helen Louise Allen Textile Collection at the Univ. of Wisconsin–Madison.

18. See Vincent, *Ladies' Work Table*, 70–72; *Needlecraft: Artistic and Practical* (New York: Butterick, 1889), 41; Adelaide E. Heron, *Dainty Work for Pleasure and Profit* (Chicago: Danks, 1891); *Embroidery Lessons in Colored Studies*.

19. See Vincent, *Ladies' Work Table*, 84–94; *Needlecraft: Artistic and Practical*, 81.

20. Emily Burbank, *Woman as Decoration* (New York: Dodd, Mead, 1920).

21. See David F. Burg, *Chicago's White City of 1893* (Lexington: Univ. of Kentucky Press, 1976).

22. Although the more accurate name for the overall design style is *Craftsman* or *Arts and Crafts*, it is more often referred to in the needlework literature by the more colloquial (and less accurate) *Mission* epithet, and I am using it here advisedly.

23. See Eileen Boris, *Art and Labor: Ruskin, Morris and the Craftsman Ideal in America* (Philadelphia: Temple Univ. Press, 1986); Wendy Kaplan, *The Art that is Life: The Arts and Crafts Movement in America, 1875–1920* (Boston: Museum of Fine Arts, 1987).

24. See Jane Converse Brown, *Gustav Stickley's Interpretation of European Art Nouveau As Reflected in the Embroidery Presented in the Craftsman Magazine From 1901–1916* (Master's thesis, Univ. of Wisconsin–Madison, 1979), 74; *Modern Embroidery*.

25. Mrs. Wilson, "The Popular Stenciled Work with Embroidery," *Ladies' Home Journal* 25, no. 12 (Nov. 1908): 90.

26. An excellent discussion of the rustic tradition is provided by Craig Gilborn, *Adirondack Furniture and the Rustic Tradition* (New York: Harry N. Abrams, 1987), chap. 1. For the interface with the Japanese style, see Hosley, 113.

27. The two furniture styles were often used together. In the great rustic-style Adirondack "camps," Craftsman furniture was often interspersed with more local "twiggy" pieces.

28. Gustav Stickley made this association explicit. In explaining his choice of furniture materials, he noted: "Our eyes rest on materials which, gathered from the forests [and] along the streams are . . . interesting and eloquent." "An Argument for Simplicity in Household Furnishings," *Craftsman* 1, no. 1 (Oct. 1901): 47.

29. This is also tied with the increased possibility of summer holidays for middle- and even lower-class individuals. The rapid expansion and commercialization of leisure at the turn of the twentieth century has been discussed by Kathy Peiss in *Cheap Amusements: Working Women and Leisure in Turn of the Century New York* (Philadelphia: Temple Univ. Press, 1986) and John Kasson, *Amusing the Million: Coney Island at the Turn of the Century* (New York: Hill and Wang, 1978).

30. Peiss has shown that it was young, unmarried women who had gained the most access to the new forms of leisure activity at the turn of the century. She also

clarified the fact that this was a time when primary allegiances were shifting, and when entertainment and other aspects of social life moved from a homosocial to a heterosocial focus (see 47, 137). Her thesis helps explain the lessening power of the separate sphere ideology.

31. See Melanie Ann Herzog, *Gathering Traditions: The Arts and Crafts Movement and the Revival of American Indian Basketry* (Master's thesis, Univ. of Wisconsin–Madison, 1989).

32. Brown, *Gustav Stickley's Interpretation*, 64.

33. The same kind of reduction to simple, geometric form was also seen in contemporary designs for women's clothing.

34. See Ruta Saliklis, "World War I Relief Knitting" (unpublished MS, Madison, Wis., 1990).

35. "What I Am Making from What I Have," *Ladies' Home Journal* 35 (Nov. 1918): 36.

36. It could be argued that there was another model seen in textile design made by women who identified themselves as "artists." Individuals such as Sonia Delaunay and Anni Albers used textiles as their "art form" and treated them with an avant-garde sensibility. However, these designers were not appealing to the domestic market, and they did not work in embroidery.

37. Ethelyn J. Guppy, "A Modern Sampler Done in the Modern Way for a Modern Home," *Needlecraft* 22, no. 1 (Sept. 1928): 5.

38. See Alan Axelrod, ed., *The Colonial Revival in America* (New York: W. W. Norton, for Winterthur, 1985); Karal Ann Marling, *George Washington Slept Here: Colonial Revivals and American Culture 1876–1986* (Cambridge: Harvard Univ. Press, 1988).

39. Warren Susman has written particularly eloquently about the "cultural divide" of the 1920s, when the old order seemed to fall apart. He notes that the "reconstruction" of Historic Williamsburg (a living—if inaccurate—interpretation of colonial life) was a "hedge against the new rising industrial order." Warren Susman, ed., *Culture and Commitment, 1929–1945* (New York: George Braziller, 1973), 23; see also Warren Susman, *Culture as History: The Transformation of American Society in the Twentieth Century* (New York: Pantheon, 1984).

40. Marling, *George Washington*, 42.

41. See Beverly Gordon, *Domestic American Textiles: A Bibliographic Sourcebook.* (Pittsburgh: Center for the History of American Needlework, 1978), introduction; and Beverly Gordon, "The Fiber of Our Lives: Trends and Attitudes About Women's Textile Art as Reflected in the Literature in America, 1876–1976," *Journal of Popular Culture* 10, no. 3 (1976): 548–59.

42. See Melinda Young Frye, "The Beginnings of the Period Room in American Museums: Charles P. Wilcomb's Colonial Kitchens, 1896, 1906, 1910," in Axelrod, *The Colonial Revival in America*, 217–40.

43. *Catalogue of Early American Handicraft, Comprising Costumes, Quilts, Coverlets,*

Samplers, Laces, Embroideries and Other Related Objects (Brooklyn, N.Y.: Brooklyn Museum, Feb. 1924).

44. Celia Betsky, "Inside the Past: The Interior and the Colonial Revival in American Art and Literature, 1860–1914," in Axelrod, *The Colonial Revival in America*, 240–77; Marling, *George Washington*, 42, 176.

45. The same kind of paradoxical or contradictory blending of the past and present was seen in many objects. A 1923 design for a telephone screen made in the shape of a full-skirted colonial woman that also appeared in *Needlecraft* magazine (Grace Allison, "Valentine Favors, Dainty and Delightsome," *Needlecraft* 14, no. 6 [Feb. 1923]: 10) also captured it well.

46. Significantly, women were particularly active in this new form of collecting. Electra Havermeyer Webb began in the 1920s to seriously collect the objects that were later seen by the public in the Shelburne (Vermont) Museum. Constance Rourke was also at the forefront of the appreciation of American folk art in the 1930s. See Elizabeth Stillinger, *The Antiquers* (New York: Alfred A. Knopf, 1980), 240–45; *Collecting America: Folk Art and the Shelburne Museum* (Washington: National Gallery of Art, [1990?]), videotape; Arthur F. Wertheim, "Constance Rourke and the Discovery of American Culture in the 1930s," in *The Study of American Culture/Contemporary Conflicts*, ed. Luther S. Luedtke (Deland, Fla.: Everett/Edwards, 1977).

47. Allen H. Eaton, *Immigrant Gifts to American Life: Some Experiments in Appreciation of the Contributions of Our Foreign-Born Citizens to American Culture* (New York: Russell Sage Foundation, 1932).

48. Susman's discussion of the 1930s fascination with "the folk" and "the people" is also illuminating. See *Culture and Commitment*, 20–21, and *Culture as History*, 158–213.

49. Betsky, "Inside the Past," 249. Note that Helen Wilkinson Reynolds's book, *Dutch Houses in the Hudson Valley Before 1776*, was first published in 1929 (Payson & Clarke, for the Holland House). (It is available in a reprint edition put out by Dover in 1965).

50. "Futuristic Designs," *Scholl's Art Needlework Catalogue* 3 (1931): 10; Davide Minter, ed., *Modern Needlecraft* (New York: Charles Scribner's Sons, 1932).

51. Needlework was also applied to garments and costume accessories, but these are excluded from consideration here. This profile is based on many years of study of needlework items. I have conducted several formal examinations of objects illustrated in magazines, catalogs, and books (see, for example, Gordon's *Domestic American Textiles* and "Victorian Fancywork"), but this discussion can be considered an informal compilation. I am also in the process of conducting a formal study of domestic needlework of the interwar years, 1915–45, the results of which should be available in 1994.

52. Patterns for sofa cushions with these two designs appeared in *Embroidery Lessons in Colored Stitches*, 107.

53. The "single most arresting feature of the interwar years was the strength of the notion that women's place is in the home," noted Deirdre Beddoe in *Back to Home and Duty: Women Between the Wars 1918–1939* (London: Pandora, 1989), 3. The rest of the book is devoted to illustrating this point.

54. Jan Gordon and Jean MacArthur, "American Women and Domestic Consumption, 1800–1920: Four Interpretive Themes," *Journal of American Culture* 8, no. 3 (Fall 1985): 35–46.

55. See, for example, Anna G. Bailey, "First Aid in the Laundry," *Needlecraft* 15 (Nov. 1923): 17.

56. One such African-American "maid" doll that came into the author's collection was made as a bridal shower gift for a middle-class Ohio woman who was leaving the teaching profession to become a full-time housewife. The engaged girl received thirteen gifts at her shower, each of which was a "helpful" doll made out of kitchen and cleaning items. Each was fashioned by a different shower guest. The owner was now sensitive to the racist assumptions of the black-face character but indicated that "they just didn't think anything of it" at the time she was getting married. A pattern for a doll made out of such kitchen items appeared in "Centerpiece for a Kitchen Shower," *Dennison's Party Magazine* 2, no. 4 (July–Aug. 1928): 16.

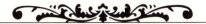

Pictures in the American Home, 1880–1930

William S. Ayres

Paintings and other pictures are chosen and displayed in the home primarily according to their perceived ability to act as tools in carrying out certain social strategies. Because predominating social strategies change over time and because certain types of pictures (and types of picture display) are perceived to serve certain social strategies better than others, the predominating types of pictures (and types of picture display) also change over time. This chapter will explore this phenomenon in the American home from about 1880 to 1930, by examining popular decorating advice publications and pictorial representations of period interiors.

Sociologists have divided the functions of objects and behavior into various "levels," and this division has been adopted by writers dealing with material culture. As used here, these levels of function are as follows: *technomic function*, which refers to "the utilitarian or physical use of an object"; *ideotechnic function*, which "describes the use of objects in religious and psychological contexts"; and *sociotechnic function*, which "involves their use in contexts of social interaction."[1]

Viewed in the above terms, pictures are most interesting, for they are almost totally without technomic function; that is, they function in almost exclusively ideotechnic and sociotechnic ways. As possible technomic functions, one might argue that certain pictures, such as pictorial maps and charts, do serve technomic or utilitarian functions in that they may convey necessary or useful information, and it might also be argued that the very basic decorative role of pictures is technomic. Here, however, both of these functions will be classified as ideotechnic, as they involve the communica-

tion of ideas and sensory data or, rephrased, because these functions can be carried out only through interaction with and evaluation by the human mind.

If the technomic functions of pictures (or lack of them) are simple to assess, their ideotechnic/sociotechnic functions are multifarious, complex, and difficult to enumerate and evaluate. This is particularly so because Western society has imbued not only pictures but also many individual facets of them with many meaning-laden characteristics: their subject matter, the style in which they are done, whether they are "originals" or copies of other works, the colors and shapes used to compose them, their size, how they are framed, and their method of display all contain important signals about those who acquire (or already possess) and use them; and pictures are, in turn, utilized by their owners to send certain mutually understood signals to others, consciously or unconsciously.

In the mid-nineteenth century, writers had argued for an active, didactic role for pictures in the home, encouraging creative selection and dynamic display of paintings and other original works of art as a potent means of achieving desirable social and cultural ends.

In *A Plea for Art at Home*, published in the United States in 1879 and earlier in England, William J. Loftie provided prescriptive advice to Victorians on the collection and display of "fine" art in the home. Loftie justifies collecting in arguments calculated to appeal to the bourgeoisie of high Victorian England, which the publishers of the American editions also apparently felt were applicable here. Loftie spends an entire chapter justifying the purchase of art in businessmen's terms: art collecting, if undertaken intelligently, can be done "quite as profitably as [an investment] in shares."[2] In addition, such collecting furthers the moral duties of the head of the household, making "his family happy by making his home beautiful."[3] Finally, collecting works of art will help to educate the buyer in matters of taste, will afford him a chance to meet "intellectual men on common ground," and will result in "wholesome excitement."[4]

Loftie goes into great detail as to the type of art one should purchase and display. In general, his advice is conservative. Contemporary "finished" painting that evidences "honest hard work" and avoids "disagreeable subject matter" is preferred.[5] More avant-garde collecting trends are inveighed against: the collection of old master oils (due to periodic swings in taste in such collecting and the abundance of fakes) and works of art-for-art's-sake painters and other "eccentrics" ("a picture which does not tell its own story is but half a picture").[6]

Loftie spends little time (compared to Eastlake and others, who will be discussed later) on the details of arrangement and display of pictures. Oil portraits are kept for their commemorative, not their artistic, value and are important (if one is fortunate enough to have them) to warrant furnishing the entire room in the historic period that they suggest. Both oils and watercolors should be hung "where they look best."[7] As for the details of wall arrangement, pictures should be placed to achieve two results, so that "the pictures are at the greatest advantage" and the "room itself is most ornamented by the pictures."[8] In Loftie's view, pictures are forceful and dynamic tools; they should determine other details of furnishing, not vice versa.

For Loftie, what we might consider to be external institutions—church, school, and the business world—extended into the home, indeed, begin there. The home is a center for instilling virtue and for education. Rigidly defined duties are owed to family and guests; a further duty is to furnish one's home with wise monetary investments. In the end, art is justified in moral terms: "The higher our conception of material beauty, the higher will be our ideal of moral beauty."[9] The sensual leads to the intellectual, which, in turn, leads to the spiritual. Any display technique that serves this end is, by definition, justified and laudable.

The period under consideration here, 1880 to 1930, witnessed a strong adverse reaction to the profuse and creative domestic display of works of art advocated by High Victorian writers such as Loftie. The first anti-dynamic-use-of-pictures effort was part of the Anglo-American "reform" movement of Charles Eastlake, Clarence Cook, and others in the 1870s and 1880s. These writers were disturbed by what they felt to be a distasteful profusion of objects in the home, a lack of agreement on appropriate modes of arranging them, and an absence of a universal cultural authority entitled to rule on matters of appropriate behavior in the acquisition, use, and display of objects.

Charles Eastlake's *Hints on Household Taste*, first published in England, enjoyed a wide circulation in the United States in the 1870s and thereafter. Eastlake aimed his *Hints* at the upper echelons, hoping, however, that the public at large, who "will by degrees take their cues from others of more cultivated taste," would eventually be won over.[10] He treats the subject of the use of pictures ("oil and watercolour paintings, engravings, and photographs") at length in his chapter on "Wall-Furniture." "Independently of the intrinsic value which such works of art may possess," he says, "they become collectively an admirable means of legitimate *decoration*" (emphasis added).[11] Two considerations will aid in the proper decision as to "how we

can dispose them on our walls to the best advantage": "judicious associa-
tion" and the choice of appropriate frames. In the first instance, pictures
should be classified, both as to medium and subject matter; thereafter,
works of one type should generally be segregated from those of another (for
instance, oil paintings should be reserved for use in the dining room). Pic-
tures should be hung in "one row only; and that opposite the eye": "A row
thus formed will make a sort of coloured zone around the room."[12] Draw-
ings or paintings should be spaced rather widely apart and interspersed with
"such small objects" as "sconces, small ornamental mirrors, or little wooden
brackets, supporting statuettes, vases, &c."[13] Pictures should be hung by
cords or wires extending to an iron rod hung just below the ceiling or nails
located high on the wall; each picture should be hung from two indepen-
dent cords, not by one cord hung over a nail so as to create a triangle above
the picture, because such an arrangement would be "inharmonious with the
horizontal and vertical lines of a room."[14] Pictures should lie flat against the
wall and should not tilt outward toward the viewer.

In Clarence Cook's *The House Beautiful*, we turn to an all-American work.
Both Eastlake and Loftie enjoyed popularity in the United States, but both
authors were English and both their books were originally aimed at English
audiences. As with Eastlake, Cook's audience is middle class: the lower
classes are dismissed as inconsequential, and the most wealthy members of
the upper classes, he concedes, "do not . . . want things that other people
have" and therefore will not be interested in his advice.[15] If middle class,
however, it is *upper* middle class, to be sure. Well-to-do people, he believes,
will be convinced to abandon the indiscriminate purchase of mass-produced
goods, and their enlightenment will trickle down the socioeconomic scale.

Cook's room-by-room method of proceeding prevents him from discuss-
ing paintings in general. The hearth is central in the household and "the
mantel-piece ought to second the intention of the fireplace as the center of
family life—the spiritual and intellectual center, as the table is the material
center."[16] On and over the mantelpiece, therefore, should be grouped "a few
beautiful and chosen things . . . to lift us up, to feed thought and feeling,
things which we are willing to live with, to have our children grow up with,
and that we can never become tired of, because they belong alike to nature
and humanity."[17] This would include a painting, if one owned one, "but
this is so rare a piece of good fortune we need hardly stop to consider it."[18]
Engraved copies or photographs of great works will have to suffice in most
cases.

Compared to the Englishmen Eastlake and Loftie, Cook spends little

time on paintings and other pictures—rather odd considering his profession as an art critic. Most likely, Cook felt that the audience that he was addressing in *The House Beautiful*—housewives—was not the group who made (or should be making) decisions as to major investments that paintings represented or, more importantly, made decisions as to the major social strategies that their selection and display entailed. Paintings simply involve issues of an entirely different nature, magnitude, and importance than the mere "home furnishing" with which *The House Beautiful* deals—issues with which, in Cook's view, women amateurs are not competent to deal.

Cook's reference in the first sentence of the book to "those who are chiefly concerned with the *control* and *management* of industrial art in this country" (emphasis added) is telling. His plea is for the housewife to submit to such control and management of the process of home decoration by rational processes articulated by arbiters of taste such as himself. This rationalizing process, in the end, points to the doom of spontaneity, "personalization," and all home-based decorating decisions based on morality (as distinguished from intellectuality).

The second major strain of anti-indiscriminate-use-of-pictures household furnishing and decoration philosophy was not Anglo-American but Franco-American. If Eastlake and Cook's rationalizing (and, in the end, controlling) desires had been subtle, the similar aims of this second group were blatant.

The Decoration of Houses by Edith Wharton and Ogden Codman, Jr., illustrates the shift that had taken place in taste, philosophy, and decoration by the 1890s. It looks to continental Europe for style dictates; to architects, not critics and decorators, as role models; and replaces "hints" with "science" for its methodology. The targeted audience is also somewhat different; the upper class is now explicitly aimed at. Reform "can originate only with those whose means permit of any experiments which their taste may suggest. When the rich man demands good architecture his neighbors will get it too. The vulgarity of current decoration has its source in the indifference of the wealthy to architectural fitness. . . . Once the right precedent is established, it costs less to follow than to oppose it."[19]

Easel paintings are given short shrift by Wharton and Codman: "The three noblest forms of wall decoration are fresco-painting, panelling, and tapestry hangings."[20] Pictures should be chosen and hung with due regard to their size and proportion in relation to wall panels and to their suitability in the overall decorative scheme: "It must not be forgotten that pictures on a wall, whether set in panels or merely framed and hung, inevitably become a

part of the wall-decoration."[21] Their moral and educational uses, except for children, are not mentioned. Prints, mezzotints, and gouaches are banished to the boudoir. Photographs and "decorations of the cotillion-favour type" are banished altogether.[22] High-quality reproductions of great masters on great themes, however, are suitable for the nursery and schoolroom, where children absorb taste and beauty by osmosis.[23]

With Candace Wheeler's *Principles of Home Decoration*, the pendulum swings back to English models in philosophy and furnishing. William Morris is cited as the prototype of national leader in decoration that America regrettably lacks; the English Aesthetic Movement, as refined by Louis Comfort Tiffany and others in the United States, furnished the basis for decorative schemes. The educational value of a beautiful home is cited, but of a very different sort than the literal didactics recommended by Eastlake, Loftie, and Cook. "A beautiful home is undoubtedly a great means of education, and of that best of all education which is unconscious."[24] Further, the "simple cottage" can serve as a model as well as a mansion. Creative and eclectic use of varying, often exotic, objects is championed, although detailed, controlling advice is given in their choice and arrangement.

Wheeler specifically excludes pictures from treatment in her book, "because while their influence upon the character and degree of beauty in the house is greater than all other things put together, their selection and use are so purely personal as not to call for remark or advice." "Any one who loves pictures," she continues, "can hardly help placing them where they will also have the greatest influence."[25] Having thus shunted the subject aside through overstated deference, she proceeds to illustrate interiors many of which contain no pictures at all—and most interiors that do contain them have very few. By Wheeler's time, pictures have been seriously crippled as ideotechnic and sociotechnic operatives.

Elsie de Wolfe's *The House in Good Taste* does for the Continental-inspired strain of interior-decoration reform (Wharton and Codman et al.) what Candace Wheeler does for the English version. Under de Wolfe's credo of "Suitability, Simplicity, and Proportion" is articulated a function-based ethic independent of considerations of morality. Few justifications for her pronouncements are given. In most cases, the fact that she says so seems to be enough. She was a practicing decorator, on the nuts-and-bolts level, which none of her predecessors was.

De Wolfe discusses the subject of pictures only obliquely, which is odd, because the illustrations in her book show paintings to have been a major part of many of her decorative schemes (although others have mirrors or

blank panels placed where pictures might be expected). She does advise as to the height of pictures (eye level) and recommends the use of decorative pictorial friezes. As in other areas of furnishing, she advises restraint in the use of pictures, inveighing against "dot[ting] the walls with indifferent pictures" in dining rooms and arguing for "one good picture, or a good mirror, or some such thing above your mantel shelf" in a small apartment—it being more important that there be only one of it and that it be well placed than that it be any particular type of object.[26] With de Wolfe, pictures are fine but have no importance (moral or educational, for instance) beyond their purely decorative value. Effect is everything.

In the years following World War I, several factors converged to produce an atmosphere conducive to the flourishing of more popularly oriented publications on the subject of home decorating and furnishing: the country's population was being more rapidly concentrated in urban and suburban areas, away from rural ones; smaller, non-extended family units became the norm; the general prosperity encouraged the construction of many new housing units; and the American interior decorating and design profession came into its own. Decorating and furnishing advice publications took on a more down-to-earth, sometimes even do-it-yourself, slant. Their titles were often indicative of their more popular approach, as in Alice Carrick's *Next-to-Nothing House*, and sometimes harked back to the well-known advice books of earlier decades, as in Ekin Wallick's *Inexpensive Furnishings in Good Taste*, with a nod to Elsie de Wolfe, or Lucy Taylor's *Your Home Beautiful*, paraphrasing Clarence Cook.[27] No single style of decoration predominated, as the title of Helen Koues's *On Decorating the House in the Early American, Colonial, English and Spanish Manner* indicates.[28] In addition, there arose a somewhat freer style of decorating, loosely termed *Modern*—but, as articulated by the predominant advice books, even the Modern style was rigorously principled and curiously backward looking for the most part.

The prevailing recommendations of these writers for choice and display of pictures for the home followed in the "scientific" vein of Elsie de Wolfe (who remained very much on the scene) and her adherents, the professional interior decorators and designers who came in an ever-more-organized way to make their mark on wider and wider segments of society. The collaborative work of Harold Eberlein, Abbot McClure, and Edward Holloway, *The Practical Book of Interior Decoration*, published in 1919 and reprinted as late as 1937, is illustrative.[29] Their chapter on "Pictures and their Framing" is downright discouraging toward the display of original art in the home as potentially disruptive of their controlled and "scientific" schemes. They

recommended that one should "have few pictures rather than many, and omit everything not really desirable. Avoid the cluttering of walls—if one picture is sufficient for a space do not use two. If the wall surface is highly decorative . . . use none. Generally speaking, we are not attempting art galleries: the pictures in a house are part of the decoration, and all decoration should be consistent and proportionate."[30]

If the author-decorators are forced to admit independently acquired art into their schemes, they do so grudgingly, frankly admitting a preference for reproductions in most cases:

> The writers already have a sufficient task on hand and have no inclination to take over that of changing human nature. Pictures are not usually purchased as decorative units—the best possible thing for a certain situation—but because they themselves appeal to the buyer. The matter of fitting them in is often left for future consideration or none at all. At least, then, let us appeal for the buying of good pictures only: for good art almost universally will fit in—somewhere. The cultured may browse in many fields: it is difficult to guide those who have paid attention to other things in life and have neglected art, but they are at least safe in buying reproductions of the work of the masters of the past and present, provided the reproductions themselves are worthy and adequate.[31]

Further, pictures should match their environments in terms of period, style, color, and scale. Uncontrolled eclecticism is a cardinal sin. If "really good paintings of oil or watercolour" are to be incorporated, this should be done only with professional help: "Amateurish efforts at once condemn the taste of anyone ill-advised enough to hang them."[32]

But the Victorian belief in the potency of pictures is still an undercurrent. Alice Carrick, for instance, generally eschews pictures in her Colonial Revival decorative schemes. In her own bedroom, however, described in 1922, she reverts to the sentimentality that characterized a half century earlier: "Over [my own bed] hangs Rubens's *Madonna of the Parroquet*, in brown tones that match the mahogany; a protecting little picture, too, and you can fancy so readily a small child every night kneeling down and saying, 'Four corners to my bed, four angels round my head.'"[33] Similarly, Edward Holloway, in *The Practical Book of Furnishing the Small House and Apartment* (1922), observes that picture choice can be psychologically revealing. As an afterthought, following two pages of advice on furnishing the room of a teenage boy, he adds: "Just one word more: the pictures [his emphasis] he

puts on his walls will especially show the sort of young man he is."[34] William Loftie, writing fifty years earlier, would have agreed. But here is the difference: Loftie saw pictures as causes of behavior; by the 1920s they are treated only as effects.

Visual evidence supports the prescriptive writings. In the period following the Civil War through the 1870s, the period in which Loftie was writing, pictures of one sort or another, prominently displayed, were omnipresent in the public rooms of most households of wealthy and stylish Americans, as revealed by contemporary pictorial representations of them. In halls, parlors, dining rooms, and libraries, they hang in varied profusion (see, e.g., fig. 8.1). As for number and size, the pictorial evidence shows the period 1875 to 1885 to contain larger, showier, and more pictures in regular domestic contexts than any of the later periods under discussion. ("Regular domestic contexts" has been used so as to exclude the specialized private picture galleries which flourished later and will be discussed below.)

If most prosperous American Victorian homes in the 1870s and 1880s use picture display throughout domestic interiors to achieve ideological and social strategies, at the same time, the reform strains that devalue and set strict limits on the use of pictures begin to show their effect. These are the strains that by the end of the century will result in the Beaux-Arts, Colonial Revival, and Arts and Crafts styles of interior design and decoration and, after World War I, in the "International" and Modern modes. These styles exist alongside the writings of Eastlake, Cook, Wharton and Codman, Wheeler, de Wolfe, and their followers, who reject what is perceived to be heavy-handed, oversentimental, and aesthetically distasteful use of pictures indiscriminately throughout the house. Certain picture-types are discouraged and others encouraged, modes of display are strictly prescribed and controlled, and, finally, in some cases the use of pictures in certain interior spaces is eliminated altogether.

By the 1880s, in some genteel homes, controlled, sedate, symmetrical display has entirely replaced the more creative modes. Pictures join other objects in apparent obedience to the dictates of Eastlake and like-minded authorities. As the decade progresses, proclivities toward regimentation, rationalization, and selective elimination of pictures becomes more pronounced, particularly in upper-class homes. *Artistic Houses*, which first appeared in 1883, is a study in these inclinations.[35] The apartment of Louis Comfort Tiffany (an accomplished painter), the first set of rooms in the book, sets the tone (fig. 8.2). Done in Moorish, Japanese, and other exotic styles, the rooms are studiedly arranged. Almost no pictures appear. Where

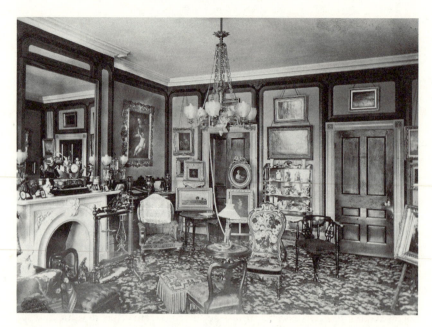

Fig. 8.1. Parlor, 2 Park Street, Boston, 1885. Photograph courtesy of the Boston Athenaeum.

they might have been, one is confronted with a stained-glass panel, ornamental wallpaper, a screen, pottery—in short, everything but pictures.

In addition to being displayed in a much more controlled, sedate, and symmetrical way, replacing the more creative modes of the preceding decades, pictures increasingly tend to be hung flat against the wall with hidden nails and cord, taking their place tight up against the two-dimensional wall space. Also in the 1880s comes the architect-decorator's use of a single large and overwhelming picture as the focal point of a decorative scheme.

If pictures tend to lose out to other decorative objects in the 1880s, in the 1890s their fate is even more ignominious: they lose out to blank walls in many professionally designed decorative schemes. By the end of the decade, the Arts and Crafts Movement, the good taste version of the Beaux-Arts style, and the Colonial Revival were all alternatives as home furnishing according to delineated rational principles, and all placed a premium on simplified, geometric furnishing patterns. What pictures there were tended to be captives of the overall plan: tiny pictures with overscaled oak frames in Arts and Crafts; pastel Pillement-type canvases literally captives of archi-

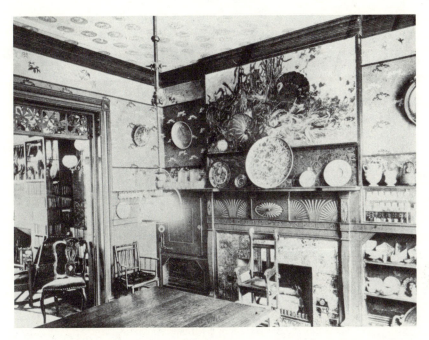

Fig. 8.2. Dining room, Louis Comfort Tiffany apartment, 48 East Twenty-sixth Street, New York, ca. 1880. *Artistic Houses* 1.

tectural panels in Beaux-Arts; and a simple portrait or two in Colonial Revival, carefully placed so as not to interfere with the decorative arts objects that prevailed. Figures 8.3 and 8.4 show two interiors, one Beaux-Arts and the other Arts and Crafts, where pictures have been eliminated almost entirely.

But by no means was the reform advice always followed. At both ends of the socioeconomic scale it often went largely unheeded. As William Seale points out in *The Tasteful Interlude*, many people "above fashion" (his examples are Admiral George Dewey and Robert Todd Lincoln) continued to furnish their houses in outmoded pictorial profusion even after the turn of the century.[36] And among the middle class, especially outside major urban centers, the pleasure of creative "artistic" display of pictures was often freely indulged (see, e.g., fig. 8.5). By the late teens and twenties, however, even the lower socioeconomic levels are directly affected by the many popularly oriented advice publications. In example after example, in both books and periodicals, writers give less-is-more advice. Figure 8.6 is an example of the

Fig. 8.3. Parlor, house of George Finch, Ninth and Cooper streets, St. Paul, Minnesota, ca. 1896. Photograph courtesy of the Minnesota Historical Society.

stressing of reduction of the number of pictures and strict control and ordering of their placement, in the interest of saving money as well as good taste.

I submit that the general devaluation of pictures in upper-middle-class and upper-class American interiors between the 1880s and 1920s was part and parcel of the gradual process of the loss of traditional values (and the discontent that followed that loss) that T. J. Jackson Lears and others have described.[37] Specifically meaning-charged and authority-laden pictures were seen, both consciously and unconsciously, as inconsistent with enlightened post-Darwinian views, but surrogates for them (less-potent varieties of pictures, ceramics hung on the wall, stained-glass panels, and so forth) were required as "pacifiers." Finally, pictures are abolished altogether in the most extreme cases of the Beaux-Arts and Arts and Crafts styles, and then allowed back into the household but only after they had been subdued and rendered subservient to imposed, rationalist decorative schemes.

Then how to account for the fact that at the same time as American home decorators were downgrading pictures, the great American collections of, for instance, J. Pierpont Morgan, Henry Clay Frick, Isabella Stewart Gard-

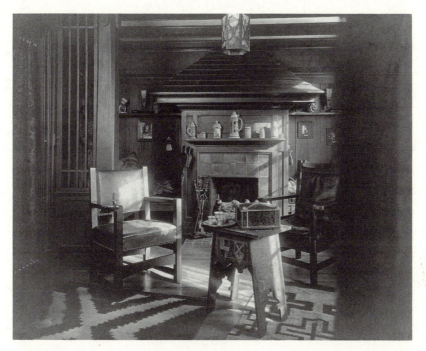

Fig. 8.4. Living room, residence of Martin Hawley, 1801 Eutaw Place, Baltimore, ca. 1900. Photograph courtesy of the Maryland Historical Society, Baltimore.

ner, Benjamin Altman, and Henry Walters were being formed and housed in their own special, elaborately constructed spaces as adjuncts to the collectors' houses—in many cases later turned over to public museums en masse, or even incorporated into museums of their own? It is suggested that this was a logical consequence: "serious pictures," banished from lived-in spaces of the modern home as uncomfortably overladen with ideotechnic value, are consigned to, indeed enshrined in, their own chapels and temples—for purposes of periodic communing on high occasions of reflection, devotion, and power display.

The phenomenon of the devaluation of pictures in domestic contexts, I further submit, had a marked effect on artists and art. Thomas Cole's generation had been almost entirely dependent on the demand for art to be displayed in lived-in interiors. As museums and collectors-with-galleries became the repositories for works of art, less attention needed to be paid to painting appropriate subjects in appropriate colors, sizes, and styles for the

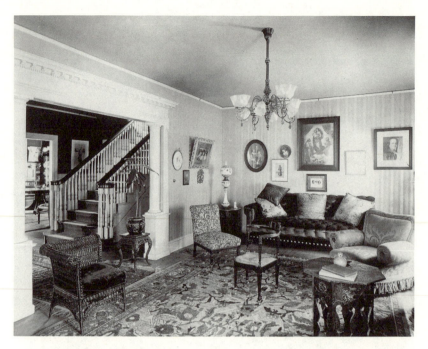

Fig. 8.5. Parlor, Boston suburb, ca. 1900. Courtesy, the Library of Congress.

Fig. 8.6. "An Inexpensive Living-Room in Modern Style," Edward Stratton Holloway, *The Practical Book of Furnishing the Small House and Apartment,* 1922.

home. Once the constraints of moral, didactic, and decorative dictates are removed (i.e., when the market for them recedes), the sky is the limit. It is no coincidence that the slide from historiated landscapes to Barbizon "realities" to Impressionism to Post-Impressionism to Modernism coincided with the dwindling of the middle-class and upper-class home market (strictly defined) for works of art. The dogma of art for art's sake was not the death knell for "bourgeois" art; rather, the drying up of the bourgeois art market made art for art's sake a necessary cry for artists if they were to survive.

Notes

1. Lewis Binford, qtd. by Kenneth L. Ames, "Material Culture as Non-Verbal Communication: A Historical Case Study," *Journal of American Culture* 3, no. 4 (Winter 1980): 619–41.

2. William J. Loftie, *A Plea for Art at Home* (Philadelphia: Porter and Coates, 1879), 7.

3. Ibid., 20.

4. Ibid., 15.

5. Ibid., 47–49.

6. Ibid., 55.

7. Ibid., 67.

8. Ibid., 69.

9. Ibid., 99.

10. Charles Locke Eastlake, *Hints on Household Taste* (London: Longmans, Green, 1878; New York: Dover, 1969), xxii.

11. Ibid., 185.

12. Ibid., 186–87.

13. Ibid., 188.

14. Ibid., 191.

15. Clarence Cook, *The House Beautiful* (New York: Scribner, Armstrong, 1878; New York: North River Press, 1980), 45.

16. Ibid., 121.

17. Ibid.

18. Ibid., 121–22.

19. Edith Wharton and Ogden Codman, Jr., *The Decoration of Houses* (New York: Charles Scribner's Sons, 1897), xxii.

20. Ibid., 38.

21. Ibid., 46.

22. Ibid., 132.

23. Ibid., 192.

24. Candace Wheeler, *Principles of Home Decoration* (New York: Doubleday, Page, 1908), 15–16.

25. Ibid., 225.

26. Elsie de Wolfe, *The House in Good Taste* (New York: Century, 1911), 243.

27. Alice Van Leer Carrick, *The Next-to-Nothing House* (Boston: Atlantic Monthly Press, 1922); Ekin Wallick, *Inexpensive Furnishings in Good Taste* (New York: Hearst's International Library, 1915); Lucy D. Taylor, *Your Home Beautiful* (New York: George Doran, 1925).

28. Helen Koues, *On Decorating the House in the Early American, Colonial, English and Spanish Manner* (New York: Cosmopolitan Book, 1928).

29. Harold D. Eberlein, Abbot McClure, and Edward Stratton Holloway, *The Practical Book of Interior Decoration* (Philadelphia: J. B. Lippincott, 1919).

30. Ibid., 350.

31. Ibid., 352.

32. Ibid.

33. Carrick, *The Next-to-Nothing House*, 213.

34. Edward Stratton Holloway, *The Practical Book of Furnishing the Small House and Apartment* (Philadelphia: J. B. Lippincott, 1922), 155.

35. [G. W. Sheldon?], *Artistic Houses* (New York: D. Appleton, 1883–84).

36. William Seale, *The Tasteful Interlude*, 2d ed. (Nashville, Tenn.: American Association for State and Local History, 1981), 216–19.

37. T. J. Jackson Lears, *No Place of Grace* (New York: Pantheon Books, 1981), 96.

The Artistic Portrait Photograph

Shirley Teresa Wajda

Thomas Bell, in his 1941 novel *Out of This Furnace*, chronicled his own family's past through the struggles of three generations of a thinly fictionalized Slovakian family living in the shadows of the blast furnaces of the Pittsburgh steel mills. The patriarch, Djuro Kracha, emigrates to America in the mid-1880s, working first on the railroad and then in the mills of Braddock, where his children grow up amid cinder dumps. His eldest daughter, Mary, weds a fellow Slovak, Michael Dobrejcak, and together they struggle to make a better life for themselves and their four children.

One episode in the life of the Dobrejcaks reveals how ordinary things assume symbolic meanings. After the Friday dinner dishes have been cleared, Mike and Mary solemnly take out the payment books of the butcher and grocer, and lay them beside Mike's pay envelope. "He shook the envelope and peered into it. 'No more. Eighteen-ninety is all there is.'"

"How much have you put aside for the rent?"

"Seven dollars. Seven dollars and some change." She got an earless cup from the cupboard.

Mike began figuring. "Five dollars to the rent. Three to the butcher. Five to the store." He looked up. "Have they been saying anything?"

Mary shrugged. "As long as I give them a little every payday they seem satisfied. What can they say? . . . We need coal. You remember I told you—"

"Can we let it go until next payday?"

She shook her head reluctantly. "We'll need another load by the end of the month. I've tried to be careful but you know how cold it has been. So early in the winter too."

"Two-fifty for coal. How much does that leave us?" He figured, moving his lips. "Fifteen-forty. And fifteen-fifty from eighteen-ninety—three-forty."

Mary looked down at her hands. "Mihal, I want to have our picture taken. All together, the whole family. You said yourself it would be nice. We wouldn't have to get many right away—just so it was taken. Please, Mihal."

"Marcha, be reasonable. Here's your answer." He moved his hand at the books and the money on the table.

"You could go to the bank." She continued hurriedly, "We wouldn't have to get many right away. Just three. That would cost only two-fifty and we could have more made later; he would keep the plate if we asked him."

"If I keep going to the bank pretty soon there won't be anything there to go there for."

"But it would be so nice to have a picture of all of us, while the children are small."[1]

There are a few extra dollars this week, and for the Dobrejcaks, necessities outweigh luxuries in their finances. Yet what does Mary desire? That the week's few extra dollars pay for a visit to the photographer's studio, for a hard-won portrait of one moment in this working-class family's life—even if it means a bank loan. The Dobrejcaks obviously cannot spare the money; more pressing demands tax their meager resources. To choose a photograph is to recast a perceived luxury as a necessity. The photograph will serve the family not only as a mirror of what is and a reminder of what was, but also as a status marker, symbolizing a certain acceptance of American bourgeois values—something Mary's parents never apprehended—thus serving to demarcate the partially assimilated second generation from its predecessor. Along with Michael's purchase of a desk, which his friends and father-in-law deem ostentatious and useless—after all, as Djuro Kracha exclaimed, "What the devil do you want with a desk? You don't write two letters a month" (156)—Mike's and Mary's use of specific things as status markers and tools for social and self-definition help us to understand how things acquire, or even lose, meaning. Mike's and Mary's choices, although fictional, mirror choices made by many Americans between the years 1890 and 1930.

Those choices were based within the constantly changing system of meaning making we commonly call culture. Goods, such as photographs,

help us domesticate our world and ourselves by making real and tangible all that is fleeting—ideals, emotions, news, relationships.[2] Mike did not object to Mary's wish for a family photograph; he merely argued that they could not afford it. Yet he was proud of his American citizenship, for which he had learned to read and to write (hence the desk), and equally proud of his family. Indeed, Mike eventually consents to Mary's wishes, and that family photograph is all that is left to their eldest son who will, by story's end, attain the American dream that defined Mike's and Mary's aspirations.

Photographs are now such familiar and accepted possessions that it is difficult to imagine a life without them. We no longer comprehend the "photographness" of the photograph, emphasizing instead the subjects of the camera. Photographs to us are, often, just pictures. We say, "That's Uncle Mike and Cousin Terry," not "this is a thirty-five millimeter Kodak color print snapshot taken with a Nikon single-reflex camera of Uncle Mike and Cousin Terry." Let us not forget, too, that photographs are also objects. This is not to say that Americans defined photographic images in the same way, but it is this trait—the photograph-as-object—that informs the following discussion. The fact that one could acquire a photograph in an era before affordable amateur photography was in itself an indication of status—a strategy of proving one's membership in a group by sharing names or knowledge[3]—and endowed the photograph with a meaning beyond the associations derived from the image alone. Simply, the ability to purchase a studio-produced portrait photograph made manifest a meaning both dependent on and beyond the affective, intellectual, or aesthetic associations derived from the image alone. More to the point, to analyze the photograph as an image and an object within a specific context—the turn-of-the-century bourgeois parlor—provides us with a more comprehensive understanding of the photograph's historical and historicizing role for Americans.

Photography was still a relatively new phenomenon in 1890. Louis Jacques Mandé Daguerre had perfected a process of fixing permanently an image rendered with light on a chemically treated surface only in 1839, and the early history of photography is one of constant technological innovation. Within twenty-five years of the daguerreotype's invention, all the other major photograph types that would be incorporated into the parlorscape were developed. The introduction of these media followed a two-step process: the first "generation"—daguerreotypes, ambrotypes, and tintypes—were unique positive images on metal or glass. By the eve of the Civil War, the introduction of the glass-plate negative and albumen

printing-out paper heralded the new and eventually permanent practice of multiple-image production on paper. By 1890, the typical American parlor held all these types of photographs, but for the most part two types of photographs were the most popular: the carte de visite, and the larger cabinet card.[4]

This is not to say, of course, that American parlors contained just these types. Large-scale copy work of famous personages, landscapes, and respected art masterpieces were also found, as were stereographs and stereoscopes, but I would like to limit the discussion here to those images for which Americans posed—that is, portraiture (fig. 9.1). Portrait photographs do appear in great quantities and this profusion—this revolution—in acquiring and displaying likenesses is noteworthy.[5]

Photographs appear in every nook and cranny of the turn-of-the-century parlor—on mantels, in portfolios and albums, on viewing stands and easels, in baskets and on walls. The bourgeois idea of *home* exalted the domestic sphere as the place where important cultural and family values were cultivated and imparted. More care and expenditure were invested in the parlor than any other room of the house, for it was the parlor that communicated the family's commitment to the perfection of society by perfecting moral character through education. Simply, the parlor, tended to by the mistress of the house, was considered both a public space and as a public face for the family. In the first role, the parlor was reserved for family interaction and company reception; in the latter, the parlor served, through the objects displayed there, to define the family and to signal to the visitor the family's membership in the club known as Victorian.[6]

The carte de visite and its successor, the cabinet card, served to symbolize the sitter's creativity and the owner's artistic taste. The carte de visite, or visiting card, was reportedly first introduced in Europe by the Duke of Parma, in 1857 (apocryphal or not, this tidbit was most likely a persuasive promotion of the photograph, advertising Continental fashion as well as social use). This little card (approximately two and a half inches by four inches) was the rage in Europe and the United States (where it was introduced in 1861), because it was duplicable as well as fashionable. Not only could friends and relatives give or send their likenesses to others both near and far, they could collect these images in albums. The carte de visite fad lasted only a decade, although they were produced into the twentieth century, and benefited from and abetted the rise of the fan club. One could purchase likenesses of favorite actors or actresses, monarchs or statesmen. A collection of cartes de visite in a leather-bound album signaled its owner's

Fig. 9.1. Cabinet card photographic portrait taken in an artistic manner. Gilbert & Bacon, photographers, Philadelphia. Author's collection.

commitment to cosmopolitanism—being "at home" in the world—as well as revealed how one saw one's self in society.

The facts that early albums could be easily arranged, having slots or sleeves to hold images, and that the identities and relationships of the subjects are often now lost, render it difficult for historians to "read" an album's intended "narrative." Yet the design of the albums gives clues to their intended use. Early albums were small and leather bound. The word *Album* was usually embossed in gold only on the spine. An index page offered the owner or reader a means to chronicle and identify images. With only a visible marker of the volume's purpose on the spine, the carte de visite album replicated expensive and cherished books—and the idea of status conveyed by these artifacts emblematic of literacy and leisure. Early albums were designed to be kept in a safe but noticeable place, cataloged with other sources of knowledge.

On the other hand, the cabinet card—*cabinet* meaning "suitable by reason of attractiveness or perfection for . . . display in a cabinet"—was the most popular form of photographic portraiture after 1880, although this form had been introduced in the United States in 1866. Cabinet cards differed from cartes de visite: these larger images, less strenuous on the eye seeking detail, were meant to be displayed, and displayed these images were.

Mantels seem to have been the most obvious and popular site for photographs. Mantels, of course, embellish the hearth—the very symbolic center of the home. Photographs of family and friends served as icons on this altar. There was no reason, however, that these images could be less than tasteful; as one decorating manual suggested, mantels, no matter how ornately carved, mirrored, or lambrequined, could only become "more artistic still by using photographs." Even solitary bracketed wall shelves became mantel substitutes where their contents connoted "mantelness"—photographs, vases, and the complement of adornments.[7]

"Samp [?] and Abbie" chose to pose next to their altar of culture, what was popularly termed an *art-corner* contained on what should be considered the quintessential piece of Victorian furniture, the whatnot (fig. 9.2).[8] Found on Samp and Abbie's etagere are their library, specimens of natural history (notice the shell at the lower left), and other treasures. A bust of William Shakespeare lends a literary and cultural imprimatur to the collection he seemingly protects, but of course what concerns us here is the number of photographs—primarily cartes de visite and a few cabinet cards—that occupies this corner. Not only does every shelf hold portrait photo-

Fig. 9.2. "Our Home, From Samp and Abbie to Fannie Rich, Minneapolis, Minn., Oct. 8, 1878." Stereograph, M. Novack. From private collection. Photograph courtesy of the National Museum of American History, Smithsonian Institution, Washington, D.C.

graphs, the wall also holds several larger portrait photographs, and even a
wall pocket behind Samp's head appears to hold photographic images.
Samp and Abbie pose before, or, perhaps more appropriately stated, with,
studio-produced portraits of their network of kith and kin, and take ob-
vious pride in that act. These photographs fit well the bourgeois definition
of "artistic"—proofs of creative expression and self-development.

Samp and Abbie displayed a knowledge of good taste and culture in their
choices and their arrangement of things. They obviously agreed with Henry
T. Williams and Mrs. C. S. Jones, who, in their household design manual
Beautiful Homes or, Hints in House Furnishing, advised their supposedly like-
minded readers:

> Household taste is but a synonym for household culture; and she is a
> wise woman who surrounds those she loves with objects of beauty; for
> she may safely rely on the influences (so intangible) which the beauti-
> ful (both in nature and art) ever exerts in a moral, intellectual, spiri-
> tual and social point of view. The beautiful picture or softly tinted
> wall, the peaceful drapery or chiseled statuette may perhaps be the
> means of opening some fount of wisdom, else closely sealed, or touch-
> ing some sensitive nerve of thought, otherwise dormant.[9]

The album did not lose its popularity when the fad for cartes de visite
waned in 1866. As a matter of fact, albums were enlarged, bound in velvet
or tapestry (imitating the feel of the increasingly "overstuffed" parlor) to
accommodate the larger, more popular cabinet card after 1880. Remember
that the album was an archive of both knowledge and conviviality. Occupy-
ing the premier spot on the parlor center table, a cabinet card album often
came with a matching stand that invited parlor visitors to gaze at its con-
tents. Mirrors inset in the plush covers of these albums reflected the viewer,
making that person part of the social record within the covers. One impres-
sive plush album may serve here as an example: to open the album one had
to pull the volume away from its stand, then unlatch the volume. This ac-
tion also revealed another, larger mirror. A file box (of sorts) is found behind
the stand, to store other, perhaps not-so-artistic cards, or to suggest, in a
subtle way, a family member's or friend's "falling out" (figs. 9.3a and
9.3b).[10]

The locations of portrait photographs within the parlor—on premier
places of culture such as mantel, art corner, or center table—reveal their
status as "artistic" elements in the parlorscape, their elegance as well as their
usefulness. How were these images "artistic"? First of all, these images were

Fig. 9.3 a, b. Parlor cabinet card album, ca. 1885. Courtesy, Clarion County Historical Society, Clarion, Pennsylvania.

posed. Paradoxically, these reproducible images, as Bruce W. Chambers has observed, approximated unique art works through the employment of widely approved conventions of social behavior, mirrored in and borrowed from the theater, and prefaced on the consensus of what a portrait should look like.[11] That consensus was in turn based on traditional modes of portraiture. One acted on a stage when one posed for a studio portrait. Such choices were not unknown to late nineteenth-century Americans, who were fascinated with the theater and the theatrical.[12] From mid-century on, Americans created and joined fan clubs; collected cartes de visite of their favorite performers; staged private theatricals in their parlors; attended plays in record numbers; and read about their favorites in popular journals such as *Godey's Lady's Book*, *Harper's New Monthly Magazine*, or *Scribner's Monthly*, imitating them in photographs.

The plain bust portrait photograph remained popular. Vignetting—a framing technique that featured a monotone background rather than the appearance of space or a backdrop behind the figure—served to emphasize the subject and allowed the photographer to embellish the portrait in new ways. In part, vignetting became popular as retouching the negative—a practice known by 1870—to erase blemishes and smooth wrinkles and

overall to improve on nature became practicable and acceptable. Burnishing, also a standard practice after 1870, glazed the final print, resulting in a high-gloss finish. Simply, these idealized images were more pictorial, the subjects becoming the main decorative elements. Cabinet-card portraiture provided a vehicle for creative expression that conformed to popular notions of the artistic and as a status object marked the owner and sitter as cosmopolitan.

Photographers faced with competition by the rise of amateur interest in photography—the detective camera appeared in the late 1880s, and George Eastman patented roll film in 1888—sought to distance themselves in order to retain their patronage as well as to explore and to expand the camera's potential. Professionals began calling themselves "artistic photographers" who practiced their craft in "studios": a decidedly self-conscious redefinition of the "operator" working in "operating" or "sitting" rooms only thirty or forty years earlier. This new professional role is aptly revealed in photographers' advertisements, most often carried on the reverse of the cards themselves. I. E. Hall advertised his Meadville, Pennsylvania, "ground floor gallery" (a point worth noting, given the fact that most photography studios were located on top floors of buildings to ensure the necessary sunlight for proper exposures and development) with sunbeams, camera, and artist's paraphernalia—palette, brushes, maulstick, paint box—as well as photographic apparatus. The assemblage in part, along with leafy branches of blossoms, frames an unfurled scroll containing the name of Hall's concern. The scroll not only duplicates a popular photographic style but also reveals slightly a background—also used in photographic practice—of trees and fence (fig. 9.4).

As cabinet-card portraiture became more and more popular, the ability of the photographer to manipulate the final product through technical processes as well as studio practices approximated the traditional "artist's" craft. Saylor's New York Gallery, oddly enough located at 411 North Sixth Street in Reading, Pennsylvania, not only used the association of the cosmopolitan center of New York City but also employed an iconographic marker wedding nature—sunbeams radiating from the eye—the studio camera and an artist's palette and brushes. As a matter of fact, Saylor employed several advertising motifs in his cabinet-card portraiture. A young, bespectacled academician, known by his regalia and by the owl perched on his chair (the chair back carrying a lyre design connoting the musical art), sits somewhat laconically—worldly—in front of an easel containing a canvas carrying the words *Art Studio*. He holds an artist's maulstick, pointed to-

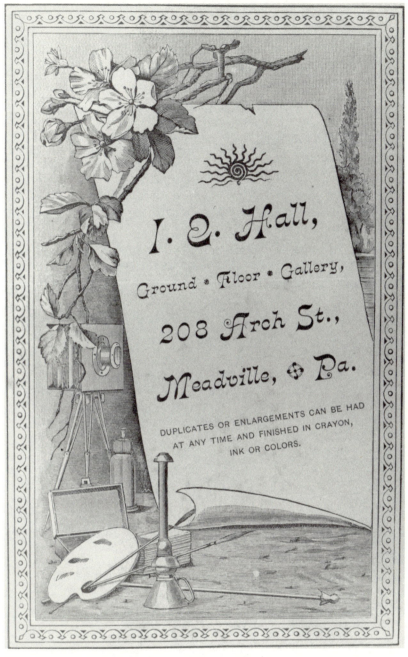

Fig. 9.4. Advertisement on the reverse of cabinet card portrait photograph, I. E. Hall, Ground Floor Gallery, Meadville, Pennsylvania. Author's collection.

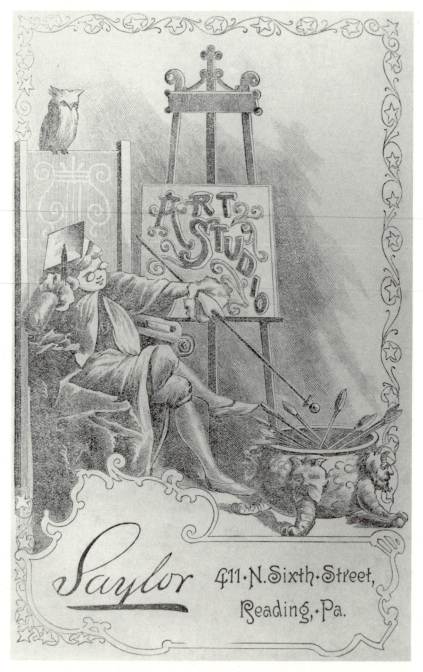

Fig. 9.5. Advertisement on the reverse of cabinet card portrait photograph, Saylor Art Studio, Reading, Pennsylvania. Author's collection.

ward a footed urn of brushes (fig. 9.5). In some advertisements, Saylor employed only "New York Gallery" as his business's name, but all the photographic references have been omitted. Only the easel, landscape, and maulstick remain. Saylor went even further, employing a bare-breasted, barefoot personification of Art on his cards. Such iconography implies that the photographer had freed himself from the camera—deemed "nature's eye"—and possessed the skills of reconstructing nature through artifice, much like traditional artists.

As quickly as photographic portraiture gained popular acceptance, revealed in its inclusion in the ritual, symbolic space of the parlor, it was just as quickly attacked by household advice writers. As early as 1881, Ella Rodman Church, in *How to Furnish a Home*, excoriated the Victorian concept of "parlor": "Who can not recall the huge, towering bouquets of dried grasses in gaudy china vases on the mantel; the numerous family photographs on the walls, in a bleak margin of ghastly white, enlivened, perhaps, by a coarse chromo given as a premium by the vapid periodical that is piled up in the back numbers on the table . . . the hideous plaster busts of popular men?"[13]

In 1908 Fred Hamilton Daniels humorously chastised readers about the less-than-considered display of photographs in the parlor through a hopefully apocryphal story:

> A visitor at a country home was astonished upon entering the parlor reserved for state occasions to see extending around the room three narrow shelves supporting cabinet photographs. He looked at this display in amazement, and noting his attention, the hostess remarked, "You seem interested in my decoration?"
>
> "Yes," replied the visitor, "it certainly is unique!"
>
> "Almost everybody notices it the first thing," returned the lady, "I'll tell you how it is. You see my husband is an undertaker, and these are pictures of the people he has buried."

Daniels concluded that he and his readers resembled this woman in their habit of including family photographs in the parlor. "To be sure," he reasoned, "we ought to cherish the pictures of our friends or relatives, but there is not reason why we should expect others to do so. Surely we can hardly expect outsiders to be enthusiastic over portraits in which we have not enough interest to know whether the people pictured are above ground or below."[14]

By 1916, Hazel H. Adler had proclaimed the end of Victorian clutter and the introduction of the "New Interior":

Objects of sentimental association, of affected culture, together with certain heirlooms and souvenirs . . . should find a happy end in a memory chest. . . .

Homes which cannot free themselves from the clutter of trivial and futile objects are mute declarations of the insincerity of their creator's pretentions to good taste and refinement. . . . "No junk!" is the cry of the new interior—no place for anything which does not serve some definite utilitarian or decorative function.[15]

What Adler and her contemporaries advocated was a new Modernist aesthetic that was "utilitarian" and true to nature and not artificial—that is, artistic. What does this mean for parlor photographs? Were they now to be considered "junk"? The new aesthetic emphasized the decorative and utilitarian; in the new living room, the parlor's replacement, pictures should not excite: "They should display pleasing subjects which will not in any way distress those looking at them; for example, such pictures as a shipwreck at sea or sheep standing in a snowstorm are not restful subjects, because they create a feeling of sympathy."[16] Portrait photographs had no place in the new living room, where affections should not be revealed by things encrusted with outdated moralistic meaning. Modernist thought postulated the rational, not the sentimental. Photographs of family, friends, and the otherwise celebrated could evoke feelings, which could disrupt the daily, rationalized flow of life through the living room. Motion, not emotion, expressed the new type of individual, the new type of status. Studio portraits seemed too contrived and staid for the new culture of personality, embracing the active and the ever changing.[17]

Indeed, photography journals after 1890 chart a marked increase in the number of amateur camera clubs through the United States. Most clubs sponsored several group outings yearly, exhibited members' work at juried exhibitions, and through dues, offered and maintained darkrooms and meeting spaces. The pursuit of amateur photography was often paired with other then-novel pastimes—bicycle riding, and later auto touring—that took every family member out of the home. Even hunting clubs invited members armed with cameras. The pairing here would seem obvious, for the bourgeois American, having created home as a secure camp, sought to domesticate the world as well: after all, the term *snapshot* first referred to a hunter's getting a quick shot off without aiming; one loads, shoots, and aims a camera as well as a rifle. Both actions appropriate: the gun, its prey; the camera captures its quarry through the lens. Amateur photography was also a cosmopolitan endeavor, fitting the more active definition of leisure.

We may return to *Out of This Furnace* to sum up the changes in the rela-
tionship between the consumer and the photograph by 1930. Recall that
Mary and Mike Dobrejcak eke out a living, and spend several, rare extra
dollars, on a family portrait. Mary and Mike, however, die all too young,
and leave only the photograph and the desk to their eldest son Johnny,
nicknamed Dobie.

Dobie, in the 1920s, is an electrician closed out of the mills due to a
strike. With free time on his hands, he bicycles all around the Pittsburgh
area: "It was a warm, hazy day; the air was very still, the river sparkled with
sunlight and autumn had set the hills flaming. He felt a little like a world
traveler and little like Daniel Boone, and longed for a camera to capture
something of the moment forever" (243).

The camera in the hands of amateurs was a tool of a conqueror, one who
domesticates through knowledge and categorization—an urbane endeavor.
The camera in the hands of the amateur also influenced the subject matter,
as well as the style of the image. Again, the life story of the Dobrejcak fam-
ily tells the tale. After Kracha's funeral, near the end of the novel, Dobie,
his wife Julie and his brother Mikie sit in the kitchen, reflecting on life:

"Reminds me." Mikie rose and went upstairs. He returned carrying
his camera. "I want a couple pictures of you two."

"In here?"

"Sure. I'm using a fast film and I'll pull her wide open."

Dobie, a shade self-conscious, began rolling a cigarette. Mikie
snapped him licking it. When he pointed the camera at Julie she ex-
claimed, "My goodness, I'll look terrible! At least let me take off the
apron and get these potatoes out of the way."

"No, no! You sit right there and peel potatoes. Only don't hold
yourself so stiff. Smile. Think of something pleasant. Think of your
wedding night or something."

"My wedding night! Whatever made you think of that?" She
glanced at Dobie and burst into laughter, and Mikie got her with her
head back, her mouth open, a potato in one hand and a paring knife in
the other. (376)

Note that Dobie and Julie wish to pose. Accustomed to what portraits
should be, Julie begins to stiffen and primps herself for the camera. Yet
there is a dissonance here—the kitchen is not a studio. And the artistic here
is not that of performance before a camera but that of the realistic art that is
daily life. The camera in the hands of amateurs provided a new means of
displaying class status; those who could afford a camera used it in their lei-

sure time. Amateur photography also facilitated a new aesthetic, more "natural" to out modern eyes. Fathers taking pictures of family members in the kitchen, the backyard, or at Old Faithful created and still create a family record and a status marker that fit new notions of what the ideal family was—more private, nuclear, and active. The static elegance of the Victorian photographic studio portrait was gone, as was the parlor in which it was displayed; yet the photograph retains its usefulness to help us make sense of ourselves and our culture.

Notes

This essay is based in part on my dissertation, "'Social Currency': A Domestic History of the Portrait Photograph in the United States, 1839–1889" (Univ. of Pennsylvania, 1992). See especially chapters 6 and 7.

1. Thomas Bell, *Out of This Furnace: A Novel of Immigrant Labor in America* (1941; rpt. Pittsburgh: Univ. of Pittsburgh Press, 1986), 182–83. Subsequent page references appear in the text.

2. The study of the cultural roles and meanings of things has concerned scholars in anthropology, art history, history, and American studies. See Thomas J. Schlereth, comp. and ed., *Material Culture Studies in America* (Nashville: American Association of State and Local History, 1982), and more recently, Robert Blair St. George, ed., *Material Life in America 1600–1860* (Boston: Northeastern Univ. Press, 1988); Grant McCracken, *Culture and Consumption: New Approaches to the Symbolic Character of Consumer Goods and Activities* (Bloomington: Indiana Univ. Press, 1988); and Mihaly Csikszentmihalyi and Eugene Rochberg-Halton, *The Meaning of Things: Domestic Symbols and the Self* (Cambridge: Cambridge Univ. Press, 1981).

3. Mary Douglas with Baron Isherwood, *The World of Goods: Towards an Anthropology of Consumption* (New York: Basic Books, 1979), 76.

4. Standard histories of photography stress generally technological innovation and/or the aesthetics of the photographic image. See, for example, Beaumont Newhall, *The History of the Photograph from 1839 to the Present Day*, 5th ed. (New York: Museum of Modern Art, 1982); Beaumont Newhall, *The Daguerreotype in America*, 3d rev. ed. (New York: Dover, 1976); Helmut Gernsheim and Alison Gernsheim, *The History of Photography from the Camera Obscura to the Beginning of the Modern Era* (New York: McGraw-Hill, 1969). Robert Taft, *Photography and the American Scene: A Social History 1839–1889* (New York: Macmillan, 1938), is an early consideration of the photograph's meaning within American culture, as is Richard Rudisill's *Mirror Image: The Influence of the Daguerreotype on American Society* (Albuquerque: Univ. of New Mexico Press, 1971); and, most recently, Martha A. Sandweiss, ed., *Photography in Nineteenth-Century America* (New York: Harry N. Abrams, for the Amon Carter Museum, 1991).

5. On stereographs, see William C. Darrah, *The World of Stereographs* (Gettysburg: Times and News Publishing, 1977); Edward W. Earle, Jr., ed., *Points of View: The Stereograph in America—A Cultural History* (Rochester: Visual Studies Workshop, 1979); Richard N. Masteller, "Western Views in Eastern Parlors: The Contribution of the Stereograph Photographer to the Conquest of the West," *Prospects* 6 (1981): 55–71; Shirley Wajda, "A Room with a Viewer: The Parlor Stereoscope, Comic Stereographs, and the Psychic Role of Play in Late-Nineteenth-Century America," in *Hard at Play: Leisure in America, 1840–1940*, ed. Kathryn Grover (Rochester and Amherst: Margaret Woodbury Strong Museum and Univ. of Massachusetts Press, 1992). On landscape and view photographs for framing, see Jane Addams, *Twenty Years at Hull House with Autobiographical Notes* (New York: Macmillan, 1910); Lizabeth A. Cohen, "Embellishing a Life of Labor: An Interpretation of the Material Culture of American Working-Class Homes, 1885–1915," *Journal of American Culture* 3 (Winter 1980): 752–75.

6. Katherine C. Grier employs the term "public face" in *Culture & Comfort: People, Parlors, and Upholstery 1850–1930* (Rochester and Amherst: Margaret Woodbury Strong Museum and Univ. of Massachusetts Press, 1988), 59. The bourgeois parlor as a ritual space, not to mention the symbolic aspects of the entire Victorian house, have interested many scholars: Kenneth L. Ames, "Material Culture as Non-Verbal Communication: A Historical Case Study," *Journal of American Culture* 3 (1980): 619–41 (on parlor organs); Clifford Edward Clark, Jr., *The American Family Home, 1800–1960* (Chapel Hill: Univ. of North Carolina Press, 1988); Sally McMurry, *Families and Farmhouses in Nineteenth-Century America: Vernacular Design and Social Change* (New York: Oxford Univ. Press, 1988); Marilyn Ferris Motz and Pat Browne, eds., *Making the American Home: Middle-Class Women and Domestic Material Culture, 1840–1940* (Bowling Green, Ohio: Bowling Green State Univ. Popular Press, 1988); William Seale, *The Tasteful Interlude: American Interiors through the Camera's Eye, 1860–1917* (Nashville: American Association for State and Local History, 1981); George H. Talbot, *At Home: Domestic Life in the Post-Centennial Era, 1976–1920* (Madison: State Historical Society of Wisconsin, 1976); and, of course, Karen Halttunen, *Confidence Men and Painted Women: A Study of Middle-Class Culture in America, 1830–1870* (New Haven: Yale Univ. Press, 1982).

A note on terminology: *Victorianism* presents a bit of a dilemma in that it has served to describe an era of values deemed so monolithic and compelling as to negate dissent and change and to preclude existence of alternative world views. This, common sense and recent scholarship dictate, doesn't hold true. We would do better to think of American cultures in the nineteenth century. Here I sometimes employ *Victorian* as a shorthand for the process of *embourgeoisment* characteristic of an increasingly industrial and urban America, defining the hegemonic culture that in turn defined other, symbiotic cultures. For a general study of Victorian culture, consult Daniel Walker Howe, "American Victorianism as a Culture," *American Quarterly* 27 (Dec. 1975): 507–32; Alan Trachtenberg, *The Incorporation of America: Culture & Society in the Gilded Age* (New York: Hill and Wang, 1982); and, most

recently, Thomas J. Schlereth, *Victorian America: Transformations in Everyday life 1876–1915* (New York: Harper Collins, 1991).

7. Quotation, Henry T. Williams and Mrs. C. S. Jones, *Beautiful Homes or, Hints in House Furnishing* (New York: Henry T. Williams, 1878), 114. Clarence Cook also advocated the use of photographs on the mantel in "Beds and Tables, Stools and Candlesticks: II. More About the Living-Room," *Scribner's Monthly* 11, no. 3 (Jan. 1876): 342–57.

8. This distinctive piece of furniture is the subject of Angel Kwolek-Folland's "The Useful What-Not and the Ideal of 'Domestic Decoration,'" *Helicon* 8 (1983): 72–83.

9. Williams and Jones, *Beautiful Homes*, 3. For an overview of household art advice manuals and bibliography, see Martha Crabill McClaugherty, "Household Art: Creating the Artistic Home, 1868–1893," *Winterthur Portfolio* 18, no. 1 (Spring 1983): 1–26.

10. The social uses of the parlor album require more study. Given the nature of the parlor as a reception and ritual space, the album may have functioned in similar ways as hall furnishings within the ritual of social calling: see Kenneth L. Ames, "Meaning in Artifacts: Hall Furnishings in Victorian America," *Journal of Interdisciplinary History* 9 (Summer 1978): 19–46; Wajda, "'Social Currency,'" chap. 6.

11. Bruce W. Chambers, "American Identities: Cabinet Card Portraits 1870–1910 from the Doan Family Collection," in *American Identities: Cabinet Card Portraits 1870–1910 from the Doan Family Collections*, ed. Bruce W. Chambers (Minneapolis: Univ. Art Museum, 1985), 8–13.

12. Karen Halttunen discusses the theatrical in middle-class life in *Confidence Men and Painted Women* (see esp. chap. 6); Chambers, "American Identities."

13. Ella Rodman Church, *How to Furnish a Home* (New York: D. Appleton, 1881), 6.

14. Fred Hamilton Daniels, *The Furnishing of a Modest Home* (Boston: Atkinson, Mentzer, 1908), 96–97.

15. Hazel H. Adler, *The New Interior: Modern Decorations for the Modern Home* (New York: Century, 1916), 38.

16. Mary Lockwood Mathews, *The House and Its Care* (Boston: Little, Brown, 1928), 176.

17. On the Modern, see Warren I. Susman, *Culture as History: The Transformation of American Society in the Twentieth Century* (1973; rpt. New York: Pantheon, 1984); T. J. Jackson Lears, *No Place of Grace: Antimodernism and the Transformation of American Culture 1880–1920* (New York: Pantheon, 1981); Richard Wightman Fox and T. J. Jackson Lears, eds., *The Culture of Consumption: Critical Essays in American History 1880–1980* (New York: Pantheon, 1982); Lewis A. Erenberg, *Steppin' Out: New York Nightlife and the Transformation of American Culture, 1890–1930* (Chicago: Univ. of Chicago Press, 1981).

Conclusion

Kenneth L. Ames

At the beginning of this book, Karal Ann Marling invited us to think about mass culture and its impact on modern domestic life. She reminded us that Americans of the early twentieth century were unsure of whether the new culture meant loss or gain. Although many people seemed to embrace the new products and services of the age with enthusiasm, some writers and cultural critics feared that something authentic, something real, something deep was being replaced by something quick, superficial, and phony. In the years between 1890 and 1930, people seem to have spent a lot of time wondering which experiences, environments, or things were more "real" than others, which more valuable or more significant than others. Was "live" music more "real" than recorded music, or were simplified "rational" interiors better than richly textured eclectic interiors? These chapters record the ways Americans of past generations wrestled with these and related questions.

As interesting as these issues are, however, I find myself more drawn to another question that goes unasked in these chapters but seems continually to lurk beneath the surface. That is the larger question of whether the domestic world was or is more or less "real" than the outside world of technology and capitalism.

This is not a question we are used to asking. On one level it probably seems like a silly question, for by some measure of understanding, all the world is equally real. Yet from another perspective the question makes a strange kind of sense. And people would not wonder about varying degrees of authenticity if they did not feel intuitively that experiences differ qualitatively. In our own lives we may sense that in some uncertain way, heightened "reality" correlates with awareness of the elemental.

But which elemental? Surely elemental experiences are valued differently. The Victorian dichotomy of separate spheres involved more than the

division of labor or male prejudice toward women. Separate spheres conventionalized and codified significantly different ways of looking at and valuing the elemental. These different ways have been called male and female, and with that naming, males, as the dominant group, have also ranked them. But we need to look at these ways without bias and reflect on their costs and benefits to humankind.

It has long been conventional to ignore the contributions of women and to denigrate the female elemental. Yet feminists have repeatedly shown us that both biologically and psychologically women are associated with life and nurture. Women are more alert to ecological and environmental issues. In our society, it is obvious that women communicate more fully and more meaningfully than men and are more aware of themselves both as people and as living beings.

All of this is commonplace and widely known. Yet keeping this in mind helps us make fuller meaning of the testimony of these essays. And it may help us see this story as one in which women play leading roles and in which women's values and attitudes are more likely to find expression, even when the point is not explicitly made. For women played the piano and sat beside the hearth. Women read aloud at least as often as men, and women created the needlework that adorned hundreds of thousands of homes. As a genre of artifacts, furnished homes are more likely to give us access to the female elemental. Once understood, this insight helps us see things like making music and needlework as no longer incidental or trivial, but central and important. It helps us recognize that there exists a value structure entirely separate from the value structure created by males and bearing no resemblance to it.

And so I ask the question again: Is the domestic world more or less real than the outside world? From the viewpoint of female elementalism, it is more real. And from any unbiased perspective, it is clear that that world is more positive and more benevolent than the much celebrated but deeply troubled male elemental world.

This book is, then, a chapter in the history of the progress of the female understanding and expression of elemental. It is also about more time-locked considerations as well. It is, for instance, about the decline of the Victorian paradigm and the piecemeal advances of modernism. And it is also an exposition of the idea that homes are centers of webs of social and cultural relationships. This collection is particularly valuable for articulating that web through the diversity of topics related to domestic life that it explores. And we have only scratched the surface. A systematic attempt to

identify and trace all networks would take decades of McFaddin-Ward House conferences. When we begin to grasp the number and complexity of systems that converge on homes we start to recognize that they may be our most intricate cultural artifacts.

This brings us back to where we started. At the beginning of this book, I referred to homes as our most prominent, most important, and most culturally revealing artifacts. The evidence assembled here has supported that claim eloquently, taking us deep into the inner workings of American homes during the forty-year period from 1890 to 1930. I might have added that homes may also be our most accessible artifacts. Some objects from the past, even of relatively recent origin, seem distant and inaccessible. What struck me forcibly on reading and rereading these chapters was how accessible this artifactual world actually is. In part that accessibility is due to the authors' evocative powers, but I am convinced it is also due to the benevolent nature of the artifacts themselves. It may also be true because the artifacts and the culture they describe still survive, albeit in somewhat altered form. Unlike the outside world, which is racked by radical change and abrupt disjunctures, the inner world of the home, the locus for that other definition of elemental, evolves at a quieter and more serene rate. It provides the center from which we can all take our bearings.

I am inclined to think that historians have had it upside down all these many years. They have chronicled the competition and change of the outside world without recognizing that it is little more than the same old drama performed again and again by an all-male cast with only a few minor changes in the script. It is a negative and depressing tale. But this book lays out another and more benign drama acted out for the most part by a different cast.

Given my choice of dramas, I opt for the latter. I do so not merely because it has been undervalued or because we need balance. I opt for it because of its universality, its utility, its accessibility, its familiarity. I opt for it because it is, at its core, about finding physical and psychic comfort, about finding emotional gratification and fulfillment, about personal growth, expression, and satisfaction. I opt for it because it is the story of the ways we find or make a place in the world, a place that strengthens who and what we are and can be. I opt for it finally because it is both central and life affirming.

Having said all of that, I admit that we are still only beginning to learn about this story. And thus we have our future work cut out for us.

Contributors

KENNETH L. AMES is chief of the historical survey at the New York State Museum in Albany. His recent publications include *Death in the Dining Room and Other Tales of Victorian Culture* (1992) and, as coeditor, *Ideas and Images: Developing Interpretive History Exhibits* (1992) and *Decorative Arts and Household Furnishings in America, 1650–1920: A Bibliography* (1989).

WILLIAM S. AYRES, chief curator at the Museums at Stony Brook, Long Island, New York, is project director for the exhibit "History Painting in America, 1775–1925," produced by the Fraunces Tavern Museum in New York City, and editor of the accompanying book of the same title (1993). Among his other publications is *A Poor Sort of Heaven; A Good Sort of Earth: The Rose Valley Arts and Crafts Experiment* (1983).

BRADLEY C. BROOKS is curator of collections and associate director at the Moody Mansion and Museum in Galveston, Texas. He coauthored the exhibition catalog *Accumulation and Display: Mass Marketing Household Goods in America* (1986).

JESSICA H. FOY is curator of collections at the McFaddin-Ward House in Beaumont, Texas. She coedited *American Home Life, 1880–1930: A Social History of Spaces and Services* (1992) and coauthored *The McFaddin-Ward House: Life-style and Legacy in Oil-Boom Beaumont, Texas* (1992).

BEVERLY GORDON is associate professor in the Department of Environment, Textiles and Design and research director of the Helen Louise Allen Textile Collection at the University of Wisconsin–Madison. She is the author of *American Indian Art: The Collecting Experience* (1988), *The Final Steps: Traditional Methods and Contemporary Applications for Finishing Cloth by Hand* (1982), *Shaker Textile Arts* (1980), and *Domestic American Textiles: A Bibliographic Sourcebook* (1978).

ANNE SCOTT MACLEOD is professor and acting dean of the College of Library and Information Services at the University of Maryland. Her publications include *American Childhood: Essays on 19th and 20th Century Children's Literature* (forthcoming), *Children's Literature: Essays and Bibliographies* (1977), and *A Moral Tale: Children's Fiction and American Culture, 1820–1860* (1975).

KARAL ANN MARLING is professor of art history and American studies at the University of Minnesota. Among her numerous publications are *Edward Hopper* (1992), *Iwo Jima: Monuments, Memories, and the American Hero* (1991), *Blue Ribbon: A Social and Pictorial History of the Minnesota State Fair* (1990), *George Washington Slept Here: Colonial Revivals and American Culture, 1876–1986* (1988), and *The Colossus of Roads: Myth and Symbol Along the American Highway* (1984).

KATE ROBERTS is exhibit curator/project manager at the Minnesota Historical Society. She developed "Minnesota A to Z," the opening exhibit for the Minnesota History Center, and is developing a permanent exhibit on the recent history of the Mille Lacs Band of Ojibwe for the Mille Lacs Indian Museum and Cultural Center on the Mille Lacs Reservation in northern Minnesota.

CRAIG H. ROELL is assistant professor of American business and cultural history at Georgia Southern University. His publications include *The Piano in America, 1890–1940* (1989); *Lyndon B. Johnson: A Bibliography*, volume 2 (1988); and, with Lewis L. Gould, *William McKinley: A Bibliography* (1988).

SHIRLEY TERESA WAJDA is assistant professor in the American and New England studies program at Boston University and a 1994 National Endowment for the Humanities fellow at the Winterthur Museum.

Index